JODY PADULANO

Jody Padulano is a happy AFOL (Adult Fan of LEGO). Although he was raised in Rome, where he was born in 1979, he has a global outlook. Jody is a computer engineer who works in telecommunications, but his passion is the creation of games and video games. He often travels and divides his time among his love of acting, his interest in other cultures, role-playing games, and, obviously, his endless passion for LEGOs, which he has never stopped collecting since he was a young child. Jody is an active member of ItLUG (the Italian LEGO® User Group) and RomaBrick, major LEGO communities, and is most enthusiastic about castles and pirates. His constructions have been on display in Italy and abroad. He wrote *The LEGO® Zoo* in 2017 for NuiNui.

HOW TO BUILD VEHICLES
WITH LEGO® BRICKS

JODY PADULANO

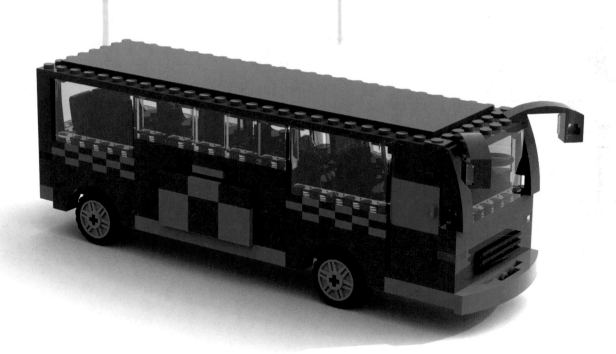

THUNDER BAY
P · R · E · S · S
San Diego, California

Thunder Bay Press
An imprint of Printers Row Publishing Group
10350 Barnes Canyon Road, Suite 100
San Diego, CA 92121
www.thunderbaybooks.com

Copyright © 2018 Nuinui, Italy

Printers Row Publishing Group is a division of Readerlink Distribution
Services, LLC.
Thunder Bay Press is a registered trademark of Readerlink Distribution
Services, LLC.
All notations of errors or omissions should be addressed to
Thunder Bay Press, Editorial Department, at the above address.
All other correspondence (author inquiries, permissions)
concerning the content of this book should be addressed to
Nuinui Srl, Via Galileo Ferraris 34, 13100 Vercelli, Italy.

The publisher wishes to thank
the ItLUG (Italian LEGO® Users Group)
for its valuable cooperation.
http://itlug.org

In memory of Dan Jezek

Thunder Bay Press
Publisher: Peter Norton
Associate Publisher: Ana Parker
Publishing/Editorial Team: April Farr, Kelly Larsen,
Kathryn C. Dalby
Editorial Team: JoAnn Padgett, Melinda Allman, Dan Mansfield

Graphic and project design: Ngoc Huynh
Cover graphics: Clara Zanotti
Translation: Contextus s.r.l., Pavia (Richard Kutner)

ISBN: 978-1-68412-560-9
Printed in China
22 21 20 19 18 1 2 3 4 5

TABLE OF CONTENTS

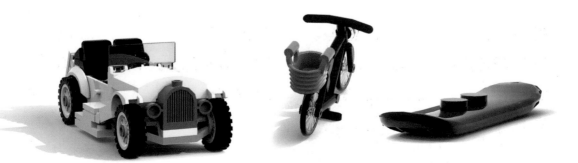

INTRODUCTION

ORGANIZE THE PIECES

Organizing the pieces is always a problem. Everyone has his own priorities, his own method, but I will provide you with a system that will always be helpful. In the next chapter, we'll examine various kinds of pieces. Even if they are most often ordered by color, usually this is not a good idea. It could be, if you decided to build something of one color with any kind of piece, but most the time the best choice is to divide them up **by type**. Here's an example: let's suppose that you have a lot of 1×1 or 1×2 BRICKS. A good solution is to put all the 1×1 BRICKS of various colors in one envelope or bag. Then, when you need one of these pieces, you'll be able to find it right away. It would be harder to find a 1×1 black BRICK among a variety of different pieces that are all black, right? And if you have many pieces of the same type and color, don't mix them with the others; keep them all together. If, on the other hand, you have very few of one type, put them with others that you think go well together.

The general rule is: By type, not by color.

BUILD WITH ALTERNATIVE PIECES

It's important to understand that the instructions that come with various products don't have to be followed to the letter. Your imagination is the most important thing! If you want to use a different piece from the one indicated—because you have pieces that you think work well together but are of different colors—use it! No problem.

Here's an example: if the instructions say to use **a** 2×2 BRICK, but you have only **two** 1×2 BRICKS of the same color, maybe the two 1×2s will work just as well. There could possibly be a structural problem, but if the construction holds up successfully and doesn't come apart easily, you've found a solution! All the vehicles are made with fairly common pieces that are easy to find, so you will almost never have a problem building them. However, sometimes you don't have a particular piece of a certain color. If this happens, and you don't want to buy one, use a piece that you already have.

The general rule is: See if you can find an alternative solution.

BUY PIECES YOU DON'T HAVE

There are various "sources" for acquiring missing pieces:

1) Boxes. As you know or can imagine, there are boxes of mixed pieces. Many of the pieces you're missing can be found inside.

2) Pick a Brick. At *https://shop.lego.com/en-US/Pick-A-Brick-11998*, you can find a selection of pieces. You might find what you need. Learn how to use the site. It's quick and useful. To use this service, you'll have to create a user account and have a grown-up on hand who can make online purchases.

3) LEGO Stores. In LEGO® stores, there are entire walls with a wide selection of bricks on display. This is another place to find the pieces you need for your construction.

4) BrickLink. Last but not least, there is BrickLink: At *https://www.bricklink.com*, you'll find the largest online selection of bricks in the world. Ask an adult to help you make your purchases. At first it might seem confusing, because absolutely everything is there, but after you have signed up and familiarized yourself with the BrickLink "stores" (categories), ordering is easy. You just have to choose the pieces you need (on the left) and put them in your cart. Once you've chosen your payment and shipping methods, you'll receive an email confirmation. The vendor (they're all private) will contact you with instructions for completing the order and will quickly send your purchase directly to your home. The best thing about BrickLink is that you can use a "wanted" list (a list of pieces you want). If you compile it correctly, it will allow you to find a store with all the pieces missing for your construction. As of the writing of this book, all the pieces for vehicles could be purchased by ordering from just one store (but not always the same store). You don't have to go to two different stores to complete your vehicle. This will help you to save money on your purchases.

BUILDING TECHNIQUES
BECOME A MASTER BUILDER

You will see that some of the projects in this book are easy and some are more difficult. Do you know what the difficulty depends on? On the technique that you use. Let me explain: Taking the pieces and putting them one on top of another (***vertical stacking***), you can build many things, but not all of them. Some pieces, like **bricks with side studs** or **brackets**, have studs on the side, not only on top. That means that you can construct something horizontally as well. The technique of building an entire construction **horizontally**, or a large portion of one, is called **SNOT**, an acronym for "**S**tuds **N**ot **O**n **T**op." You'll see that all the studs are connected sideways. Sometimes, special pieces are also used, adapted for more technical creations and therefore called "Technics."

These are all methods that will allow you to broaden your knowledge and create new and amazing constructions.

THINK IN PIECES

What if you want to try your own new creation? No problem.

After having completed all 40 projects, you'll certainly be ready to make the most of your experience.

Look for a picture of the vehicle that you would like to build, and **think in pieces**!

What colors would you like to use? Will you need a plate or a slope? Try and try again. Don't be afraid to take everything apart and start over. Only when you've found the perfect pieces will you be completely satisfied!

TERMINOLOGY

Over the years, specific terminology has come to be used for LEGO® pieces, a kind of **code** that master builders all over the world have adopted so they can communicate with one another more easily. Think of a piece. If you call it one thing and your best friend calls it another, it would be hard for you to understand each other. The use of specific terminology is very helpful: whoever wants to explain a technique or a project can be understood easily by other LEGO® fans. In this chapter, I will explain only **some** of the terms, those that are used most frequently and that will appear most often in this book. Let's see what they are.

STUD

A stud is the little "button" that you find on every piece that allows you to connect it to the others. It is generally used as a unit of measure.

BRICK

The brick is the most common piece, the one you've always used to build. It comes in different sizes. For example, there is the 1×1 BRICK, which has only one stud, or the 2×2 **stud** that has two **studs** on each side (for a total of 4 studs), etc.

PLATE

A plate is like a BRICK but shorter. Three PLATES are as tall as one BRICK. Plates are used to make smaller structures.

ROUND BRICK

A round brick is like a BRICK, but with a round edge instead of straight ones. It's a regular piece, only round.

ROUND PLATE

A round plate is a PLATE with a circular edge.

MODIFIED BRICK

A modified brick is one with something special. That is to say, it doesn't behave … normally. It might have a stud on the side or a hook or even be shaped at an angle. Basically, it's just a brick, but modified!

MODIFIED PLATE

A modified PLATE is a plate with something special. There are different kinds, for example a hole, a hook, a handle…

TILE

A tile is like a PLATE but without studs. It's completely smooth and, as the name would indicate, is used mostly for floors. But you can do anything you want with it!

MODIFIED TILE

A modified tile has something special, like a hook or other feature.

ROUND TILE

A round tile is a TILE with a circular edge.

WEDGE

A wedge is like a BRICK but with a diagonal edge.

WEDGE PLATE

A wedge plate is like a PLATE, but with diagonal edges. You can recognize it easily because it's not round or square.

SLOPE

A slope is an inclined BRICK. The amount of slope can vary and is measured in degrees. The most common pieces in this category have slopes of 30°, 33°, 45°, 65°, and 75°. A slope is easily recognizable because, regardless of how it is used, there are always more studs on the bottom than on top (like the 2×2 45° stud in the illustration, which has 4 studs on the bottom but only 2 on top).

INVERTED SLOPE

An inverted slope is like a SLOPE turned upside-down. In this case, there are always more studs on the top than on the bottom.

CONE

A cone is a brick in the form of a cone, wider on the bottom and narrower at the top.

BRACKET

A bracket is a PLATE with studs also positioned on the sides at a 90° angle. The number of studs on both sides varies according to the type of bracket.

HINGE

A hinge is a BRICK or PLATE that allows movement when it is attached to another piece. This is what we use to make moving parts (although it is not the only solution).

ANTENNA / LEVER

This piece has various names and is a kind of little lever that you'll find used in the book in different ways, often as a gearshift.

DISH

This piece is shaped like a flying saucer. It's different from a ROUND PLATE because the bottom attachment curves inward slightly.

There are many other kinds of pieces (like doors, windows, or "Technic" pieces) that aren't used in this book and are therefore not shown in this section. I have provided you with the basic terminology used by master builders, which will also be useful for your online purchases.

SPECIAL BRICKS

"I GOT YOUR PLATE NUMBER!"

For many car models I have included the license plate you see in the picture. It's the one I chose for myself, as a good luck charm, but nothing prevents you from having your own to personalize your vehicle. For this reason, when you're really into the act of creation, you won't have to refer to the one here while looking for pieces. Feel free to choose the license plate you want: lots of them are available, and I'm sure that you'll be able to find one that's just right for you and perfect for your vehicle!

"GIVE ME A LEVER ..."

The lever (or antenna) that you see in the picture is used often (in the available colors) and in various ways, for example as a gearshift or windshield wiper. In these instructions, I have chosen to separate all the pieces into groups, but often you'll also find this piece all by itself. Don't be surprised, then, if you have a hard time finding the single components. Take the entire lever and use it. You'll find it in the "lever" category. Its code is generally 4592c0X, where X is a number from 1 to 5.

IN THE DRIVER'S SEAT

The information provided for the lever is the same for the steering wheel. I have chosen to indicate the two pieces of which it is composed separately, but I have put them in the same section of the instructions. The steering wheel, however, is often found attached as one piece. It usually comes this way in the box, and you may have difficulty in locating the wheel separately from the shaft. As for the antenna/lever, here's a hint: the code for the steering wheel is generally 3829c0X, where X is a number from 1 to 4.

Keep the code where you can find it easily.

LEVEL 1

Here are ten little vehicles to prepare you for the construction of bigger, more demanding models. They are composed of few pieces, sometimes only one, and are very easy to put together.

Start playing right away!

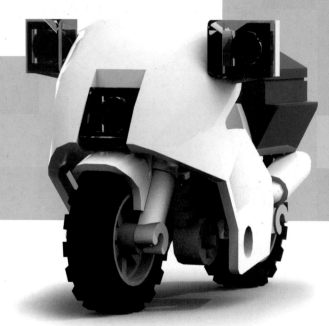

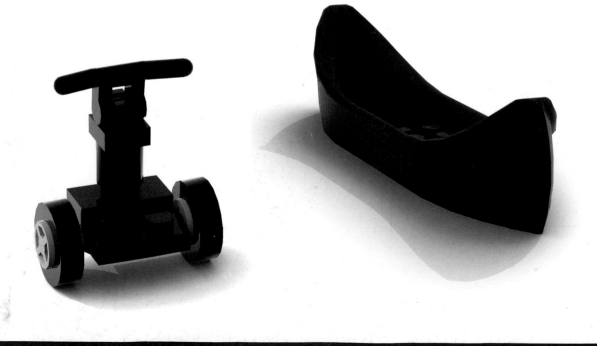

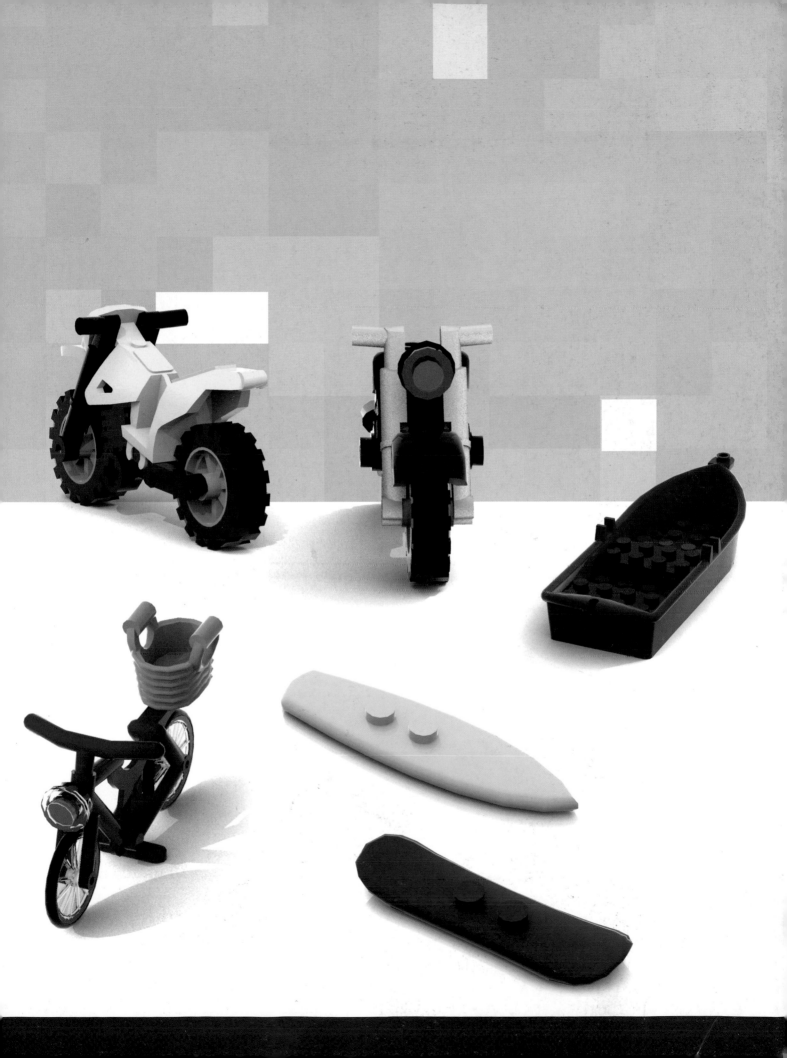

SNOWBOARD

Let's start with snow. With the snowboard you'll be able to do fantastic tricks like an Olympic champion. Beginning in 1998, snowboarding became an Olympic sport.

with just one piece, you'll be able to slip and slide like lightning on the snowy slopes.

Pieces required

1 x
93218

SURFBOARD

The surfboard, on the other hand, is for flying on water, riding the waves. It seems modern, but actually people recorded seeing this means of water transportation in the early 1800s in Polynesia and Hawaii, where it was called *he'e nalu*, Hawaiian for "slide over the waves."

Attach your favorite minifigure and become king of the sea!

Pieces required

1 x
90397

SKATEBOARD

The skateboard is like a snowboard but smaller and with wheels. It was invented in California in the 1940s and became a worldwide sensation in the 1970s, when lots of kids used it to whizz down the streets of big cities.

With only three pieces, it's very easy to put together and ready to go in a flash!

Pieces required

1 x
42511

2 x
2496

1

1 x

2

2 x

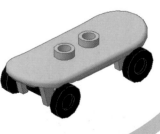

ROWBOAT

For this simple construction, you'll also need only a few pieces. It's easy to build your rowboat and set off for an island with buried treasure. Along with the raft, it's the oldest known watercraft.

This one is not so old, but you can use it as a lifeboat for a gigantic galleon!

Pieces required

4 x
3023

2 x
3020

1 x
2551

1
1 x

2
4 x

3
2 x

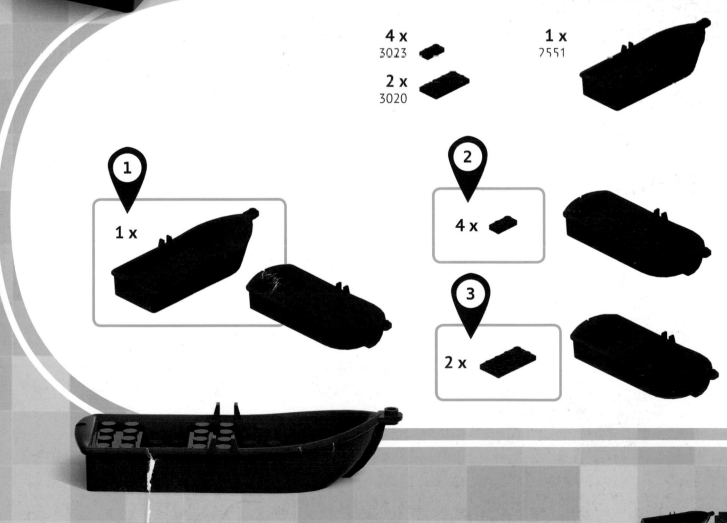

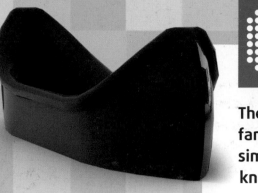

CANOE

The one in the illustration is the oldest and most famous canoe: the Canadian canoe. It's different from similar craft because the person who propels it sits or kneels and uses a paddle instead of oars.

Native Americans used it on rivers and big lakes. You can navigate on any body of water, even in your bathtub!

Pieces required

1 x
3022

1 x
6021

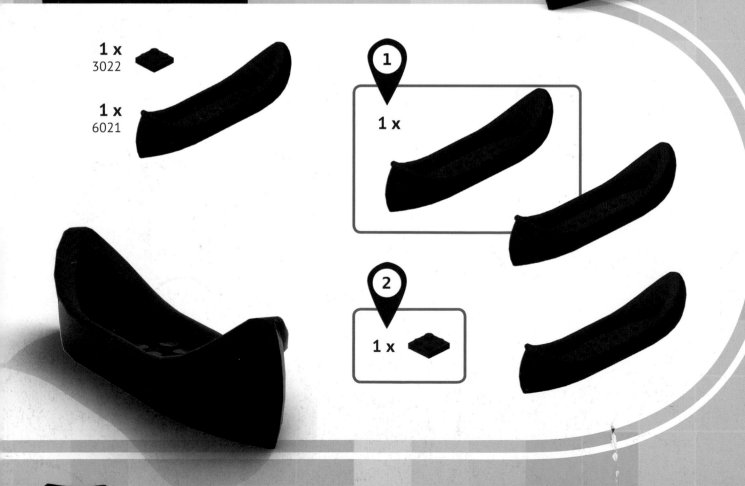

1

1 x

2

1 x

BICYCLE

You need only three pieces to climb onto your seat and start to pedal, but if you want to upgrade your fabulous bike with a rear basket and a light in front, you'll have to add them. The bicycle was created in France in 1791. At that time it was bigger and very strange. The one you can build with the LEGO® pieces looks like the English version from the end of the nineteenth century.

Pedal away—the minifigures don't get tired and don't sweat!

Pieces required

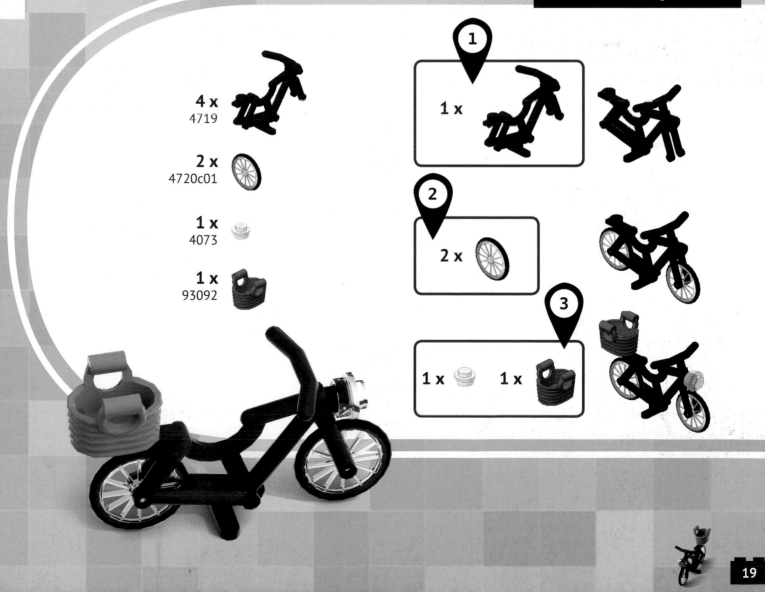

4 x
4719

2 x
4720c01

1 x
4073

1 x
93092

1
1 x

2
2 x

3
1 x 1 x

SEGWAY

It takes only a few steps to construct what is certainly the vehicle of the future. Like the hoverboard, the Segway was inspired by the scooter and by science-fiction films. It runs on batteries, it's ecological, and it can keep going for up to 25 miles and reach speeds of up to 12 mph. You drive it standing up, using the movement of your body by simply leaning in the direction you want to go.

The first Segway prototype dates from 2001.

Pieces required

1 x
4600

1 x
30031

2 x
3139

1 x
3794

1 x
3062b

1 x
2555

2 x
4624

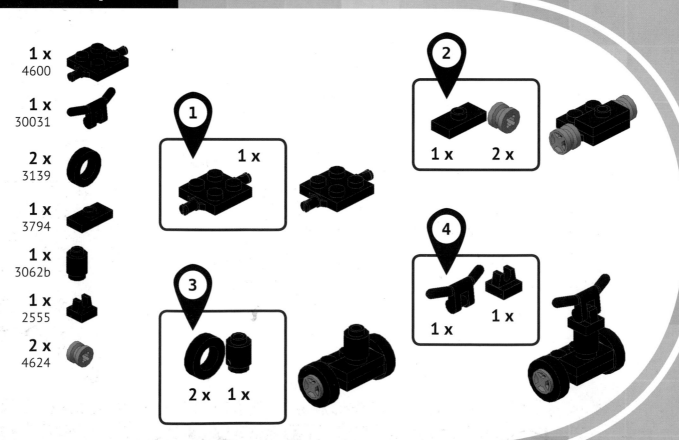

1
1 x

2
1 x 2 x

3
2 x 1 x

4
1 x 1 x

MOTORCYCLE

If you don't feel like pedaling, here's a motorcycle. In 1897, the French company Werner attached a motor to a bicycle, patenting the "Motocyclette." All you need is a few pieces to build a motorcycle that's fast but easy to steer. You'll definitely have a great time!

Step on the gas and fly through all the streets in the world on your motorcycle!

Pieces required

2 x 50861

1 x 6141

1 x 85983

2 x 50862

1 x 50859

1
1 x

2
1 x 2 x

3
2 x 1 x

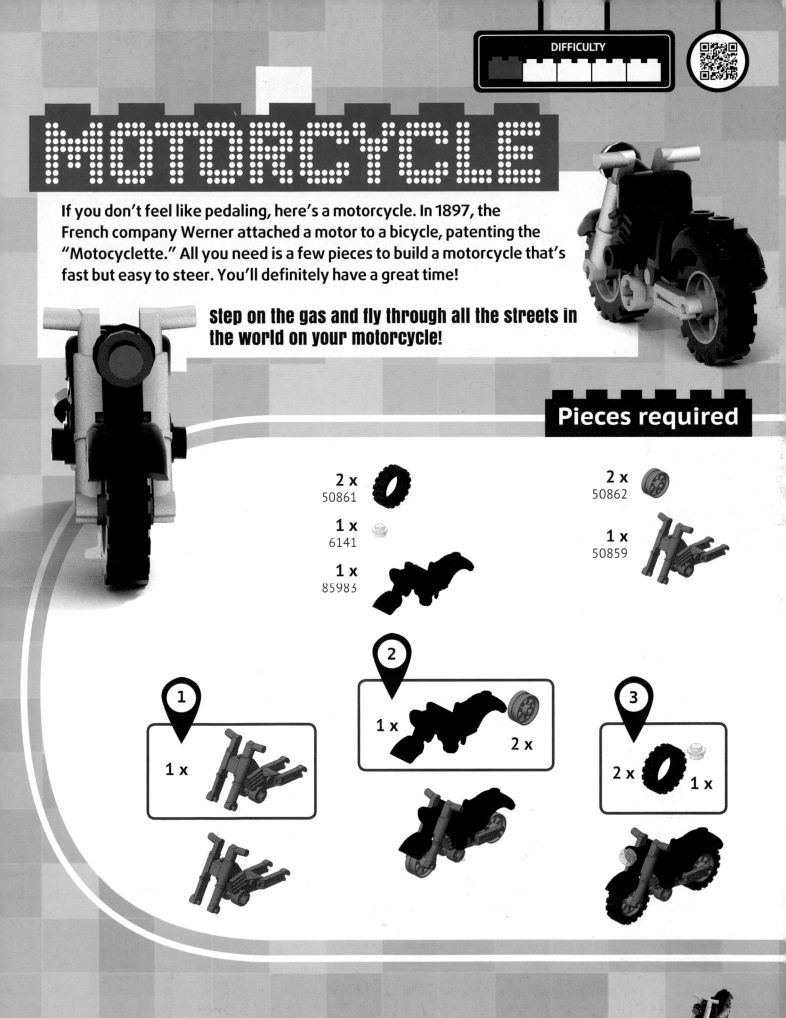

MOTORCROSS BIKE

All you have to do is change the bottom part, and your motorcycle becomes a motorcross bike (like a small motorcycle), with taller shock absorbers and the ability to make fantastic jumps! Motorcross is a sport that requires crazy physical training. Jumping on narrow courses, drivers must maintain perfect control of their bikes. They need strong arms, shoulders and knees!

A motorcross bike needs to be powerful, of course, but the most important thing in this sport is the driver's ability.

Pieces required

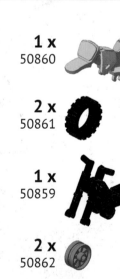

1 x
50860

2 x
50861

1 x
50859

2 x
50862

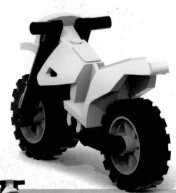

1
1 x

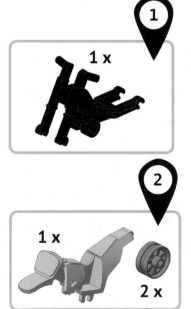

2
1 x
2 x

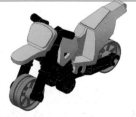

3
2 x

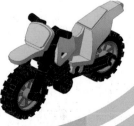

POLICE MOTORCYCLE

This motorcycle has many more accessories than the others. Even though it is bigger than the previous models, it rivals them in speed and agility. Police motorcycles, in general, are regular motorcycles that have been modified so their riders can chase down criminals.

Are you ready? Put on your uniform and make the streets of your city safer!

Pieces required

1 x 52035

2 x 3023

4 x 85984

2 x 50861

1 x 54200

2 x 54200

2 x 50862

1 x 50859

1 — 1 x

2 — 1 x / 2 x

3 — 2 x

4 — 2 x / 2 x / 2 x

5 — 4 x

LEVEL 2

Great! You've passed the first level. I was sure you would. Now things get more serious. With these seven models you will learn about new techniques and new pieces.

Will you pass level 2 with ease?

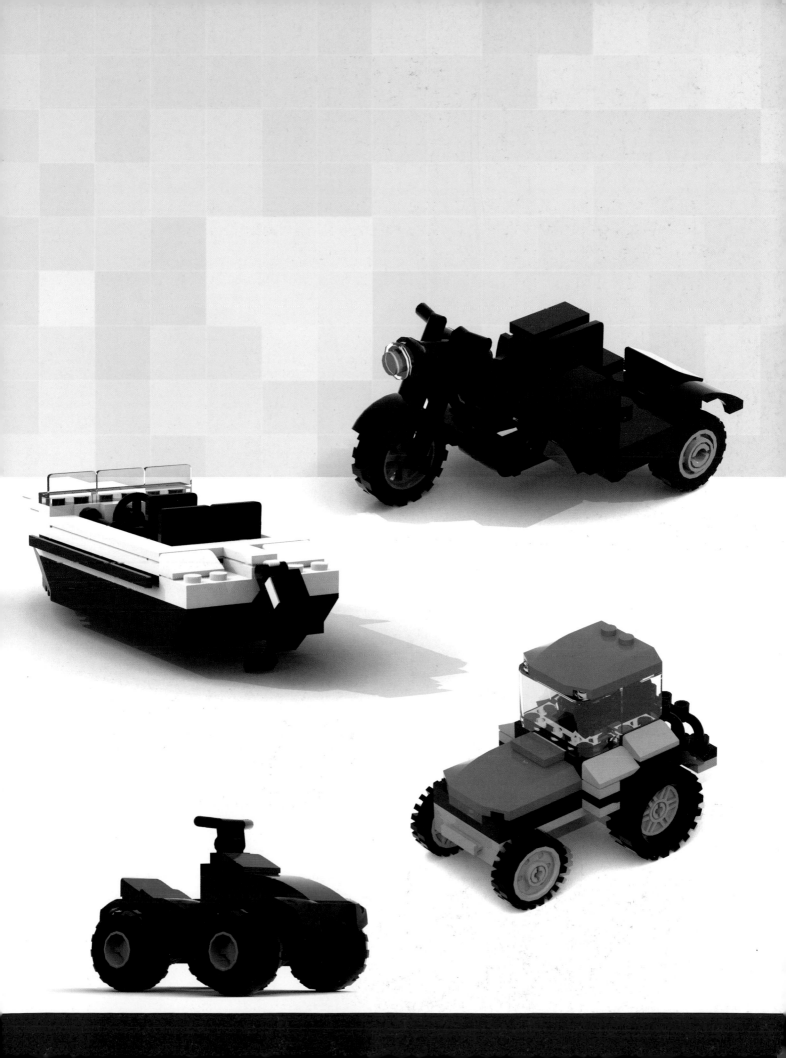

JET SKI

The jet ski is a quick way to move across the water! Ideal for a lifeguard or for anyone who wants to experience the high of water skiing, it is an ideal, very simple construction for testing your skill on your first vehicles. You can choose the color yourself. This model is green, but you can easily experiment with other colors.

Why not build a jet ski park and participate in daring races across the waves?

Pieces required

1 x
30031

1 x
2555

1 x
45677

1 x
3032

1 x
3795

1 x
43712

2 x
2420

1 x
4865

2 x
85984

1 x
3794

1 x
3004

1 x
43713

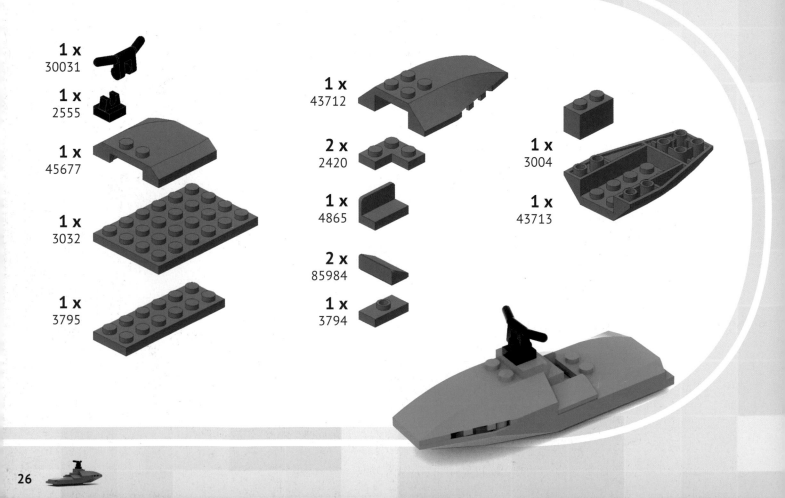

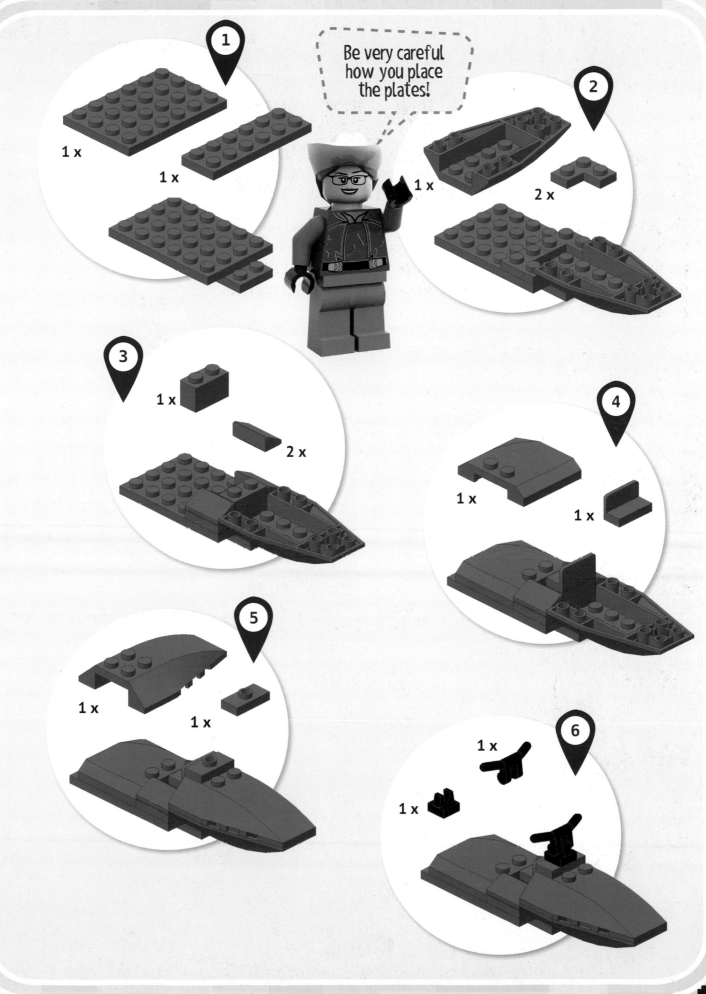

DIFFICULTY

MOTORBOAT

Cut through the waves full speed ahead with this roaring motorboat. It's the perfect vehicle for zooming over the sea. Its motor is called an "outboard" motor because it sticks out from the back of the boat. Jump into this high-speed watercraft and fly across the waves.

You can experiment with the colors as you wish.

Pieces required

2 x 3958	3 x 3794	1 x 3069b	
2 x 85984	1 x 3024	3 x 4079	
2 x 3023	2 x 3022	1 x 3024	
3 x 6636	1 x 2436	2 x 4592c03	10 x 32028
2 x 63864	1 x 2626	3 x 3660	1 x 2433
1 x 63868	2 x 4162	1 x 2626	1 x 30663
1 x 2625	4 x 3001	2 x 3023	1 x 3036
2 x 4477	1 x 60478	1 x 50303	3 x 4865
3 x 3069b	2 x 3005		

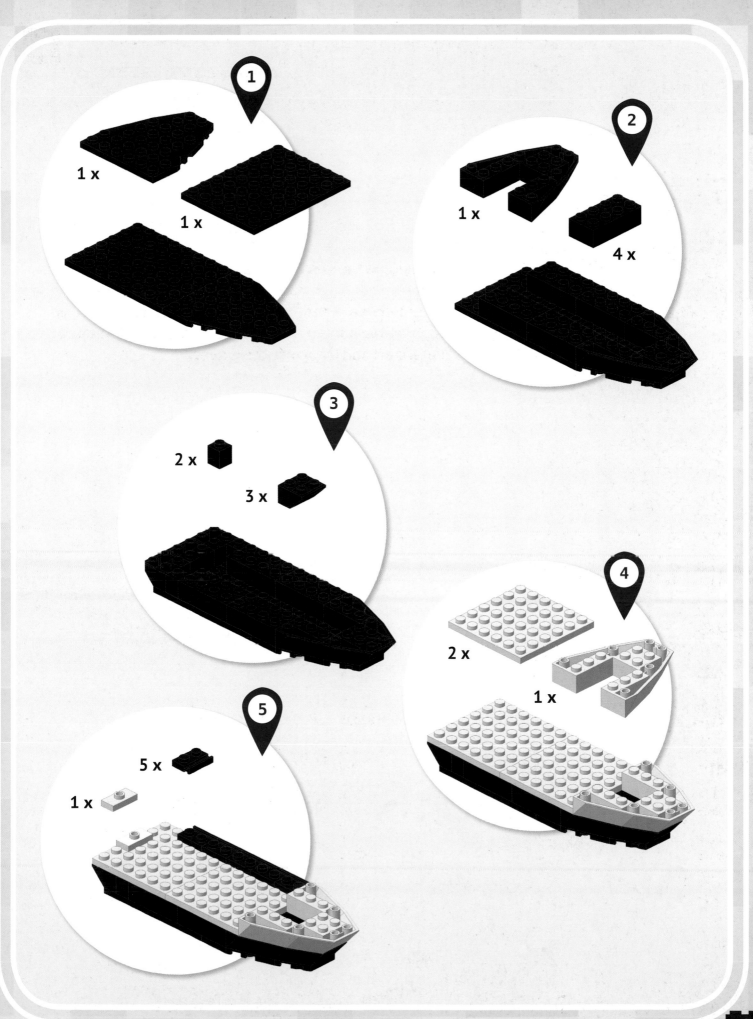

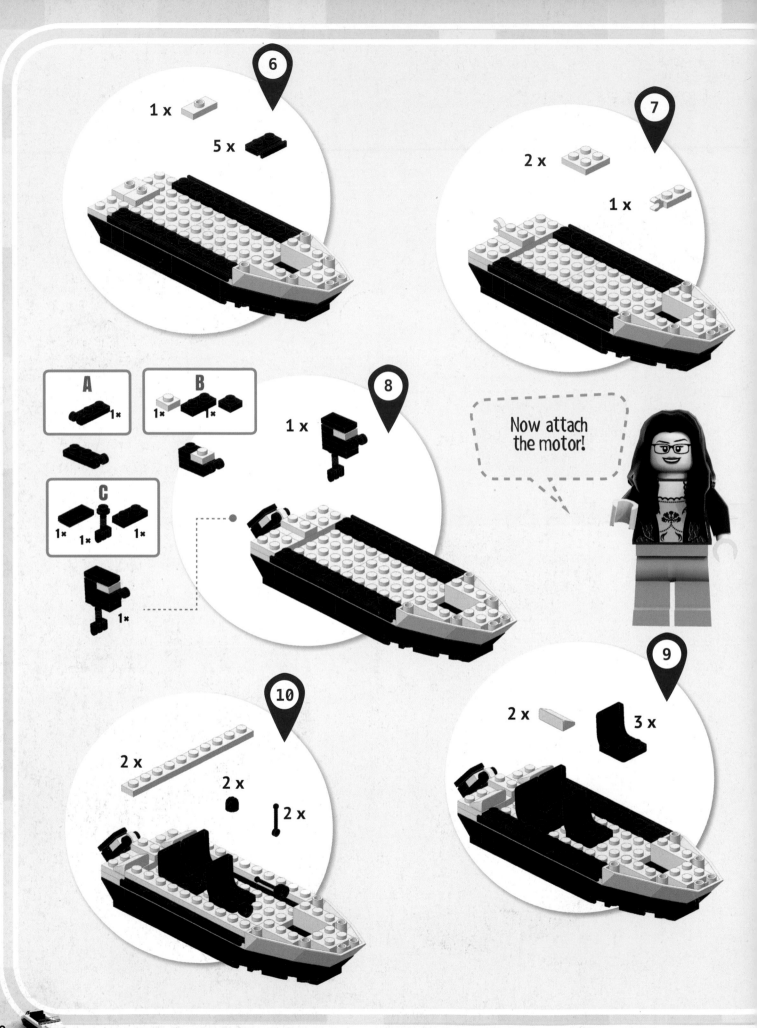

Now attach the motor!

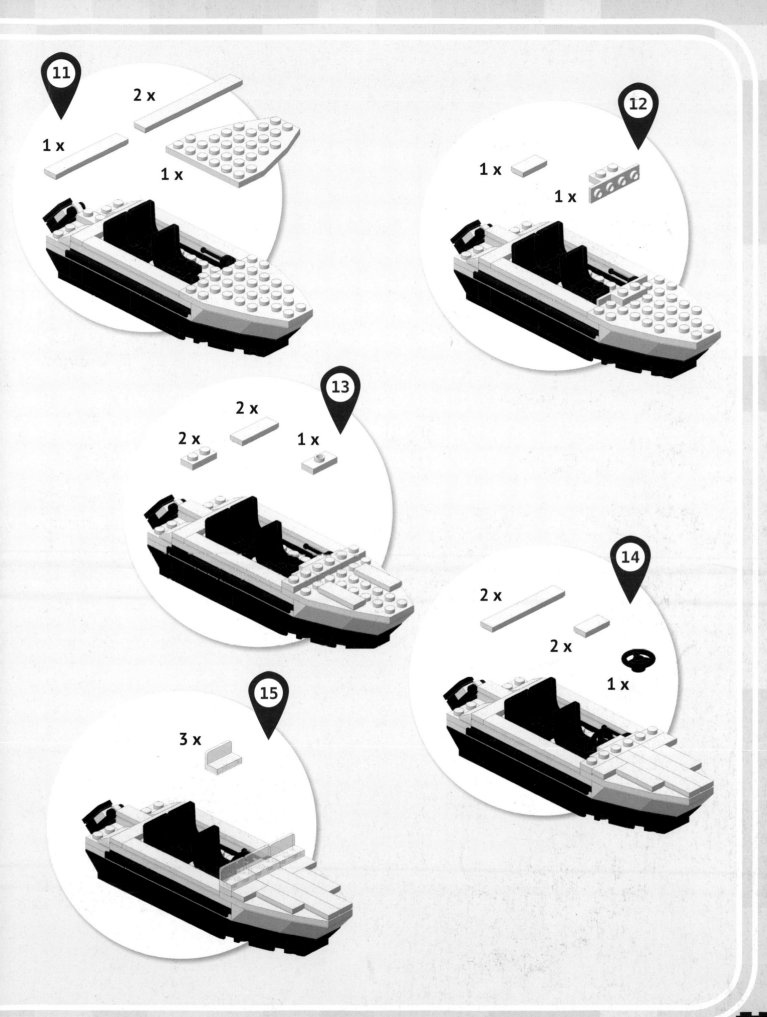

QUAD

This easy and by no means cumbersome vehicle will get you through difficult terrain, including sand dunes. It's really easy to put together and represents another important step forward in building all the vehicles in this book.

You can use your imagination to change the wheels or the colors. Try it now!

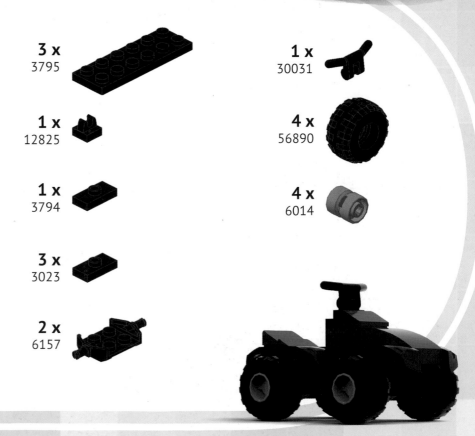

Pieces required

4 x 44674

2 x 3023

3 x 85984

2 x 50950

1 x 3003

3 x 3795

1 x 12825

1 x 3794

3 x 3023

2 x 6157

1 x 30031

4 x 56890

4 x 6014

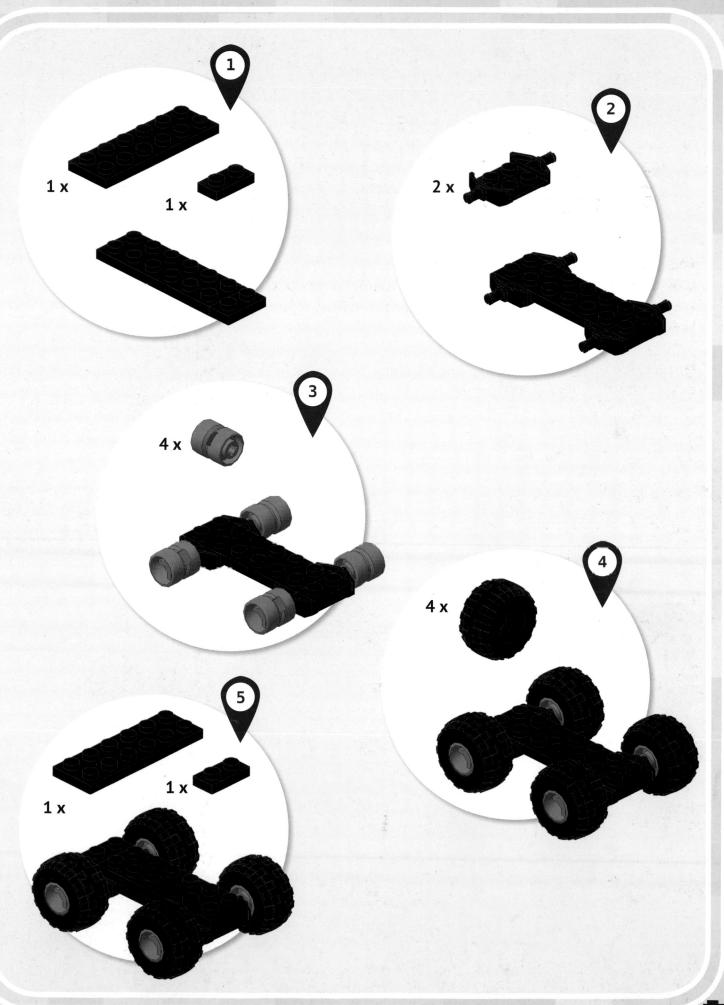

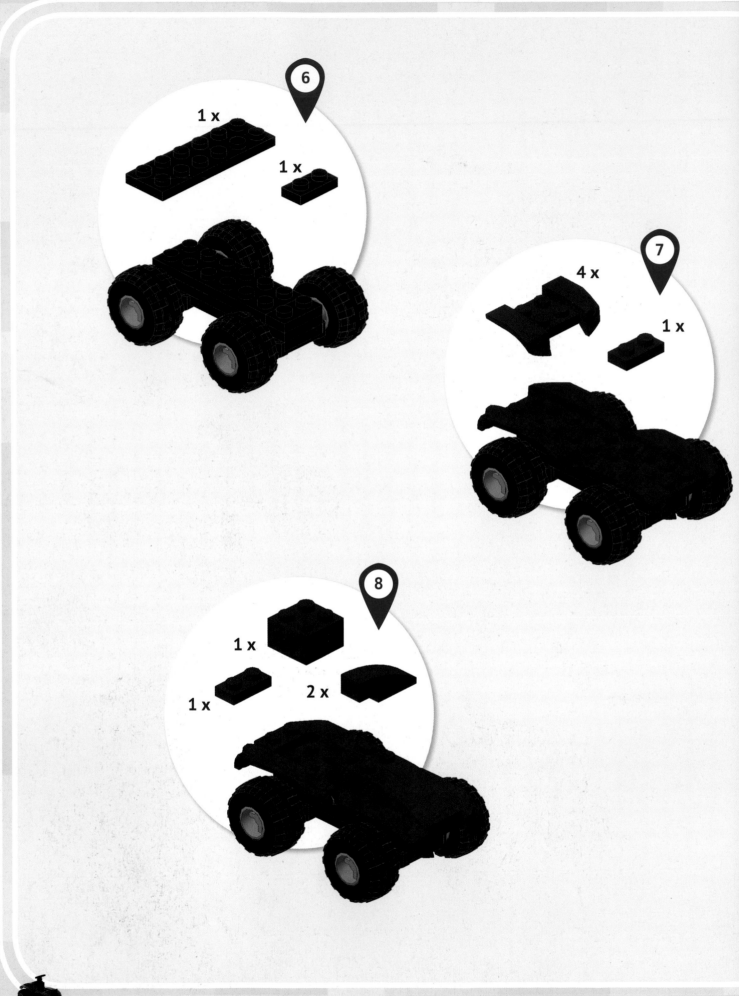

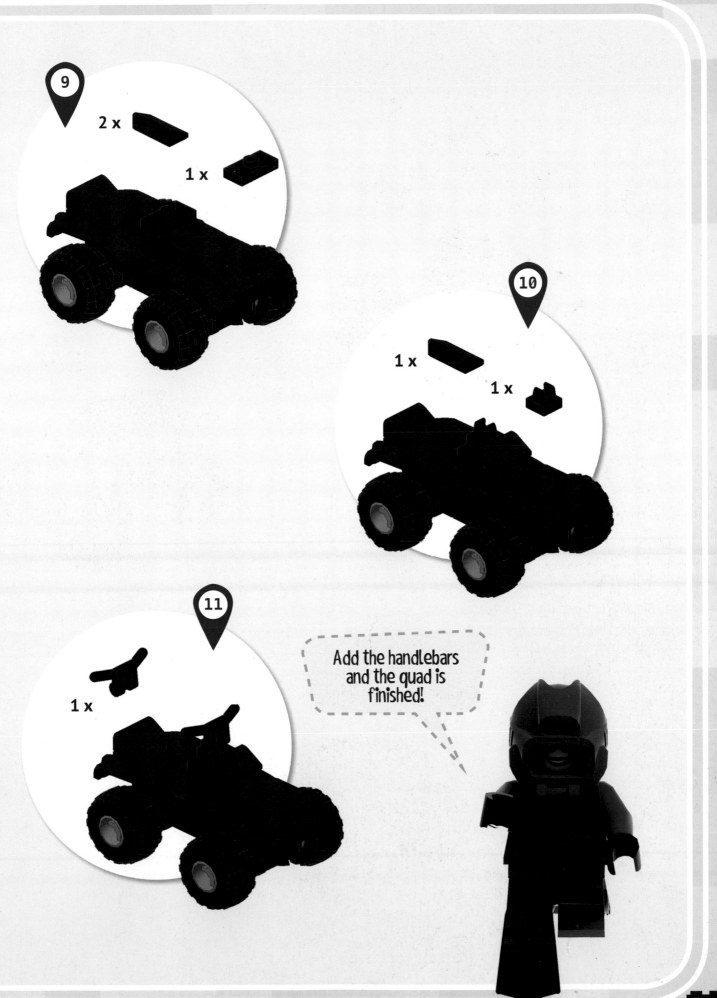

SIDECAR

The sidecar has three wheels and room for a passenger. Its look will capture your imagination, and it's easy to build: another step forward toward more demanding challenges.

Riding in a sidecar is really fun, even if there aren't too many around nowadays.

Pieces required

1 x
3069b

1 x
33299

1 x
3023

2 x
85984

1 x
50947

1 x
4519

1 x
51011

2 x
50861

1 x
50859

2 x
2817

1 x
99781

2 x
4865

1 x
4073

2 x
3023

2 x
3021

1 x
85983

1 x
30602

1 x
42610

1 x
3673

2 x
50862

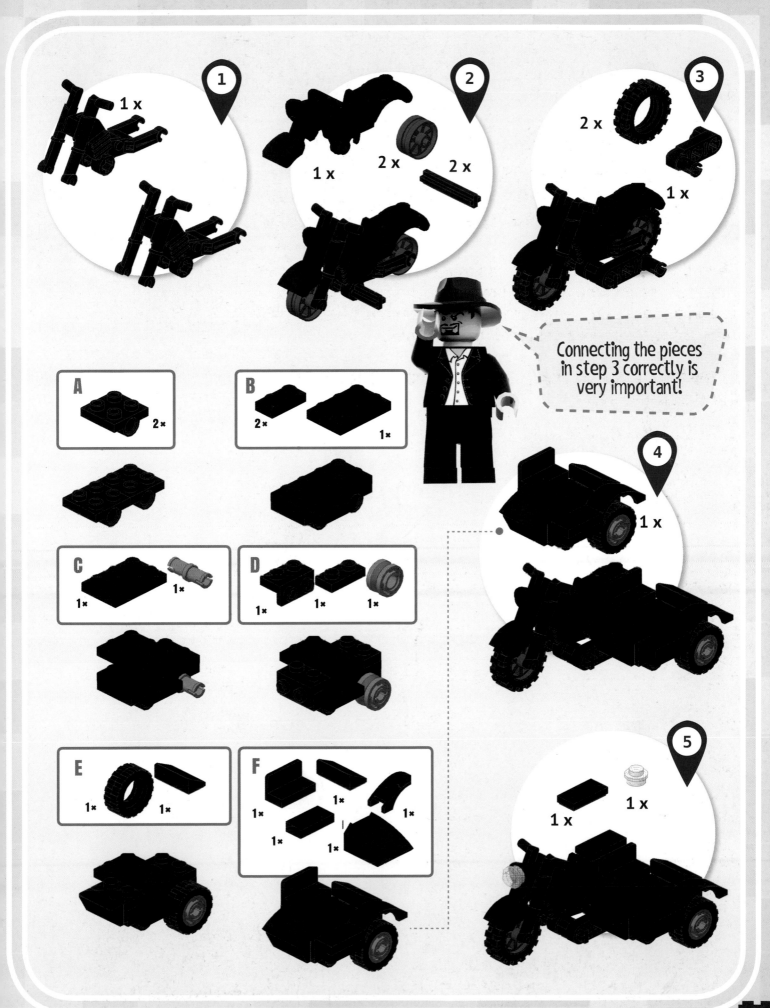

1
1 x

2
1 x 2 x 2 x

3
2 x 1 x

Connecting the pieces in step 3 correctly is very important!

A
2 x

B
2 x 1 x

C
1 x 1 x

D
1 x 1 x 1 x

4
1 x

E
1 x 1 x

F
1 x 1 x 1 x 1 x 1 x

5
1 x 1 x

OLD
CAR

This old car will remind some people of days gone by.... I rebuilt it, trusting my memory, from a model that was proposed again by auto producers in the early 1980s.

I know, a lot of time has passed, and this makes me feel old, but I feel very connected to this simple little car, and I'm happy to include it in this book.

Pieces required

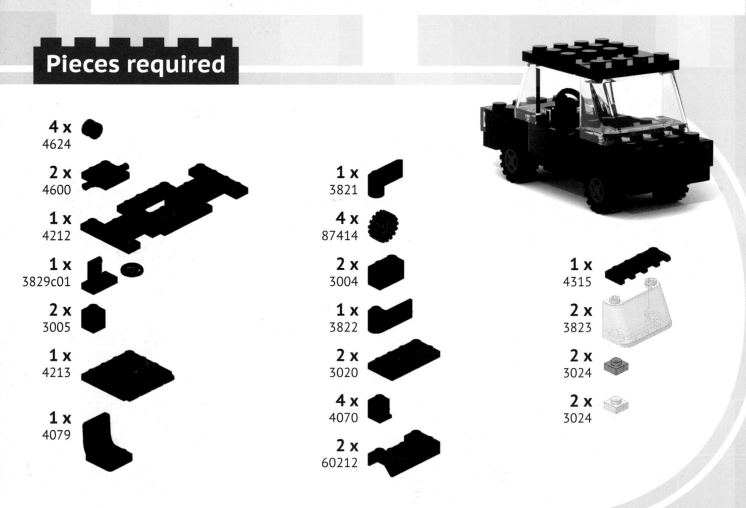

4 x 4624

2 x 4600

1 x 4212

1 x 3829c01

2 x 3005

1 x 4213

1 x 4079

1 x 3821

4 x 87414

2 x 3004

1 x 3822

2 x 3020

4 x 4070

2 x 60212

1 x 4315

2 x 3823

2 x 3024

2 x 3024

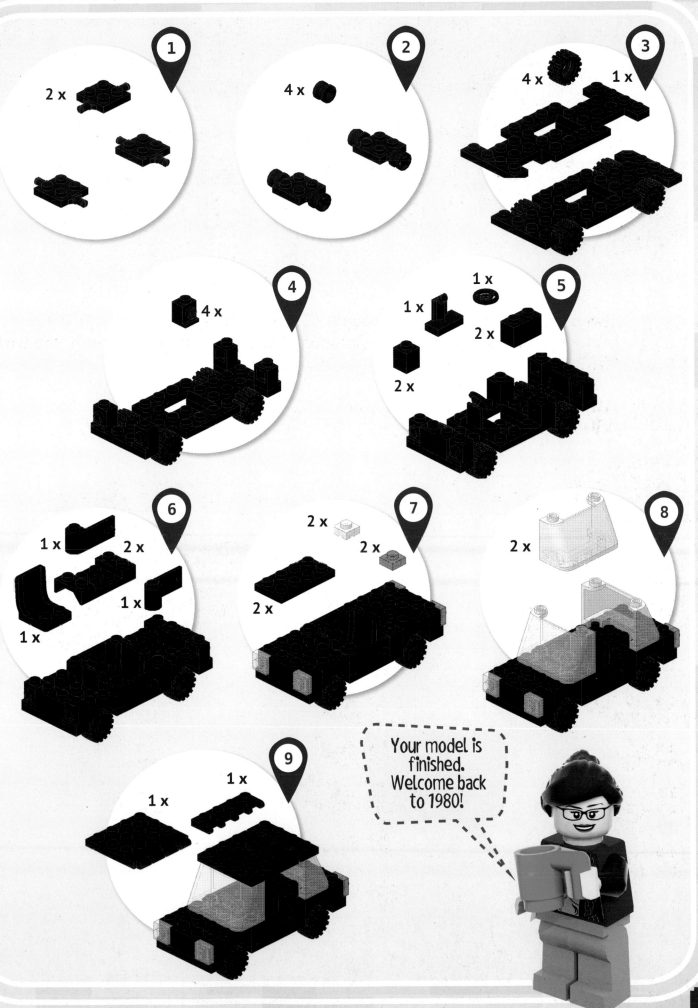

Your model is finished. Welcome back to 1980!

SNOWCAT

Even if it's named for an animal, we're still talking about a vehicle. The snowcat is extremely useful, as the name implies, for moving across the snow. It even has tracks that reduce the chances of dangerous skids. On snow, normal wheels won't work. In this model there are three rollers on each side, but there can be up to five. There's even a shovel to get rid of the snow that accumulates in front. Truly a vehicle of a thousand uses!

Pieces required

6 x 32007	**2 x** 3032	**6 x** 47508
2 x 54200	**6 x** 6558	**1 x** 87580
2 x 85984	**1 x** 3193	**2 x** 3937
1 x 3710	**2 x** 3032	**2 x** 6231
1 x 3958	**2 x** 32018	**1 x** 30413
1 x 2431	**1 x** 3794	**1 x** 3192
12 x 3005	**1 x** 4079	**2 x** 4592c03
2 x 4070	**2 x** 4592c03	**2 x** 3023
1 x 52031	**2 x** 3020	

2 x 680c01
1 x 44567
1 x 3938
5 x 3010
1 x 30663
2 x 3070b
8 x 87552
1 x 92583

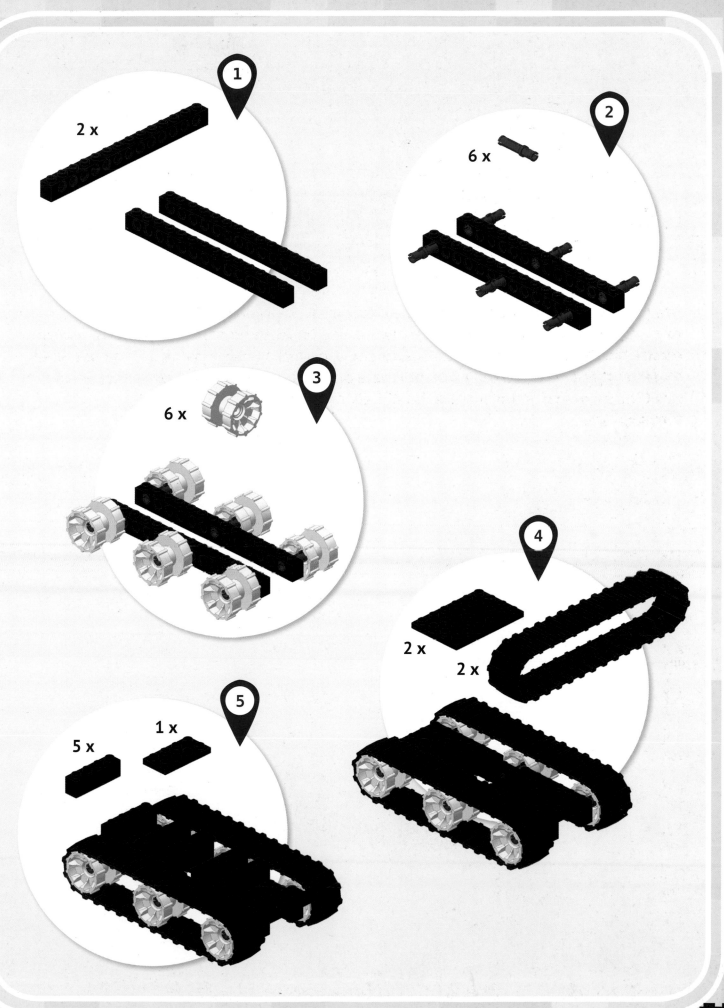

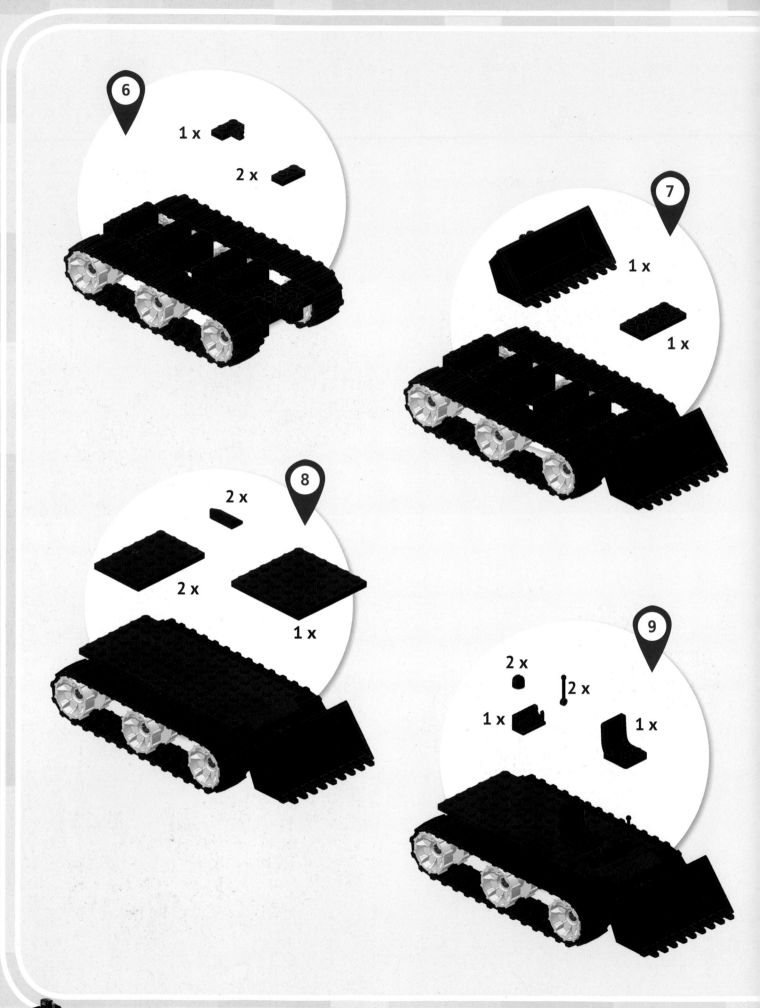

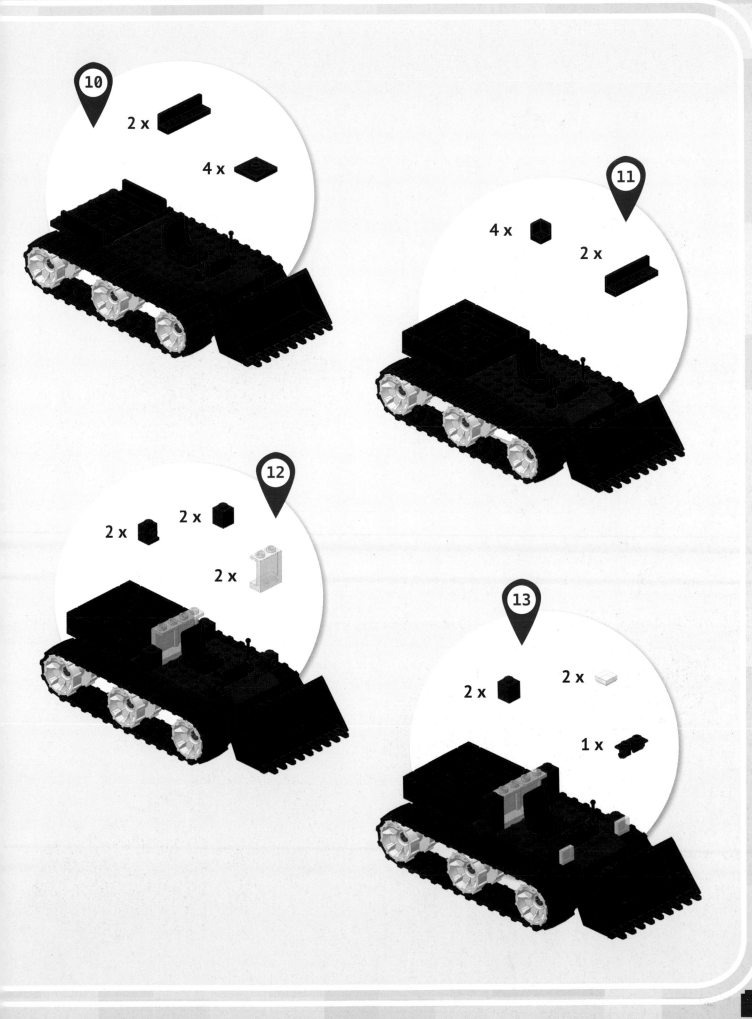

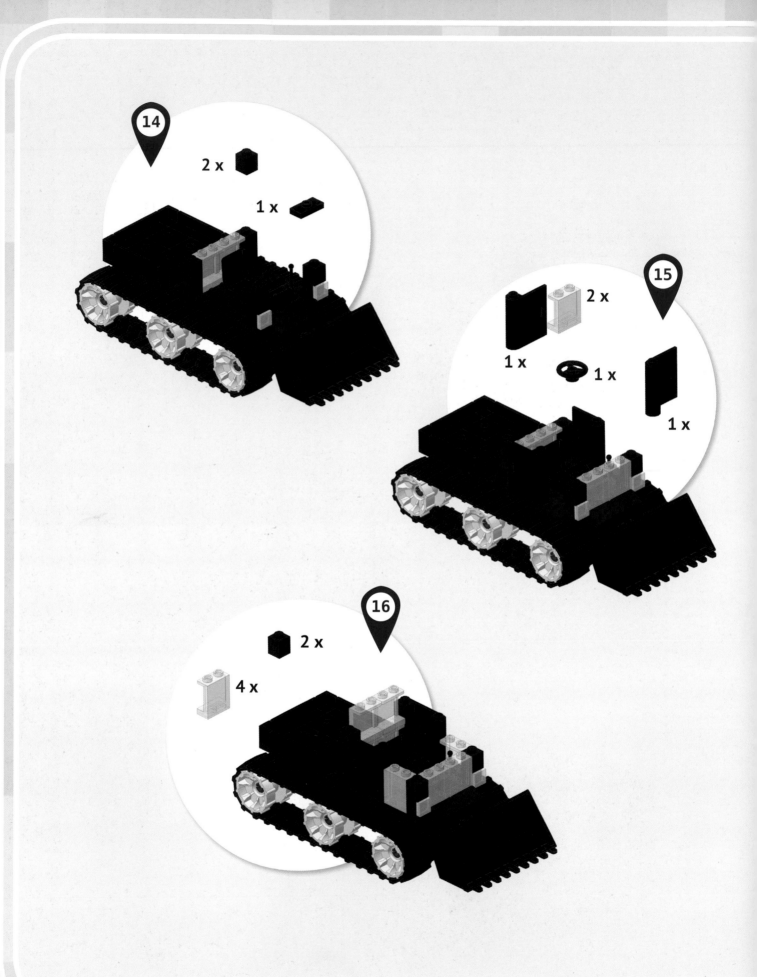

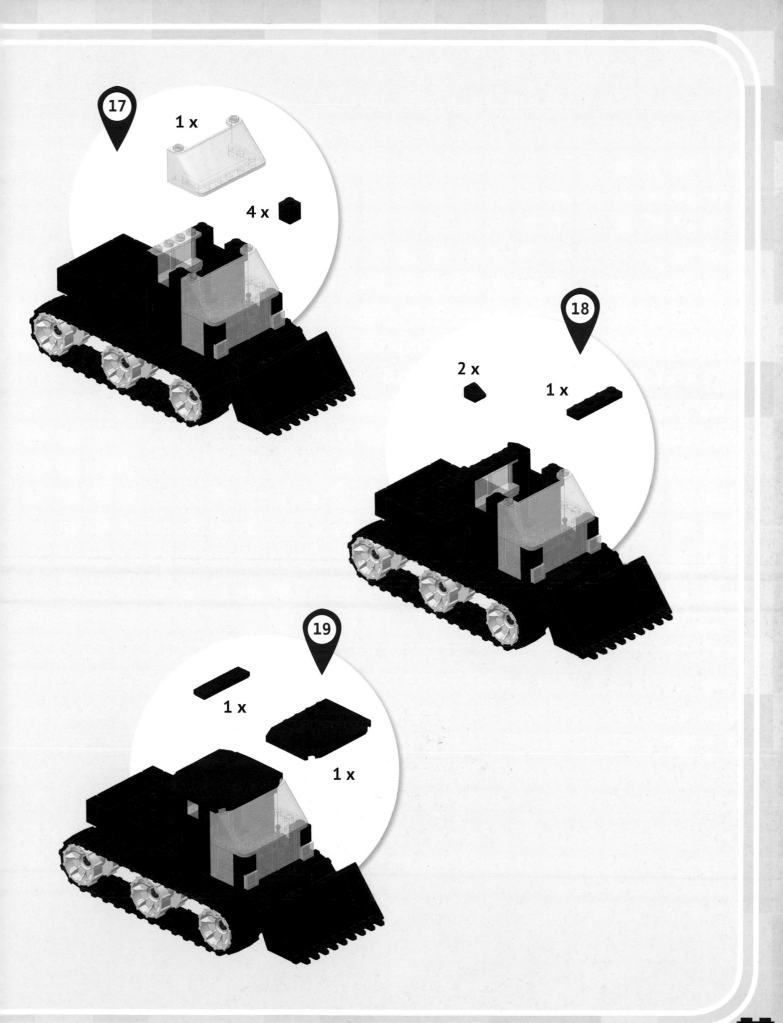

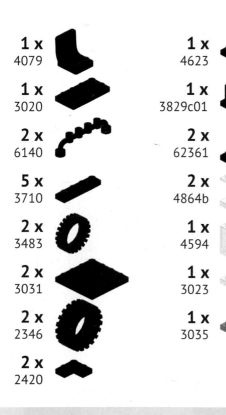

TRACTOR

Here's another vehicle you can construct rather easily. It's the most common farming vehicle, but in a smaller version. Tractors can be of different sizes based on what they have to drag behind them: small plows or heavy trailers.

Have a good time changing the color of your tractor, or use different wheels from the ones suggested. That way you can constantly create new models.

Pieces required

1 x 4079

1 x 3020

2 x 6140

5 x 3710

2 x 3483

2 x 3031

2 x 2346

2 x 2420

1 x 4623

1 x 3829c01

2 x 62361

2 x 4864b

1 x 4594

1 x 3023

1 x 3035

2 x 3023

2 x 30157

4 x 56902

1 x 32028

4 x 85984

3 x 3666

2 x 45677

1 x 3068b

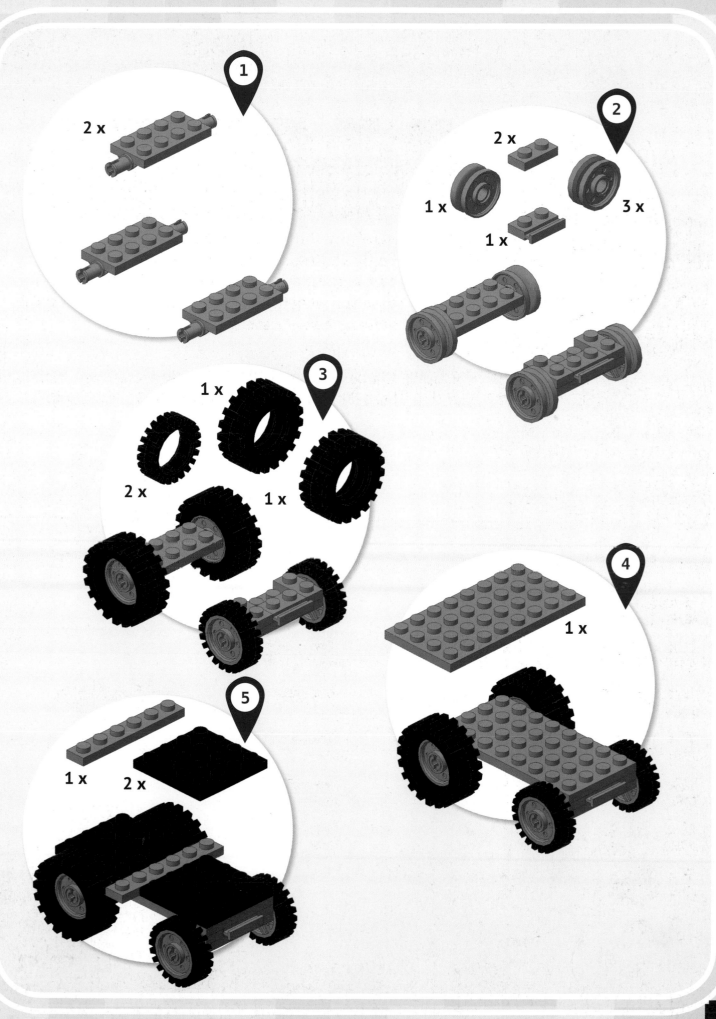

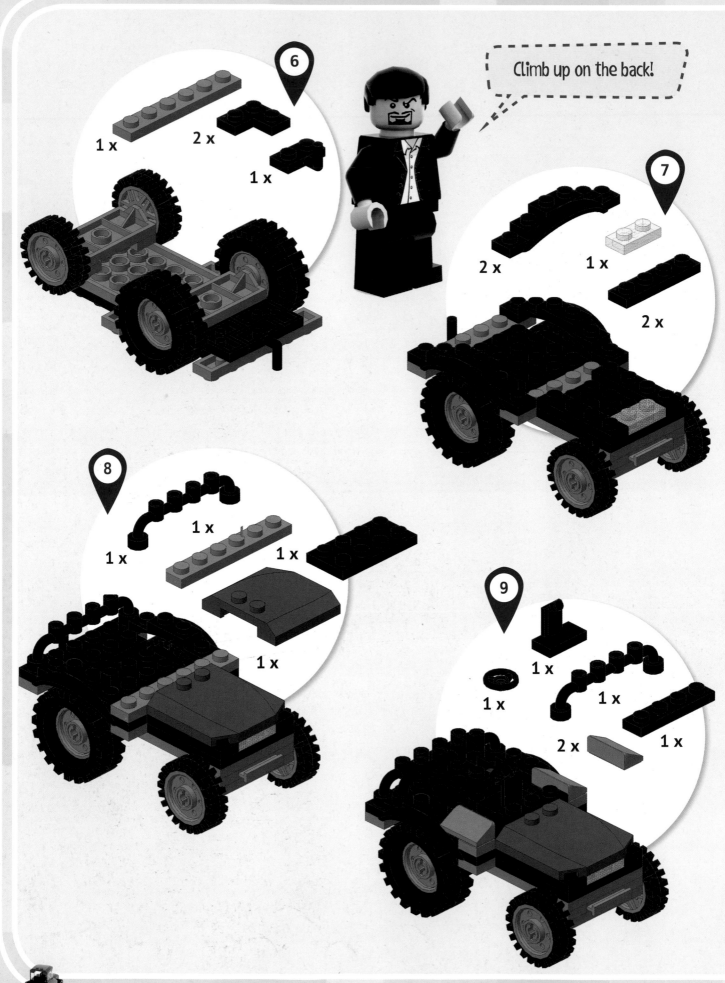

Climb up on the back!

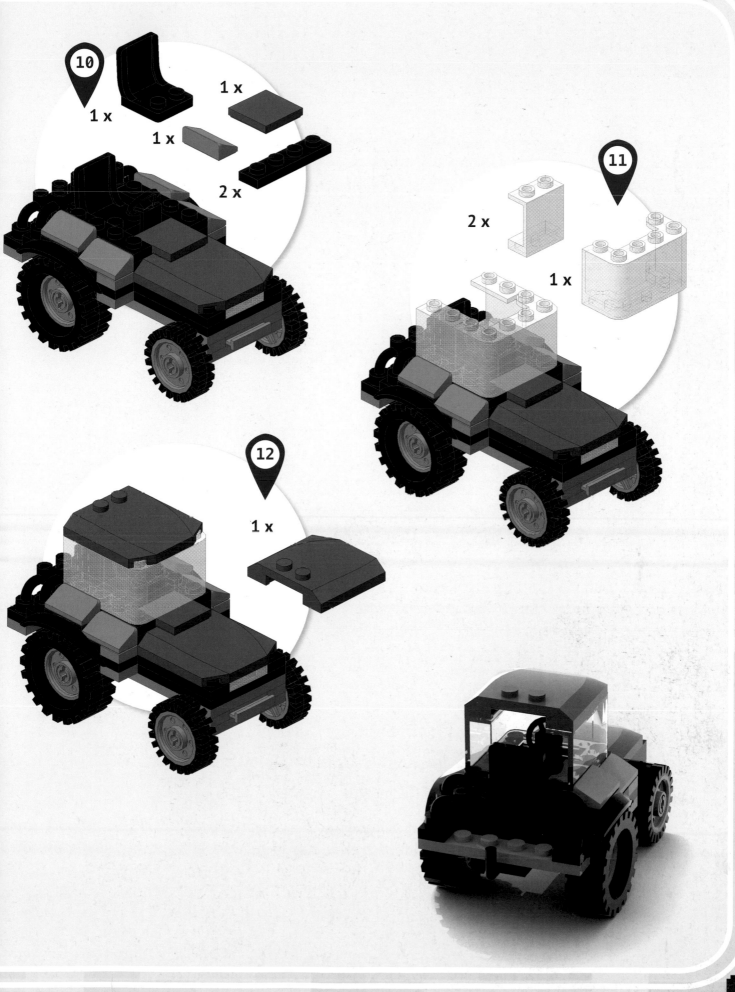

10
1 x
1 x
1 x
2 x

11
2 x
1 x

12
1 x

LEVEL 3

The first two levels were easy, right? Now the game gets more complicated. It will be harder but also more fun.

This level will show if you have what it takes to be a real LEGO® vehicle engineer!

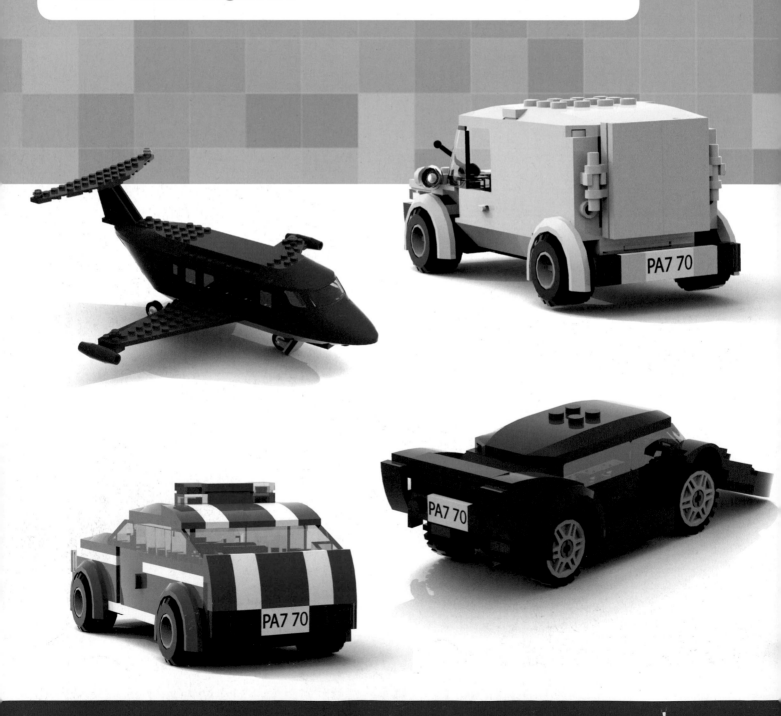

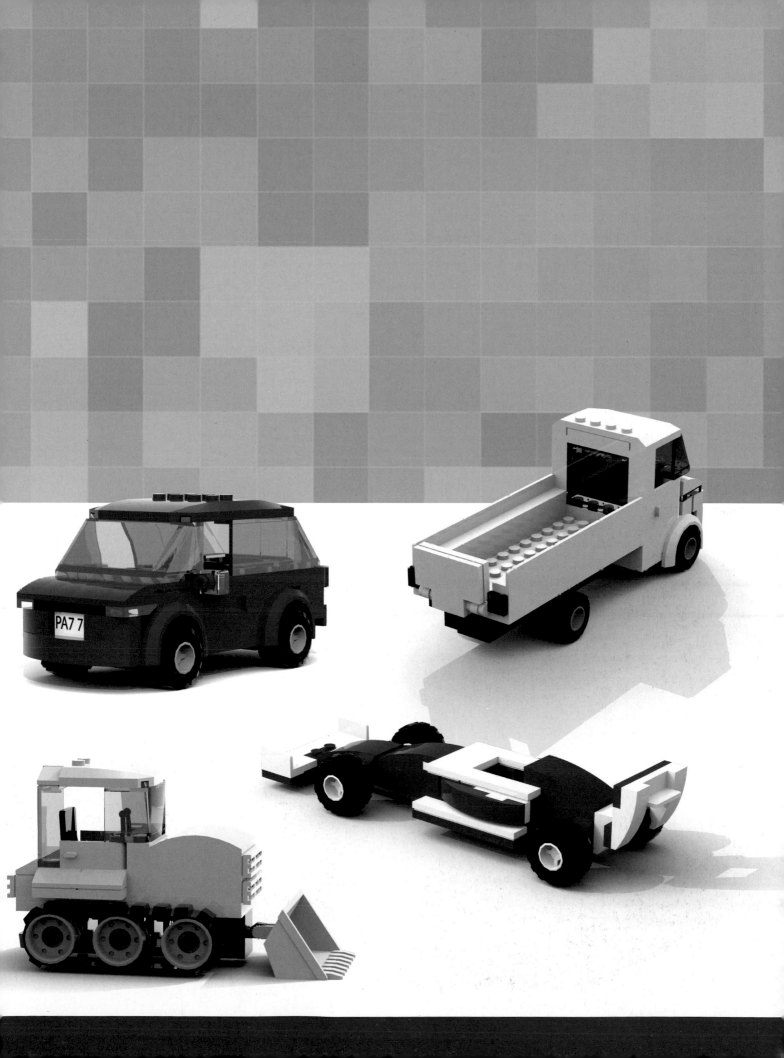

CAR

This is probably the most common vehicle of our time. How many do you see every day? They come in different colors and brands, old and new, big and small. This generic model will allow you to create your own personal version.

You can easily vary details and colors to personalize your car as much as you want. Let's get rolling!

Pieces required

2 x 3069bpb125

1 x 3189

4 x 3794

1 x 3666

2 x 4081b

2 x 3068b

2 x 3020

2 x 30414

2 x 3623

12 x 3710

2 x 50950

2 x 3031

2 x 3004

1 x 3188

6 x 3795

4 x 50745

2 x 3665

10 x 11477

1 x 30413

6 x 3023

6 x 3069b

4 x 3005

2 x 3021

2 x 52031

2 x 87087

4 x 4865

1 x 3794

2 x 4079

1 x 4592c03

4 x 4488

1 x 99781

1 x 3710

2 x 11477

1 x 3832

4 x 6015

1 x 30663

2 x 54200

2 x 3023

2 x 3070b

2 x 92583

4 x 4864b

4 x 6014

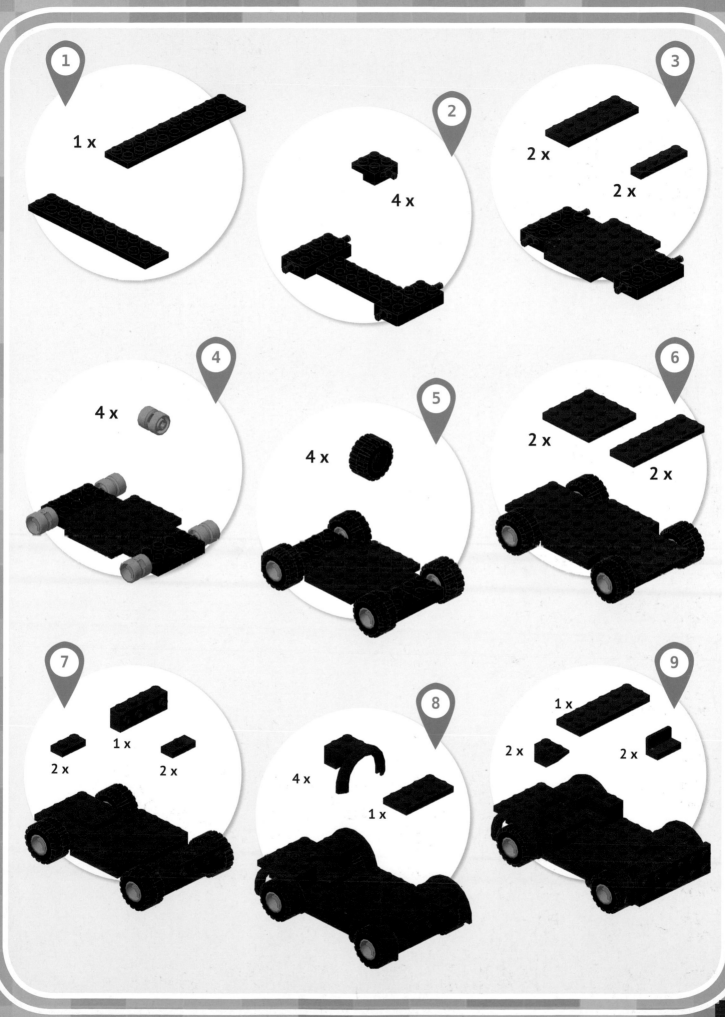

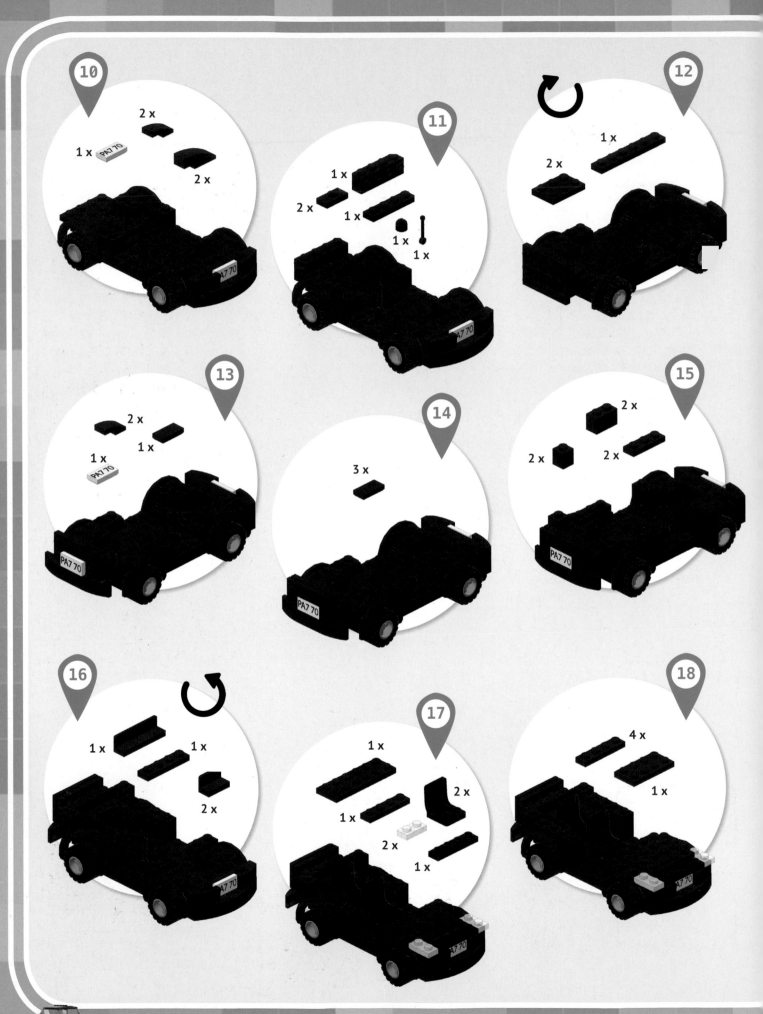

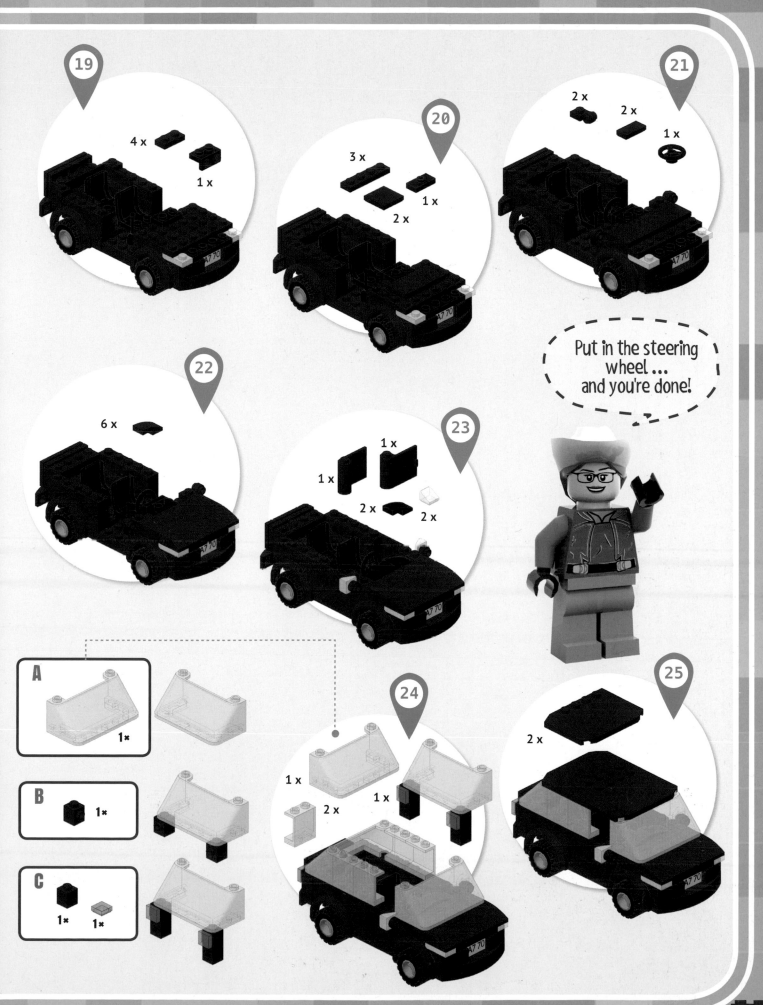

Put in the steering wheel ... and you're done!

POLICE CAR

We need to catch that criminal! Here, ready to roll, is the police car, with its siren screaming! You can't leave this vehicle out of your LEGO® city. You can change the colors of your cars—what matters is that they can do their job. Have a good time building lots of them. You can even have a police roadblock!

Be careful not to get a speeding ticket!

DIFFICULTY

Pieces required

3 x 3710	4 x 3024	1 x 3069b	1 x 3795
2 x 3069bpb125	3 x 3710	1 x 3023	1 x 85984
4 x 11477	1 x 3035	4 x 87697	1 x 85984
1 x 3958	2 x 52031	2 x 30414	2 x 3010
1 x 3795	1 x 3188	1 x 3829c01	2 x 58181
2 x 3666	4 x 50745	3 x 4079	1 x 3004
2 x 3024	2 x 3005	4 x 4488	1 x 2412a
1 x 3189	4 x 3665	1 x 3937	1 x 3938
7 x 3666	10 x 11477	4 x 3710	5 x 3070b
		1 x 3024	1 x 3070b
			4 x 3070b
			4 x 6014

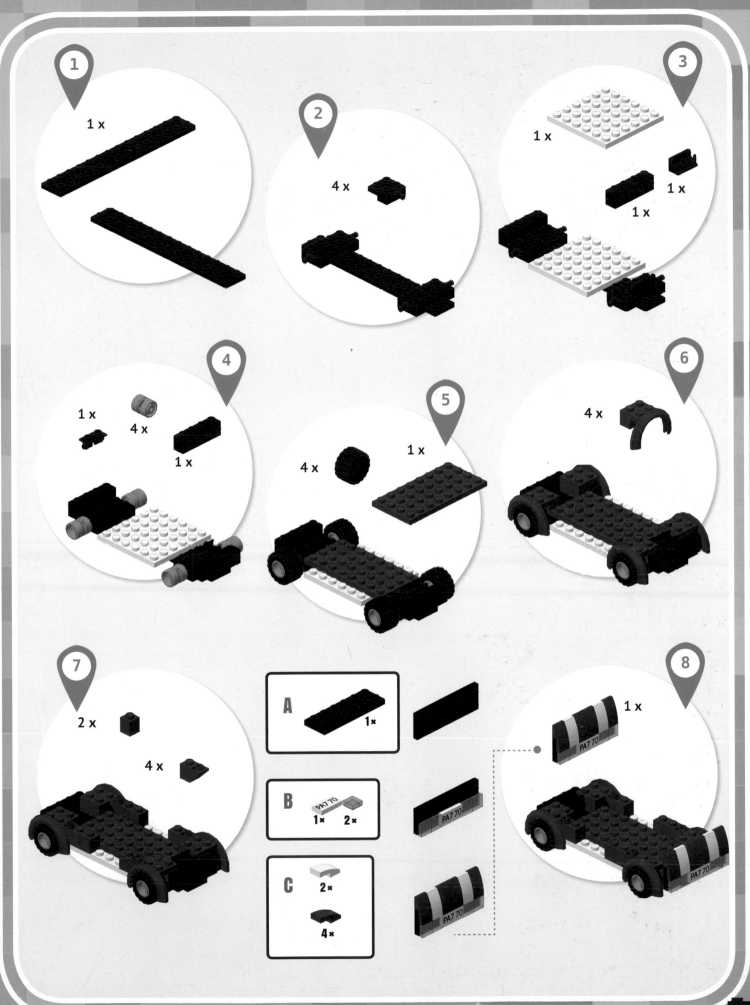

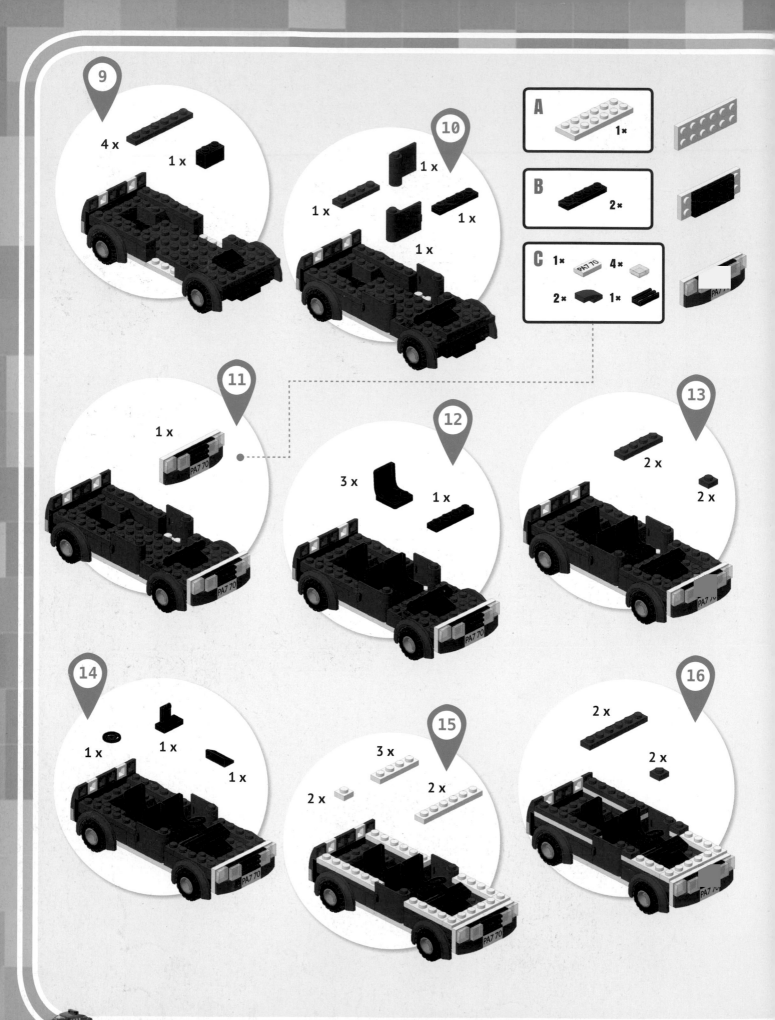

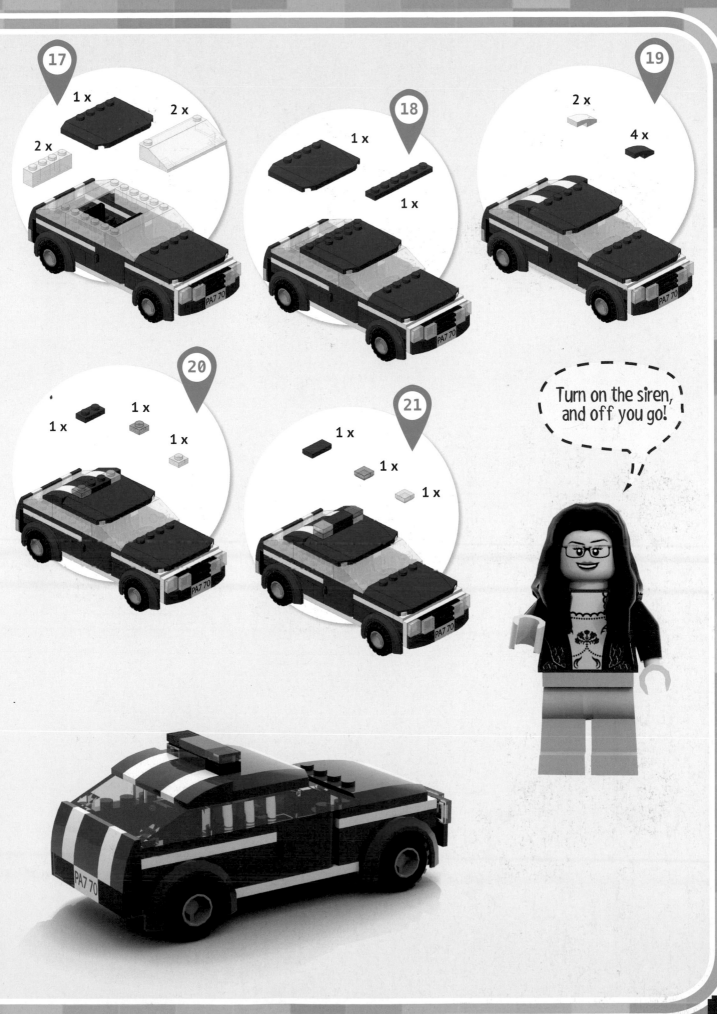

Turn on the siren, and off you go!

SPORTS CAR

The sports car is for anyone who likes the roar of a powerful engine. You can zoom full speed ahead in this car on the streets of your city, but please observe the speed limit.

Thanks to its aerodynamic lines, this model can go much faster than most other means of transportation on land or sea. In this book, though, there is a wheeled vehicle that can go even faster. Can you tell me which?

Pieces required

2 x 3069bpb125	1 x 30414	2 x 50745	4 x 61254	2 x 3024
7 x 3794	2 x 85984	8 x 11477	2 x 3024	2 x 3024
3 x 3666	2 x 3623	2 x 2431	2 x 48336	2 x 30413
2 x 63864	2 x 2436	1 x 3822	2 x 48336	1 x 6238a
4 x 3024	1 x 87079	2 x 3069b	1 x 3795	4 x 13971
1 x 3022	2 x 3710	3 x 3023	2 x 60470	
1 x 3660	2 x 4732	2 x 50947	1 x 4865	2 x 30157
5 x 3020	6 x 2420	2 x 61678	1 x 30663	
1 x 3821	2 x 45677	3 x 99780	2 x 3024	

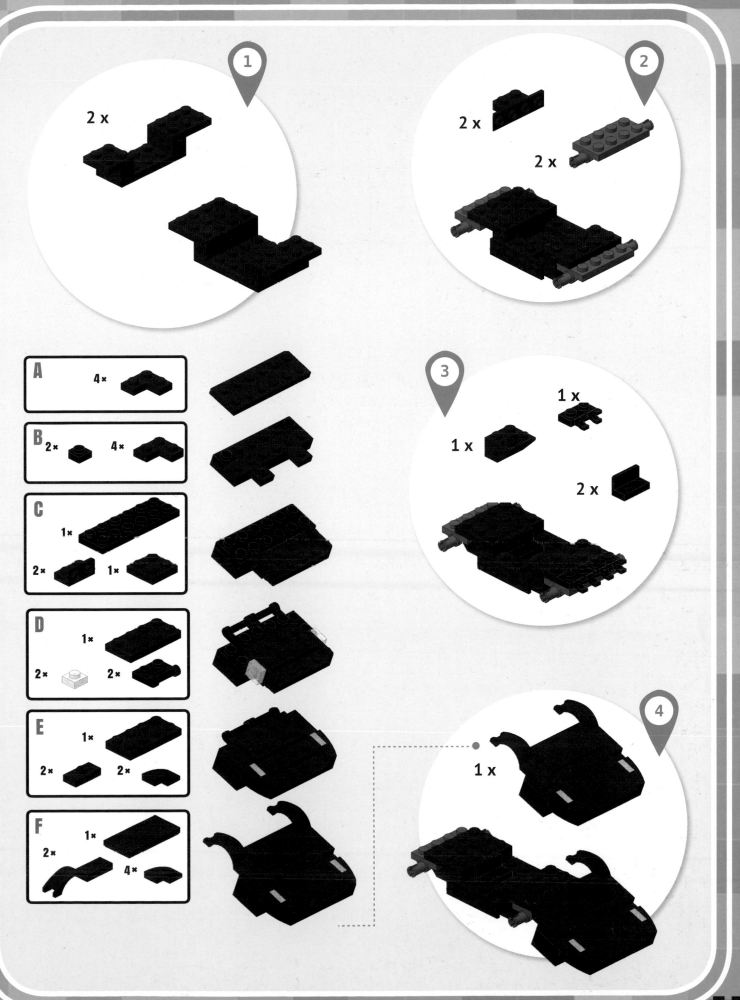

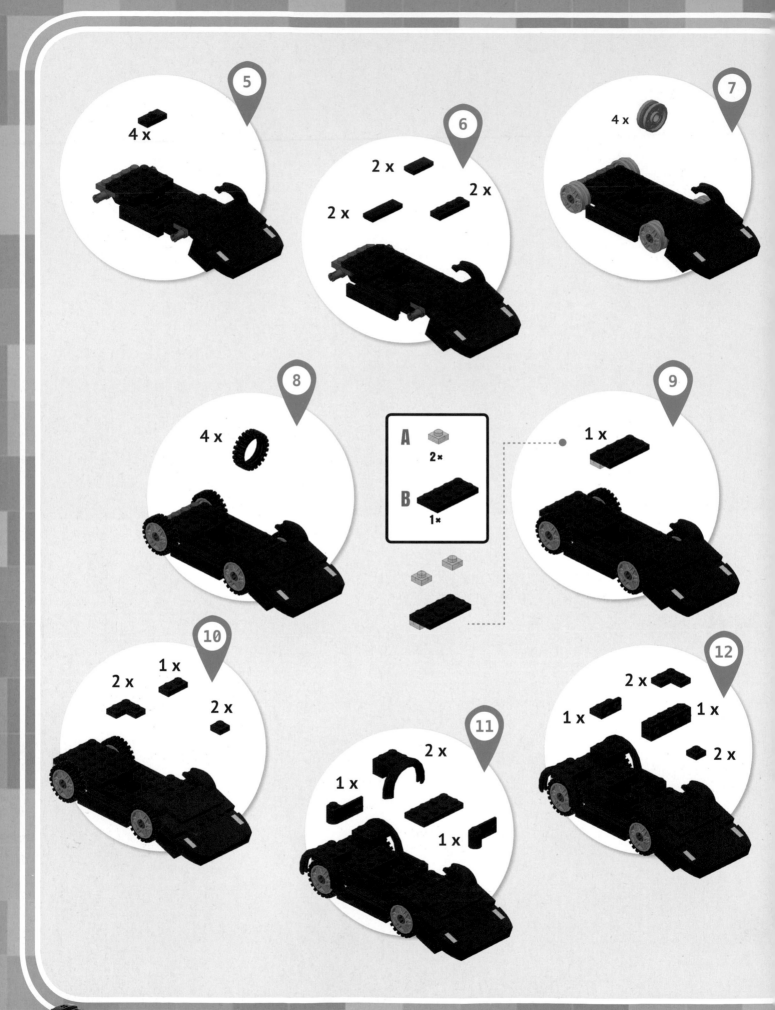

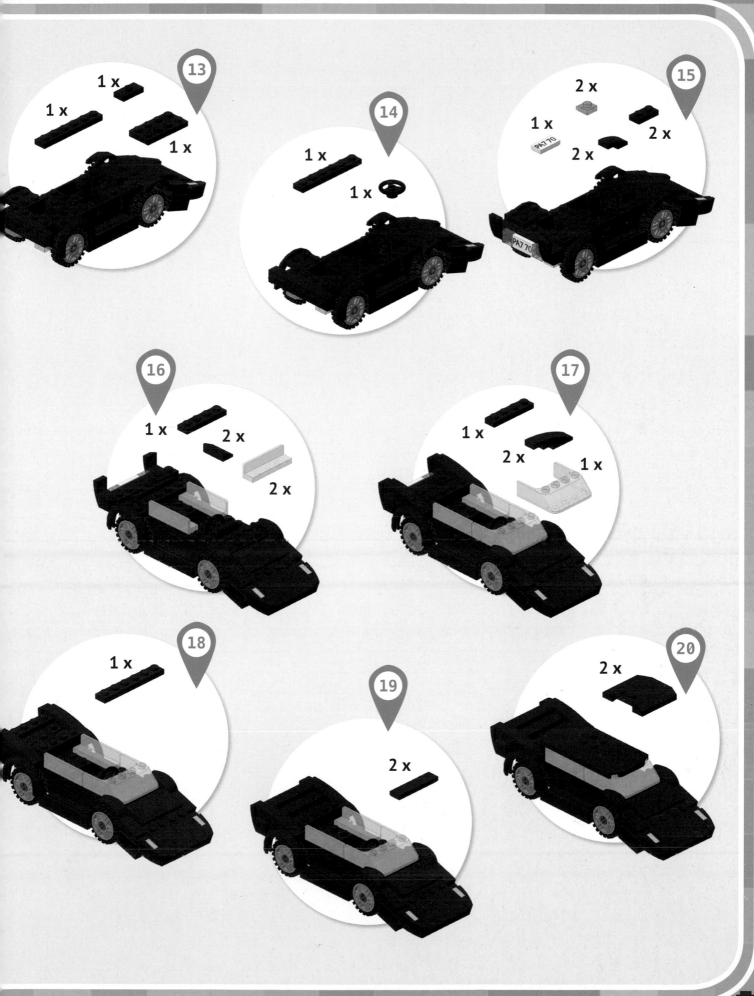

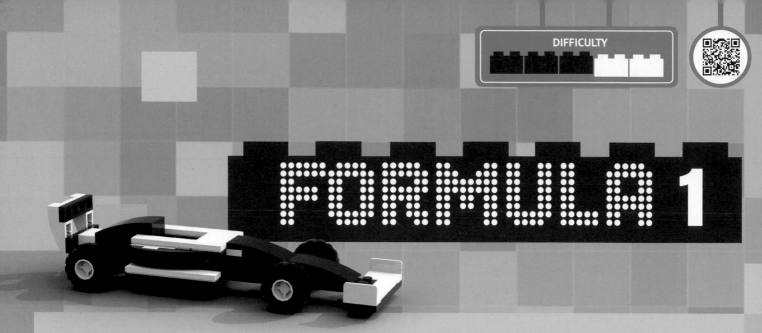

FORMULA 1

Formula 1 cars are driven at tremendous speeds on all the race courses of the planet. This one-seat racer has captured the imagination of young and old for years.

Prepare to zip around like a real champion on the most famous courses in the world in this authentic Formula 1 racing car.

Pieces required

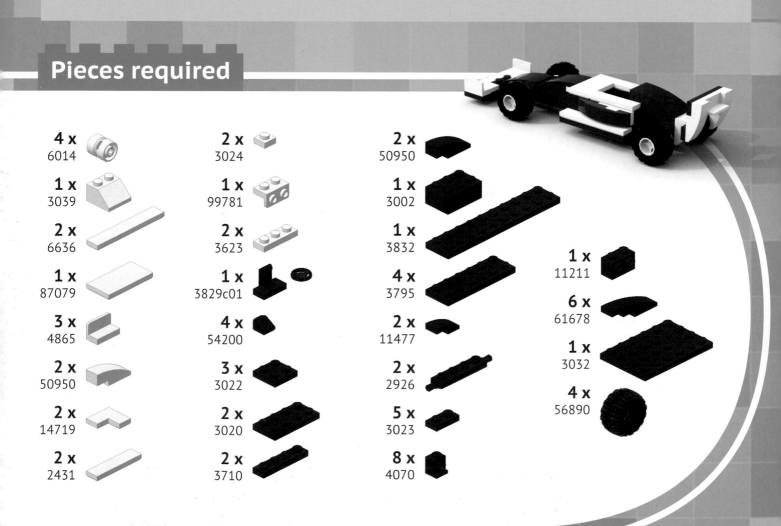

4 x — 6014
1 x — 3039
2 x — 6636
1 x — 87079
3 x — 4865
2 x — 50950
2 x — 14719
2 x — 2431

2 x — 3024
1 x — 99781
2 x — 3623
1 x — 3829c01
4 x — 54200
3 x — 3022
2 x — 3020
2 x — 3710

2 x — 50950
1 x — 3002
1 x — 3832
4 x — 3795
2 x — 11477
2 x — 2926
5 x — 3023
8 x — 4070

1 x — 11211
6 x — 61678
1 x — 3032
4 x — 56890

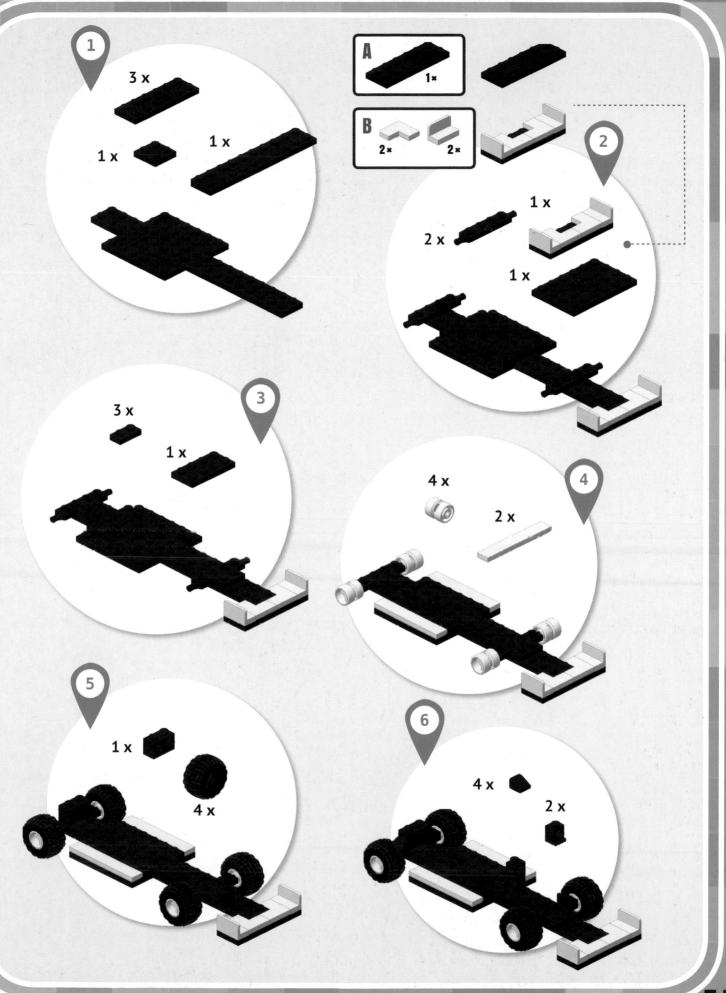

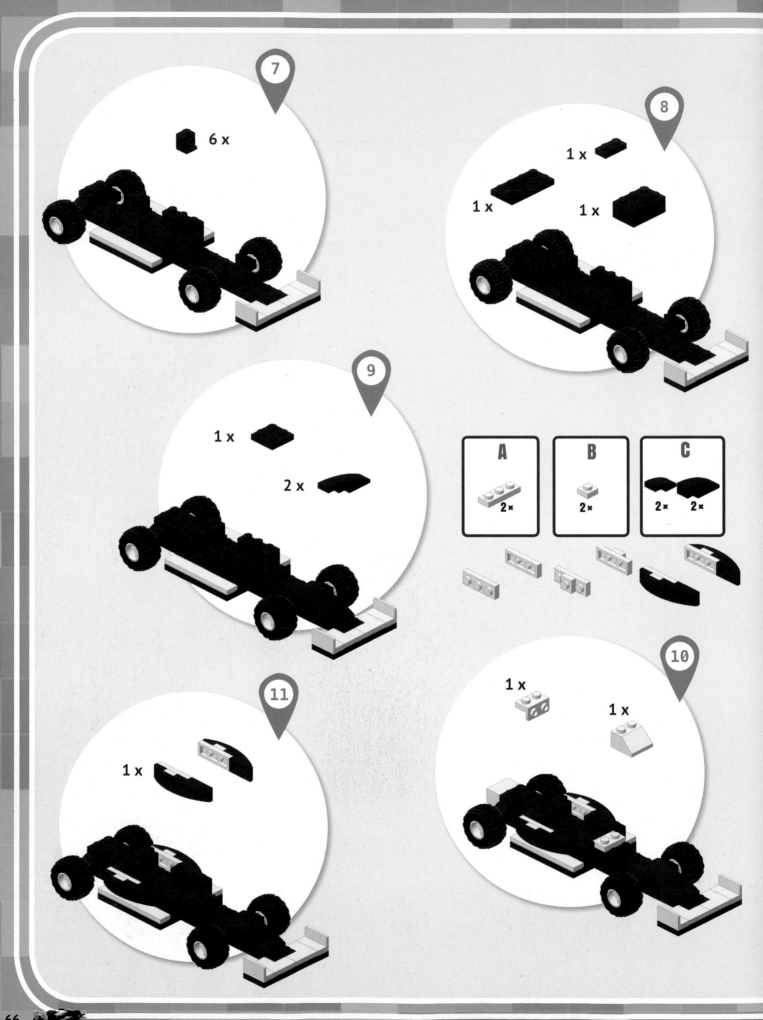

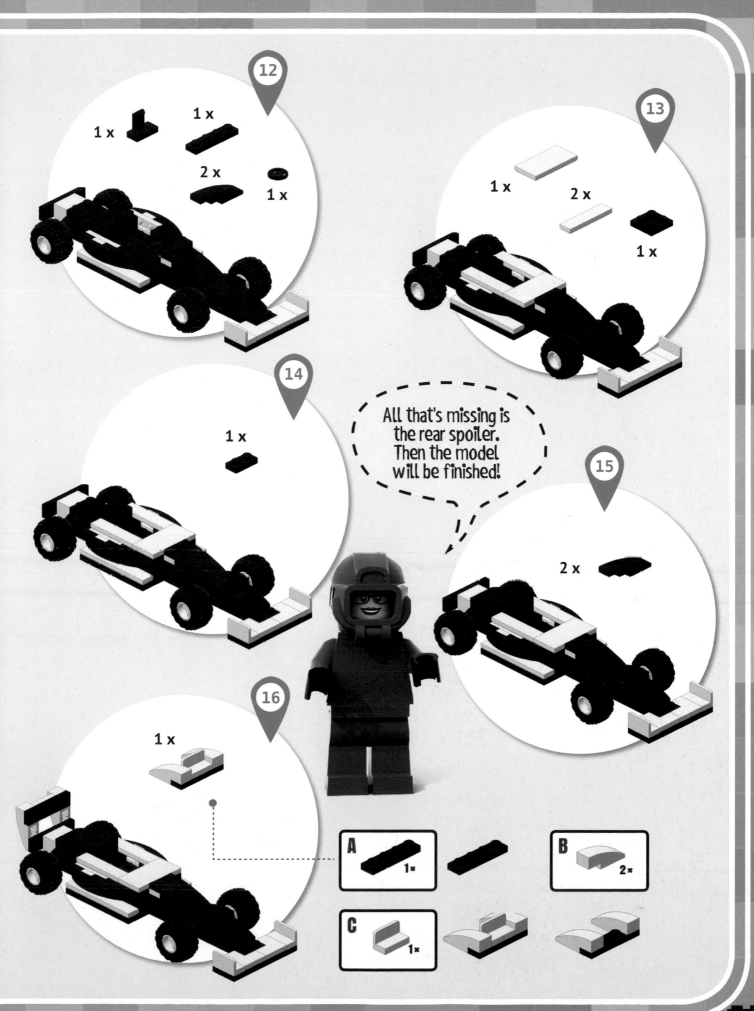

All that's missing is the rear spoiler. Then the model will be finished!

VAN

Here is a practical and agile van that can travel all around your city, always ready to transport something.... You'll choose the color. This model is yellow, but don't limit your imagination. The rear doors really open, and you can place small loads inside. You can find a parking space more easily with a van than with a big truck.

It's the ideal solution for anyone who needs to transport merchandise and wants to move easily around the city.

Pieces required

1 x 3069bpb125	2 x 3710	1 x 3822		
1 x 3829c01	2 x 3031	2 x 2540	1 x 3022	3 x 15068
1 x 4215b	2 x 87087	6 x 3010	1 x 3020	1 x 99206
2 x 4081b	1 x 60219	2 x 87079	4 x 4488	2 x 4073
4 x 3069b	2 x 30241	2 x 52501	1 x 3710	2 x 3024
4 x 3005	2 x 52031	2 x 15068	2 x 3795	1 x 4176
2 x 3666	4 x 3070b	4 x 87697	1 x 3023	2 x 3070b
8 x 3024	2 x 3665	2 x 3666	1 x 85984	4 x 6014
1 x 3821	4 x 50745	2 x 4079	1 x 2445	
1 x 2436b	4 x 3023	2 x 4592c03		

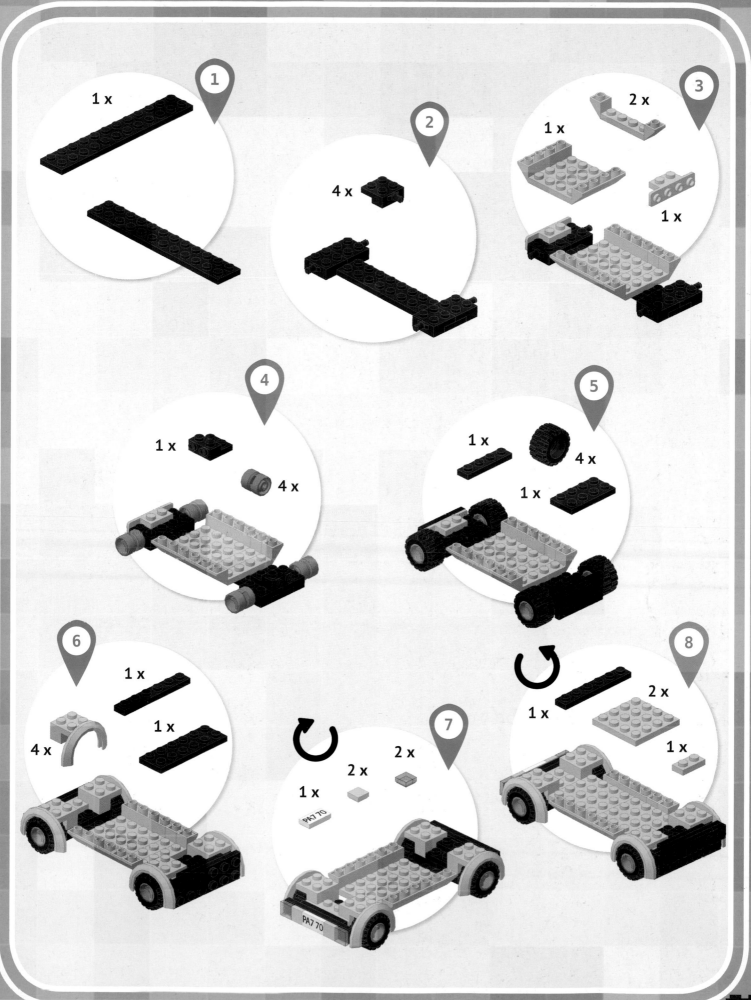

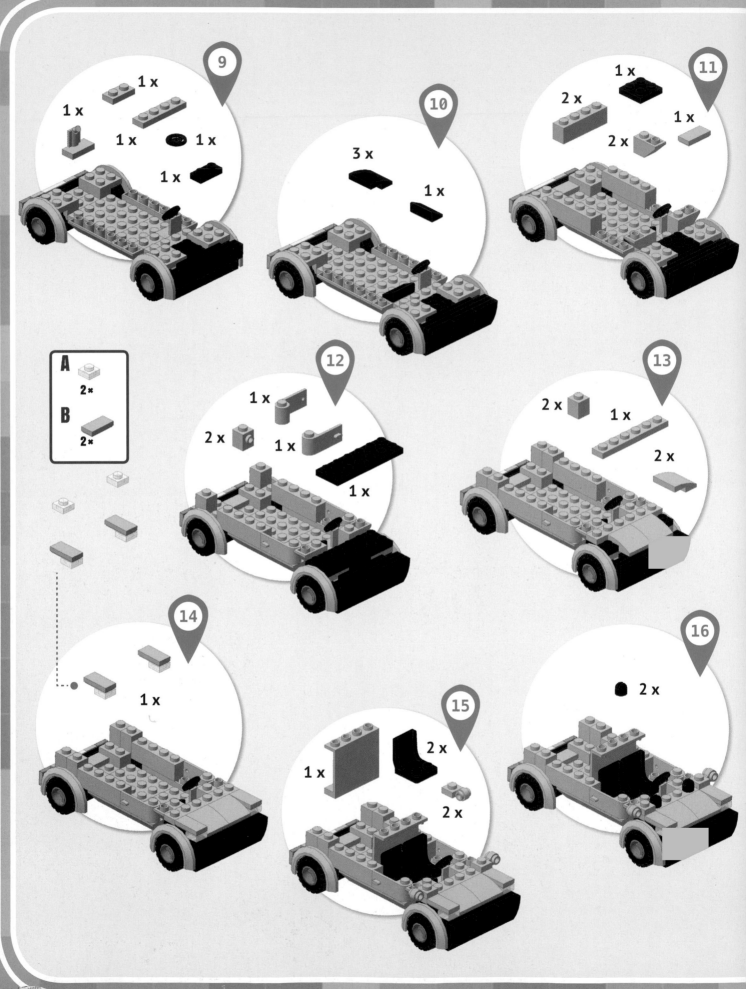

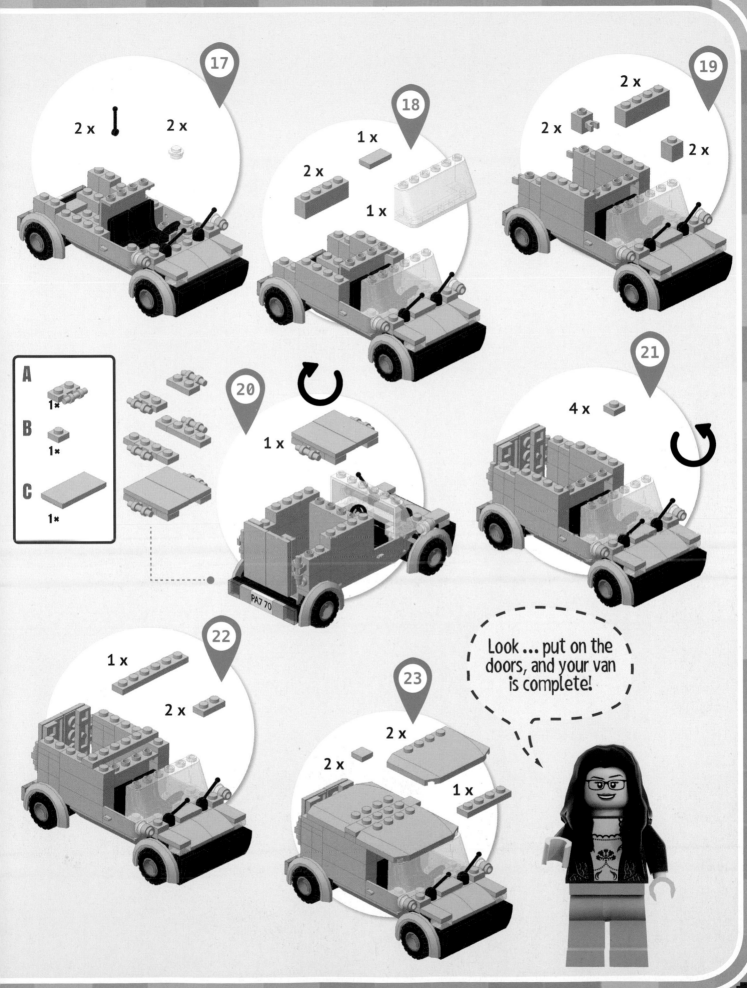

Look ... put on the doors, and your van is complete!

TRUCK

For unwieldy, heavy loads, use a truck. The one shown here is open, which means that materials can be placed in the rear compartment. However, it won't be difficult to come up with a suitable cover for this vehicle.

The colors of the pieces, as usual, are only examples. You're the one who'll decide what colors you'll use for your truck. Once it's completed, load it with anything you want and drive off to conquer the streets of your city!

Pieces required

Qty	Part	Qty	Part	Qty	Part	Qty	Part	Qty	Part
3 x	3710	6 x	30413	1 x	3028				
6 x	11477	2 x	87087	1 x	3001	1 x	4282		
1 x	2436b	2 x	63868	1 x	3189			2 x	4215b
2 x	2420	2 x	60478	6 x	3666	4 x	4488	2 x	3023
1 x	3188	4 x	3009	2 x	50745	4 x	3710	2 x	3070b
2 x	3795	1 x	6081	3 x	3660	5 x	3795	1 x	4176
1 x	3021	2 x	50950	1 x	52031	1 x	3021	4 x	6014
1 x	87079	6 x	3005	1 x	3010	3 x	2412a	1 x	99207
2 x	3004	1 x	3069b	1 x	3829c01	4 x	6015		
2 x	3622	1 x	3032	2 x	4079	1 x	3029		

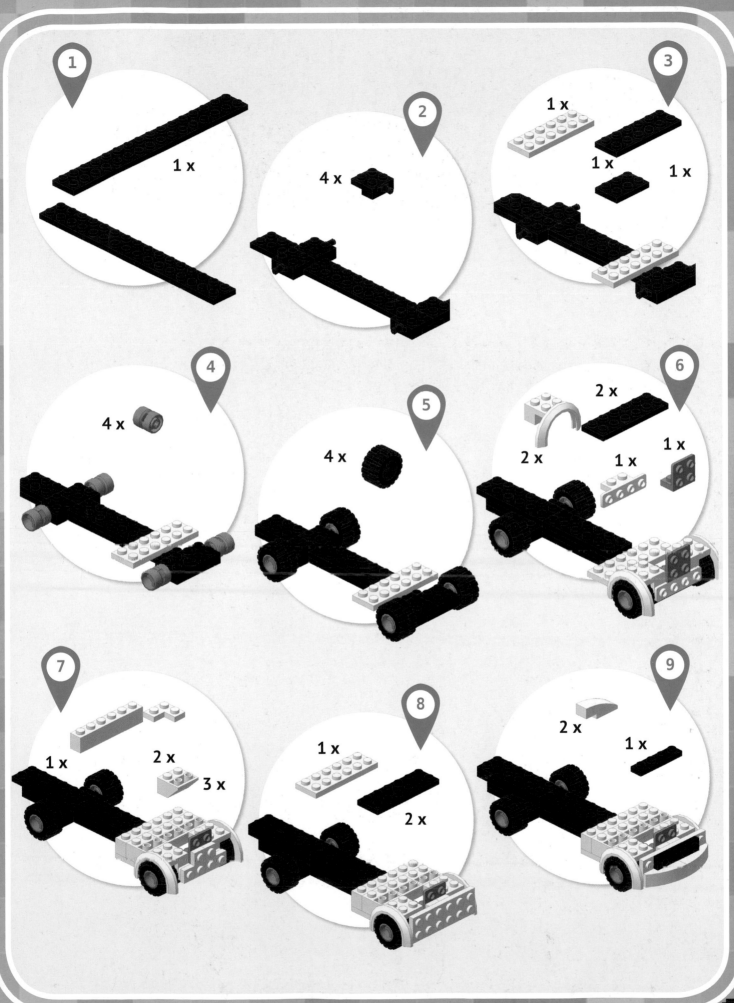

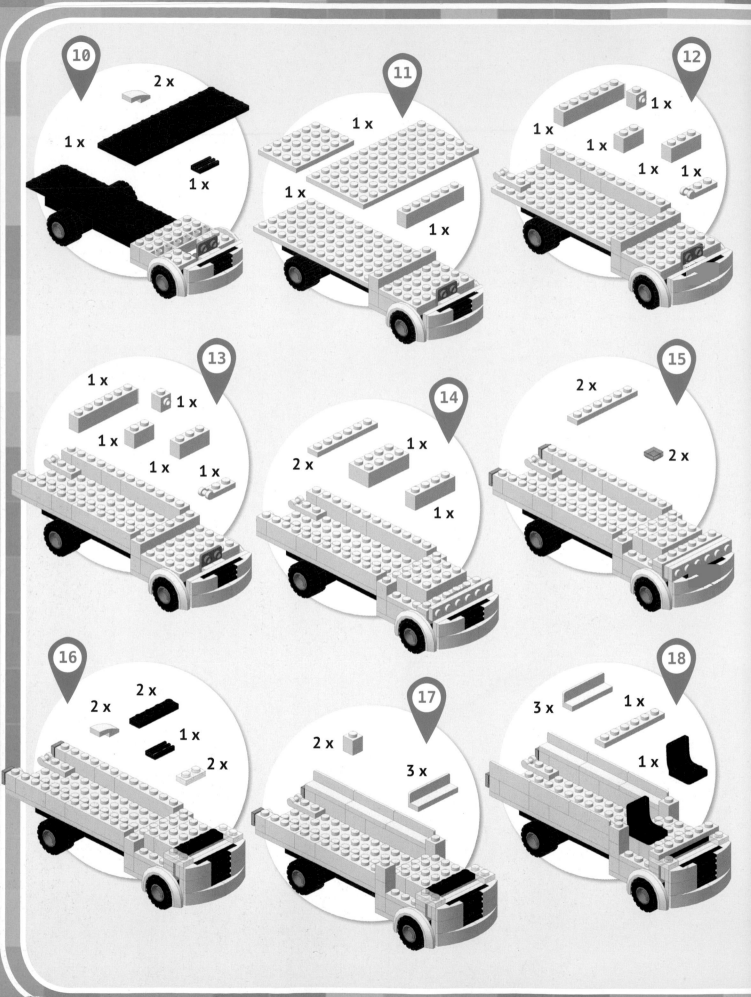

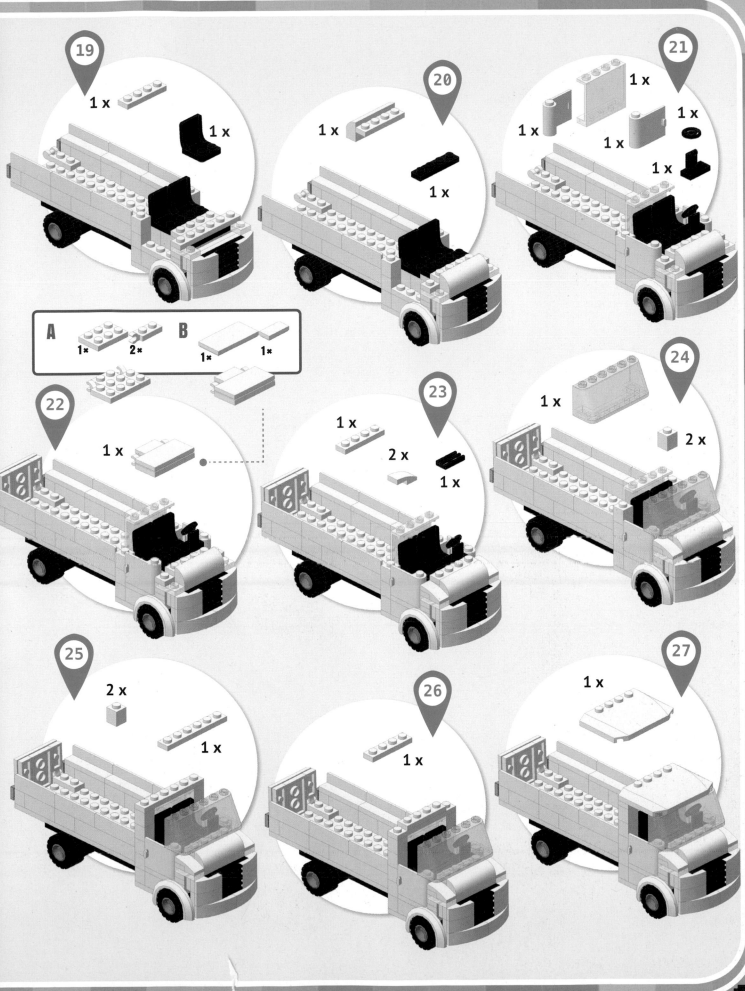

19　1 x　1 x

20　1 x　1 x

21　1 x　1 x　1 x　1 x　1 x

A　1*　2*　B　1*　1*

22　1 x

23　1 x　2 x　1 x

24　1 x　2 x

25　2 x　1 x

26　1 x

27　1 x

BULLDOZER

When you need a powerful vehicle with an enormous shovel, get a bulldozer. With its tracks, it's ready for any job and is maneuvered by exceptional people—it's a piece of machinery that you'll be sure to want in your city. Besides the bulldozer, there are many other large work machines with big shovels.

Can you think of others? Would you know how to build them? Try—all you need is your favorite equipment—your hands—and the greatest engineer I know, your brain!

Pieces required

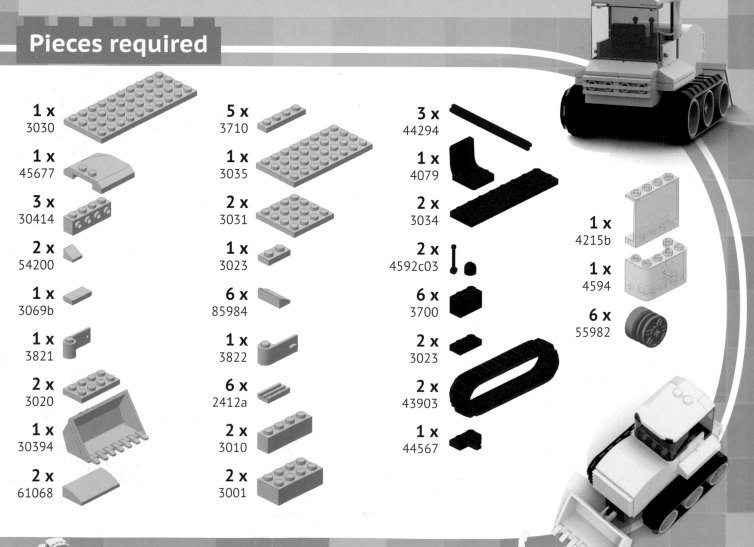

1 x 3030
1 x 45677
3 x 30414
2 x 54200
1 x 3069b
1 x 3821
2 x 3020
1 x 30394
2 x 61068

5 x 3710
1 x 3035
2 x 3031
1 x 3023
6 x 85984
1 x 3822
6 x 2412a
2 x 3010
2 x 3001

3 x 44294
1 x 4079
2 x 3034
2 x 4592c03
6 x 3700
2 x 3023
2 x 43903
1 x 44567

1 x 4215b
1 x 4594
6 x 55982

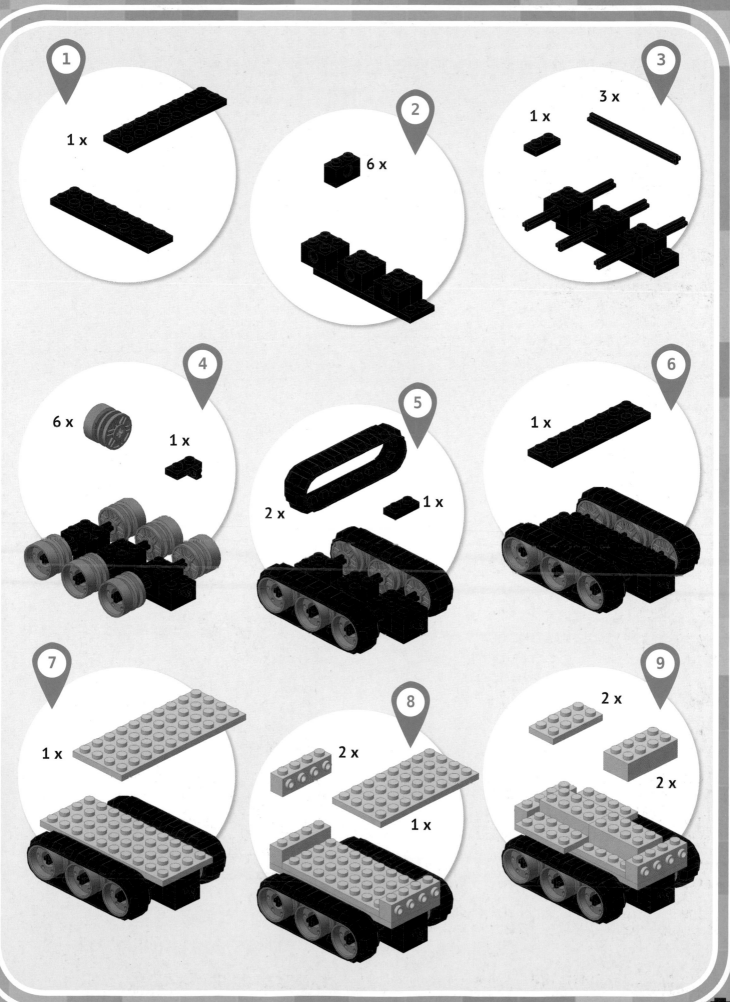

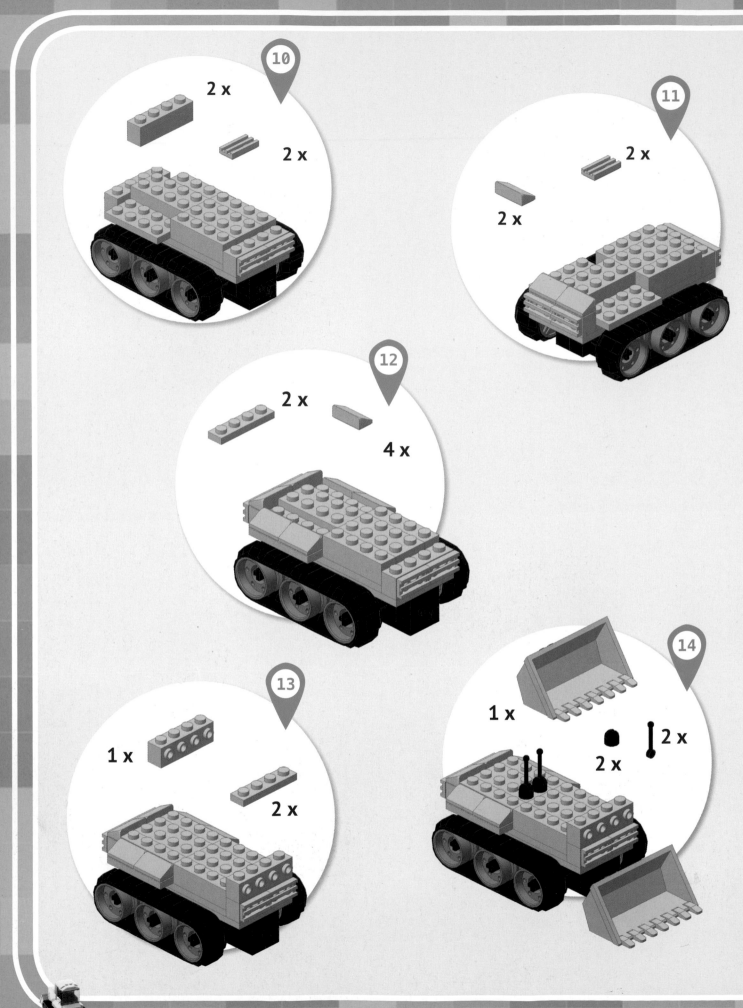

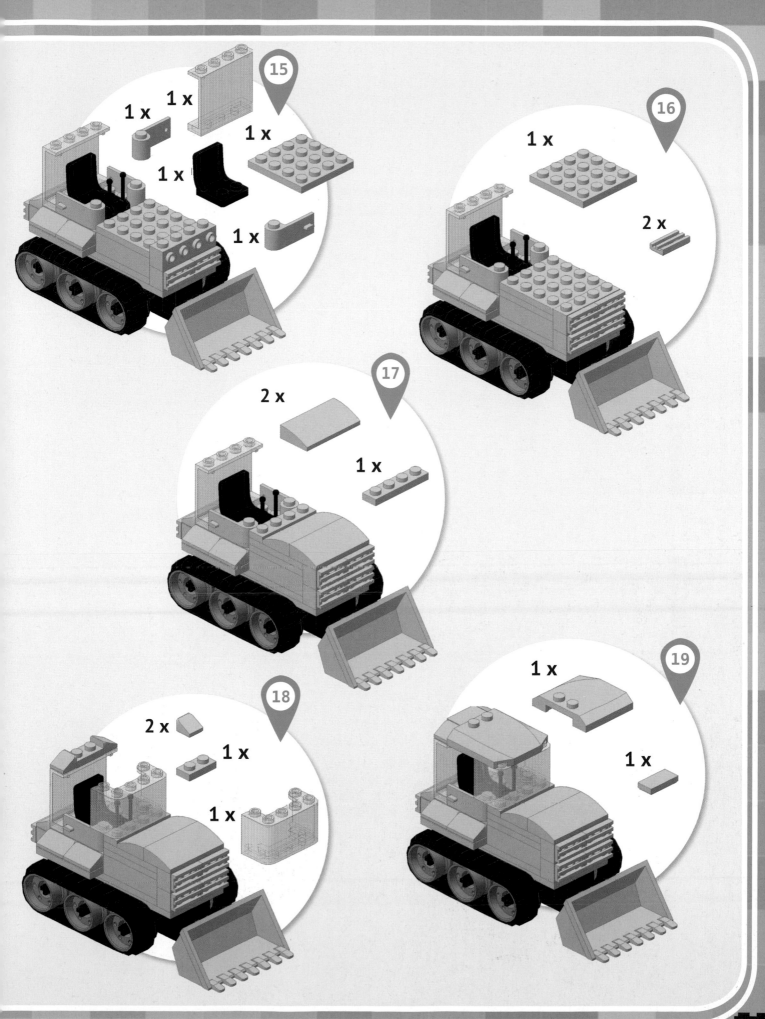

JET

Are you ready to fly? Straight off the runway, the jet, with its retractable landing gear, is taking off into the skies. This aircraft flies through the clouds and is one of the fastest that exists. The passenger cabin really opens. You can have fun playing for hours.

I have to admit that this was one of my favorite models when I was little, so I hope that you'll enjoy it as much as I did. Let's take off!

Pieces required

1 x 3039px5	4 x 85984	1 x 3585	1 x 4162
4 x 3023	1 x 3623	2 x 2340	1 x 3029
1 x 2431	2 x 87613	6 x 4863	2 x 3475b
4 x 3069b	1 x 4162	8 x 52501	3 x 3139
1 x 3039pb045	6 x 3035	1 x 3034	4 x 3010
3 x 4079	1 x 87615	1 x 87616	1 x 87612
3 x 3464	1 x 50305		12 x 4862
1 x 4531	2 x 3023	1 x 3586	2 x 4073
2 x 4275	2 x 95120	4 x 3666	2 x 4073
1 x 50304	2 x 44570	1 x 87611	3 x 2415

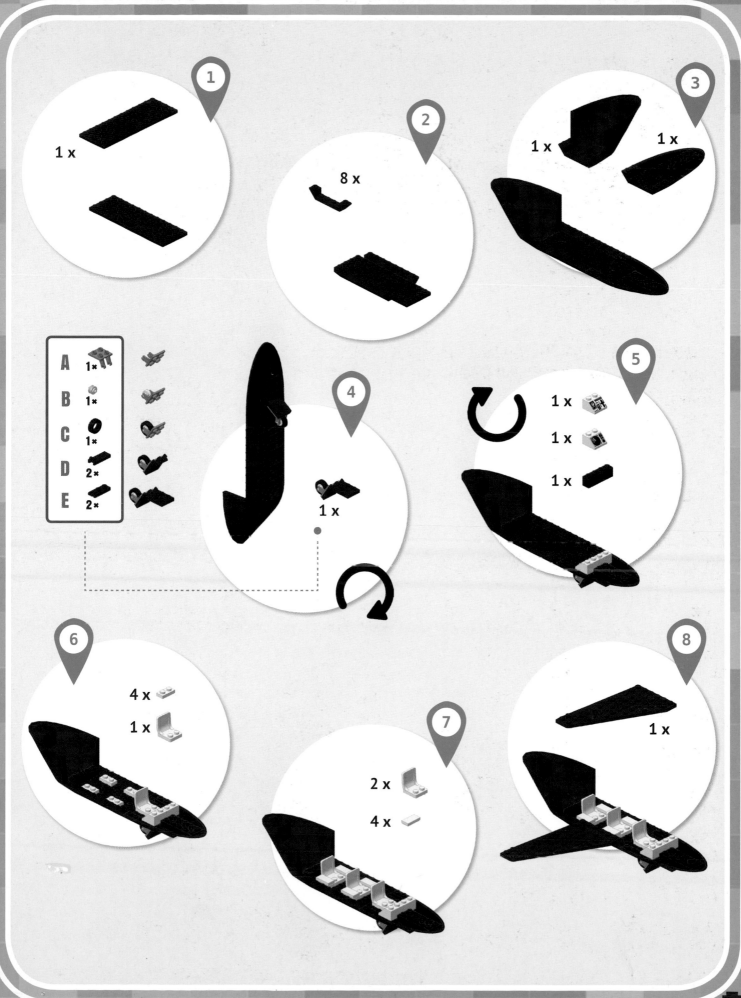

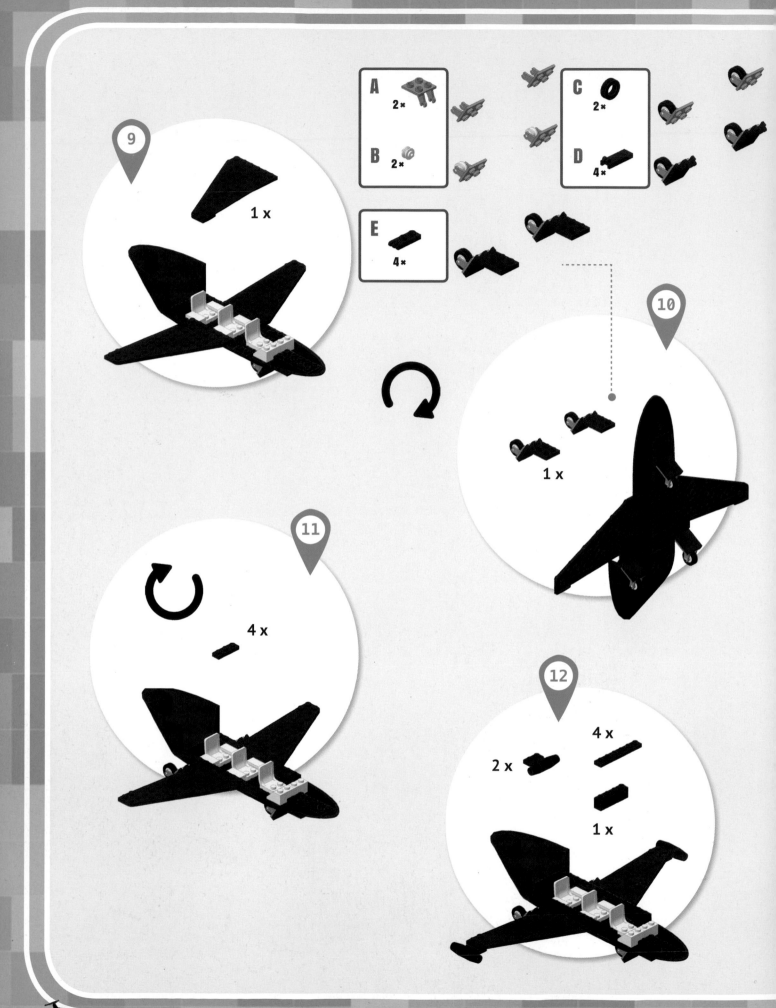

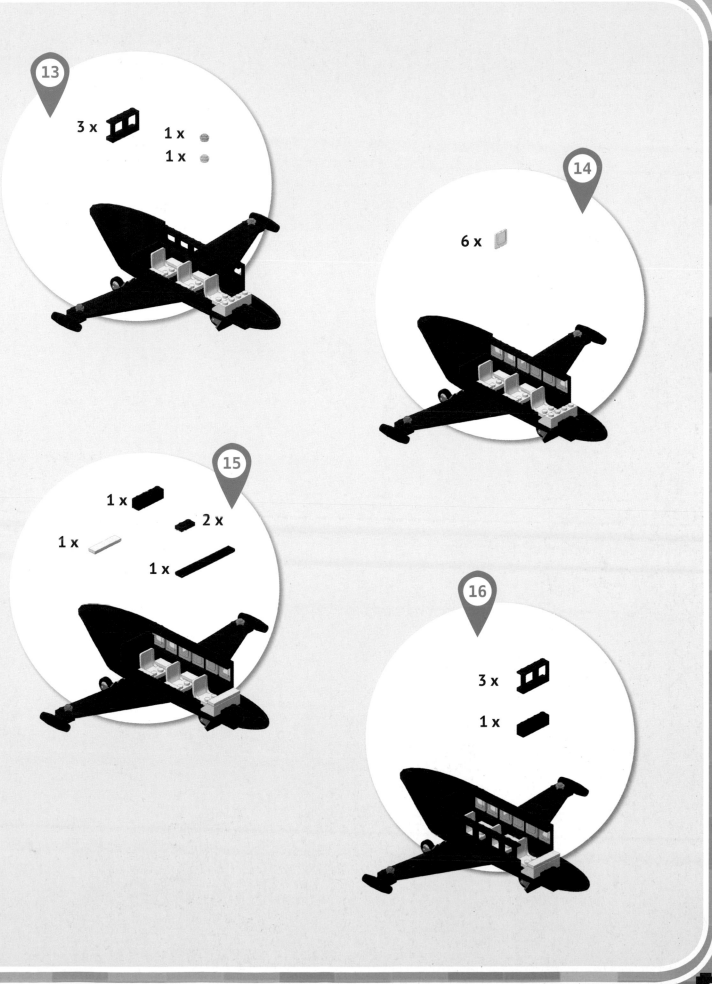

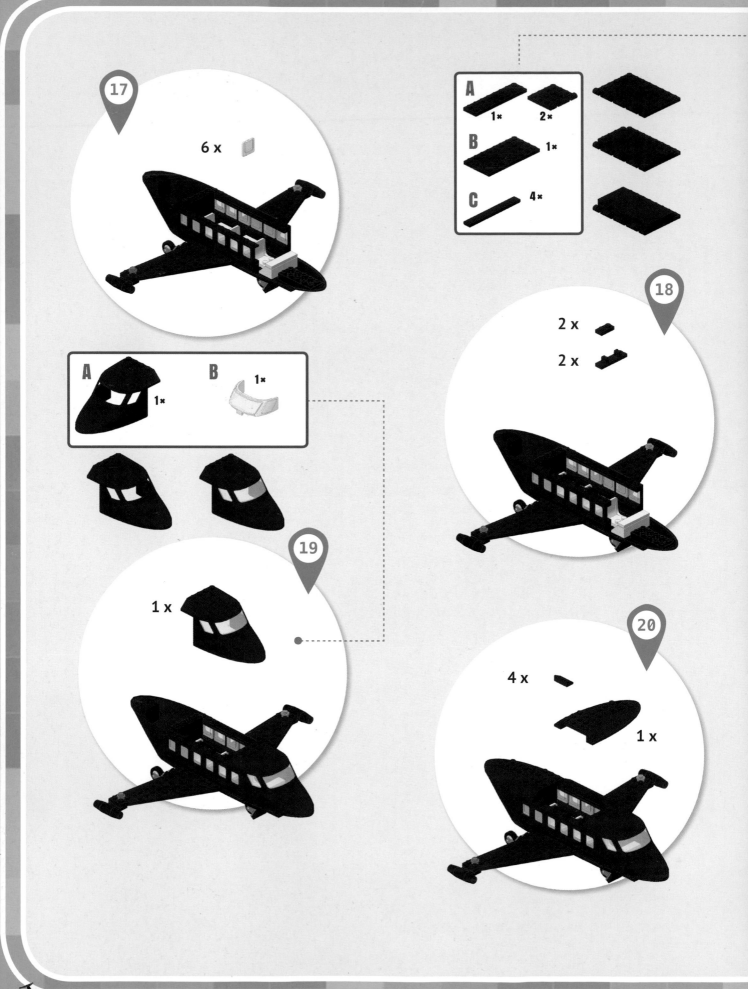

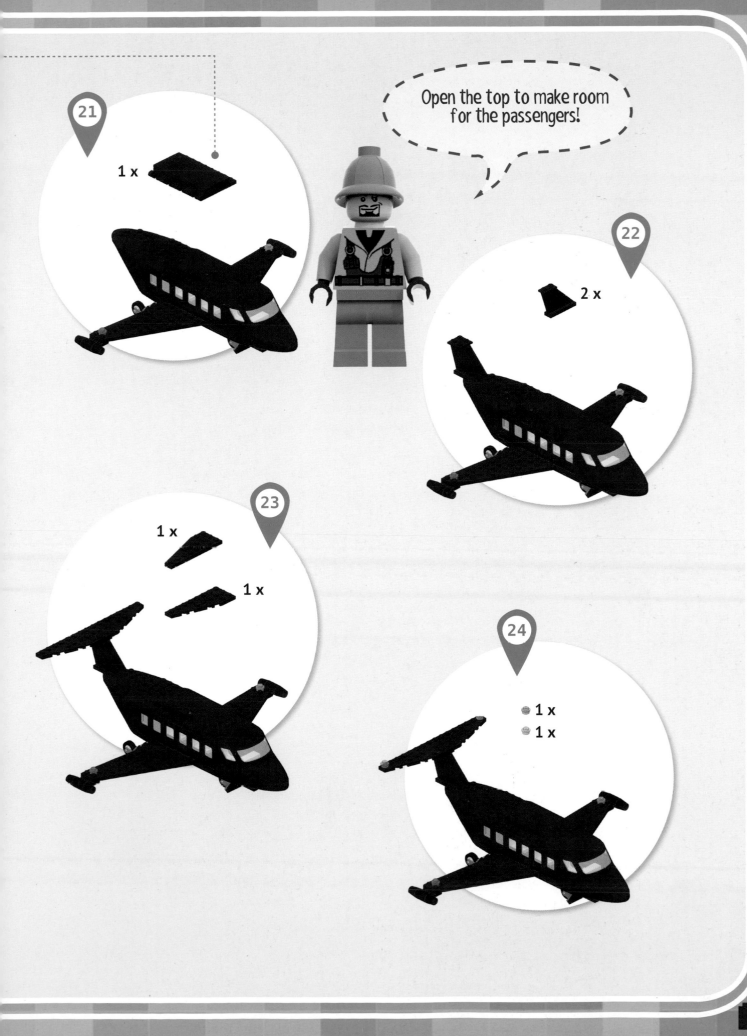

Congratulations, you've reached level 4. Now I don't have to explain anything to you. You're ready to build any vehicle according to the instructions.

Amaze me!

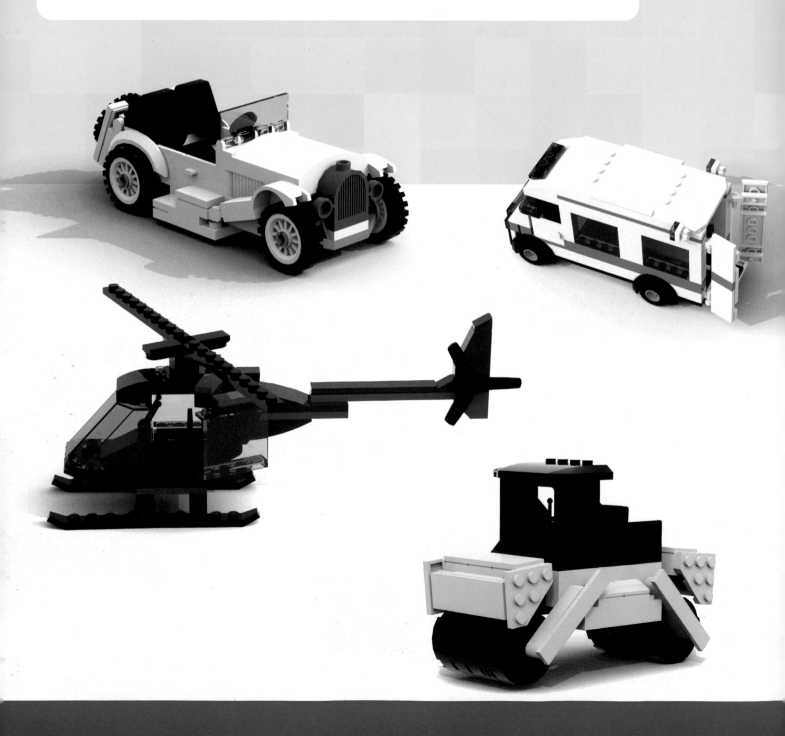

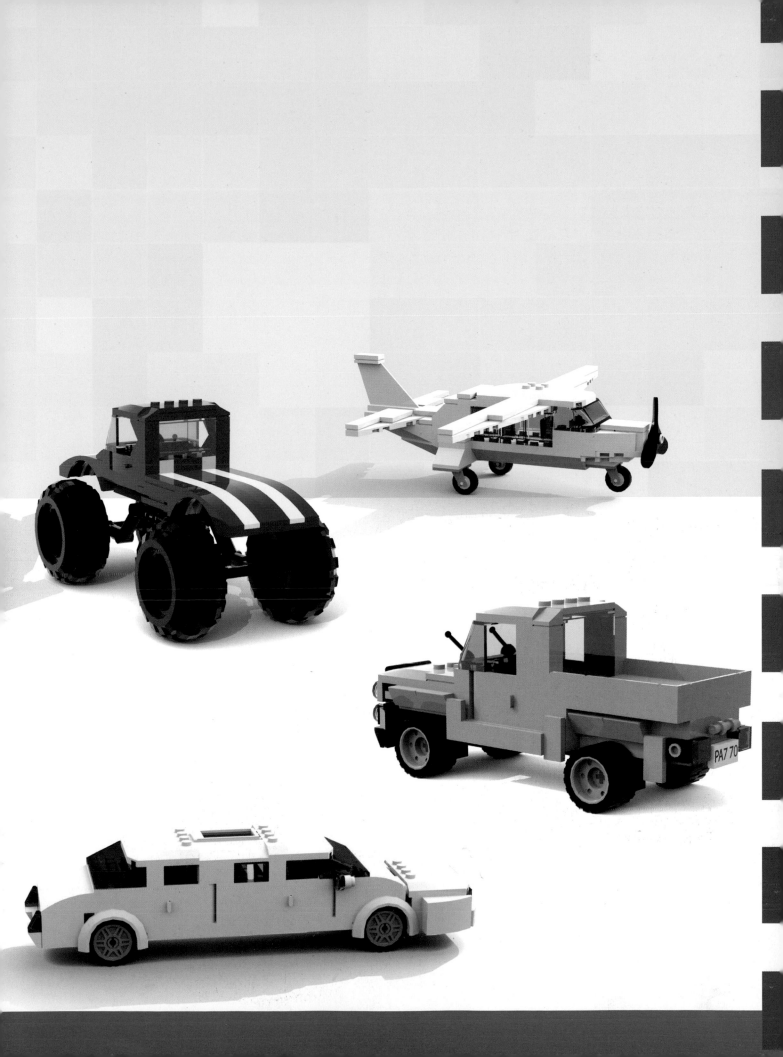

VINTAGE CAR

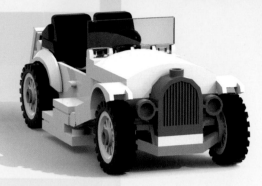

Once upon a time, cars looked like this....Today they seem to us to be real archaeological relics that only dinosaurs could have driven. But they're still around. Here's a beautiful, shiny, white vintage car that you can reproduce in your favorite color. You can even change some of the details.

I'm sure you're going to do a great job!

Pieces required

2 x 44301	1 x 2445	4 x 93273	1 x 3821						
1 x 3710	1 x 4625	2 x 44302	2 x 98282	2 x 3023					
4 x 3070b	1 x 3023	4 x 3069b	2 x 50946	3 x 85984					
2 x 50947	5 x 30155	1 x 3032	1 x 3829c01	1 x 30161					
1 x 3035	2 x 6019	1 x 32028	5 x 61254	2 x 47720					
1 x 3031	2 x 60478	4 x 3666	1 x 3022	1 x 30147					
1 x 3795	2 x 4865	2 x 3794							
2 x 3665	1 x 2460	1 x 3022							
1 x 3822	2 x 2877	2 x 3020							

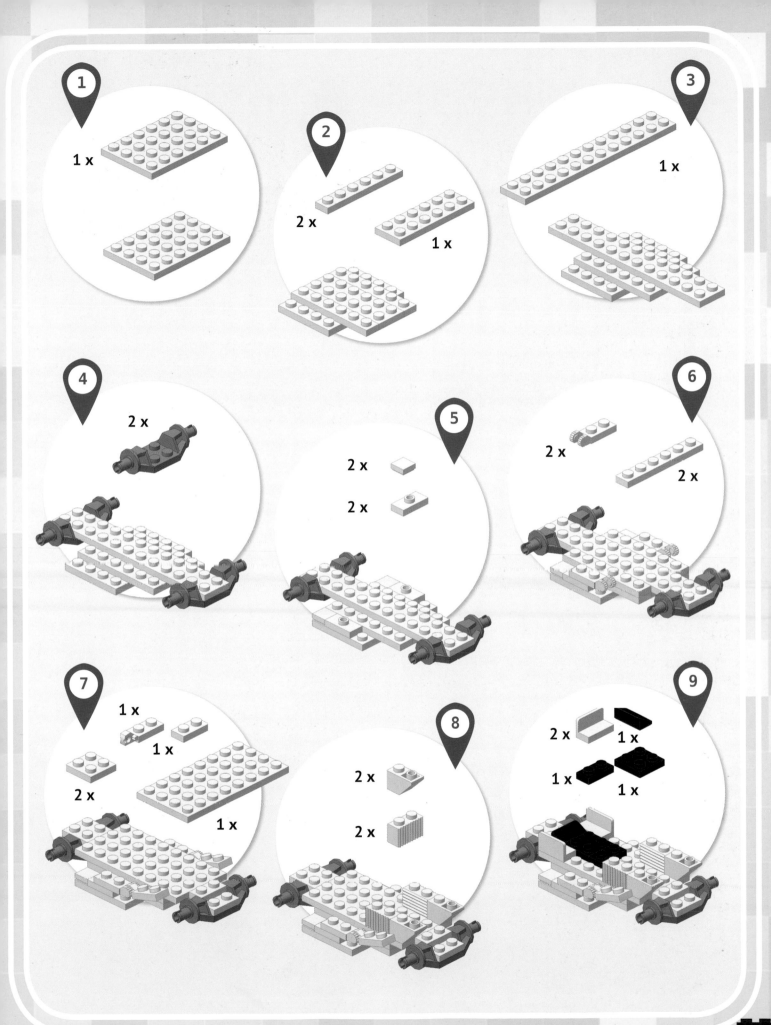

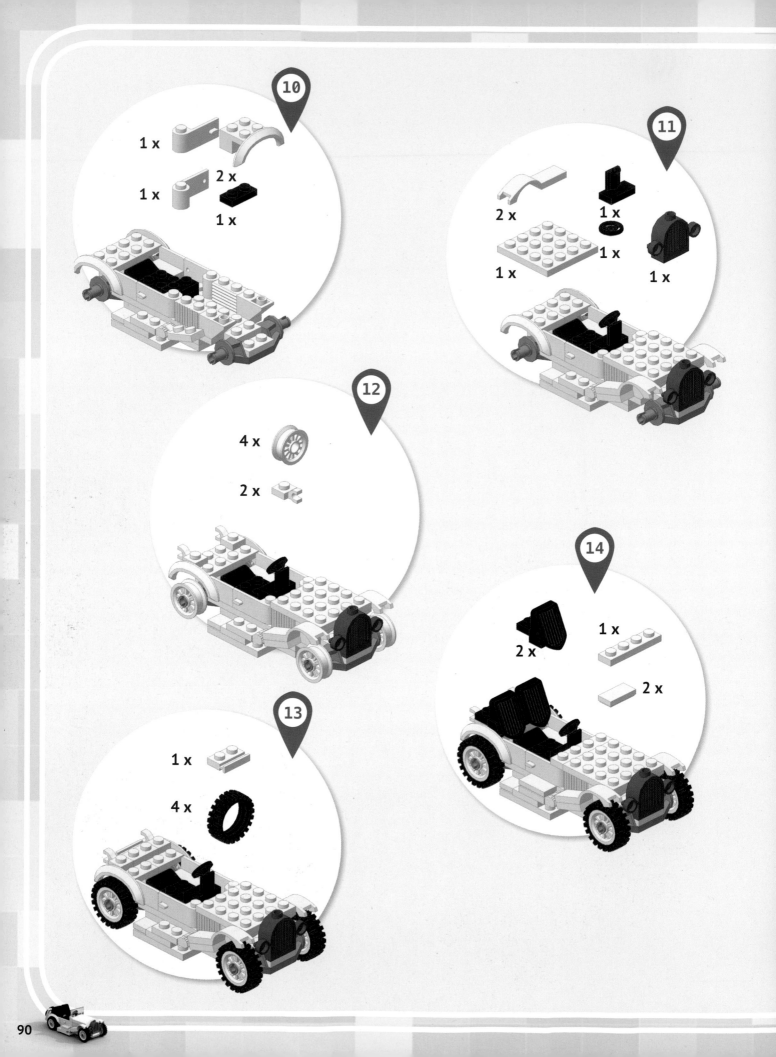

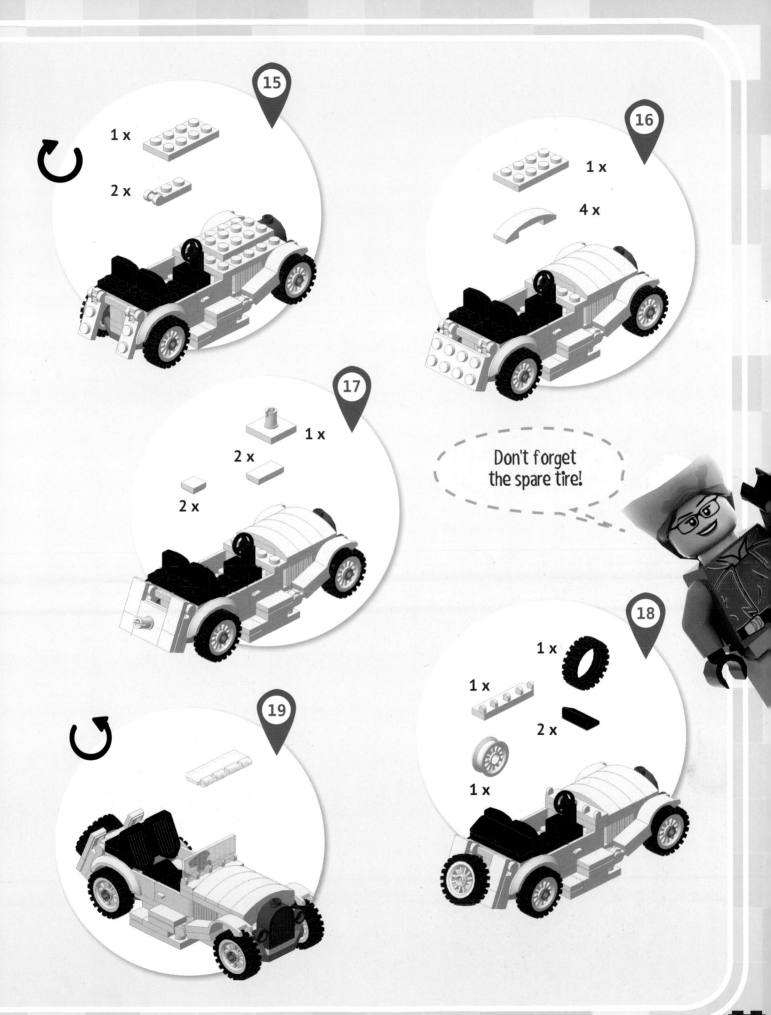

15

1 x

2 x

16

1 x

4 x

17

1 x

2 x

2 x

Don't forget
the spare tire!

18

1 x

1 x

2 x

1 x

19

FOUR-WHEEL DRIVE (4X4)

It's difficult to navigate unpaved roads in a regular car—much easier to use one with four-wheel drive! This vehicle seems to be designed specifically to move in impassable areas, along inaccessible trails and rough terrain.

Extremely powerful, with power going to all four wheels, it's the ideal vehicle for starting an incredible adventure!

Pieces required

1 x 3069bpb125	2 x 3001	2 x 54200	1 x 3958	1 x 30236
4 x 3749	1 x 30414	2 x 3010	4 x 55982	1 x 3032
1 x 3189	2 x 3666	1 x 30663	4 x 3795	8 x 85984
2 x 4592c03	1 x 3794	4 x 98138	2 x 54200	9 x 3666
2 x 3020	2 x 4079	1 x 4176	4 x 99780	9 x 99781
1 x 3937	4 x 42446	1 x 4215b	8 x 3023	1 x 3020
9 x 99781	1 x 6016	2 x 3070b	10 x 87087	4 x 3623
3 x 3710	2 x 3035	4 x 2431	3 x 30413	2 x 52031
4 x 89201		2 x 3710	2 x 4865	4 x 3004
4 x 85984		8 x 3069b	2 x 3070b	3 x 2412a
1 x 3938	4 x 3700	4 x 3005	1 x 3010	
2 x 2555	1 x 3188	2 x 6231	6 x 3068b	

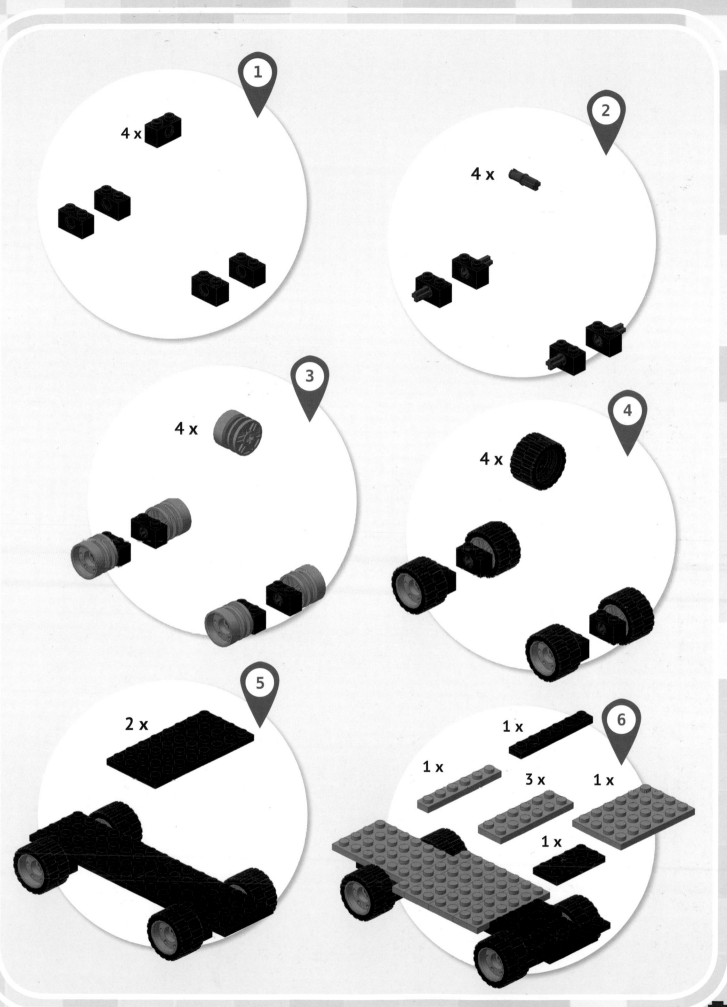

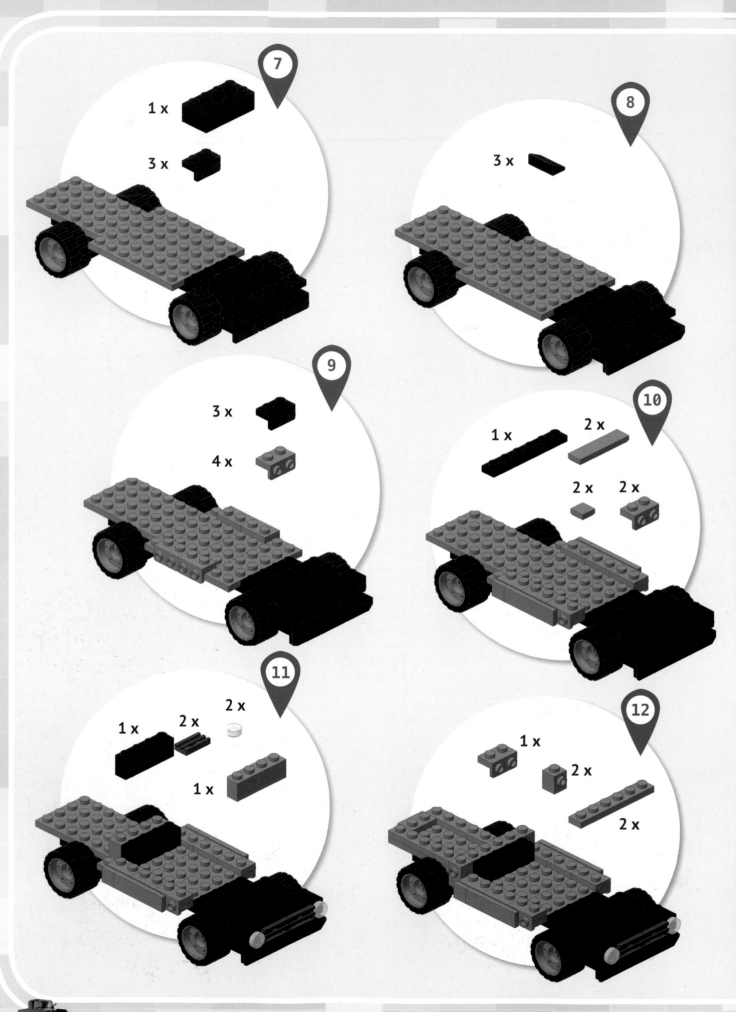

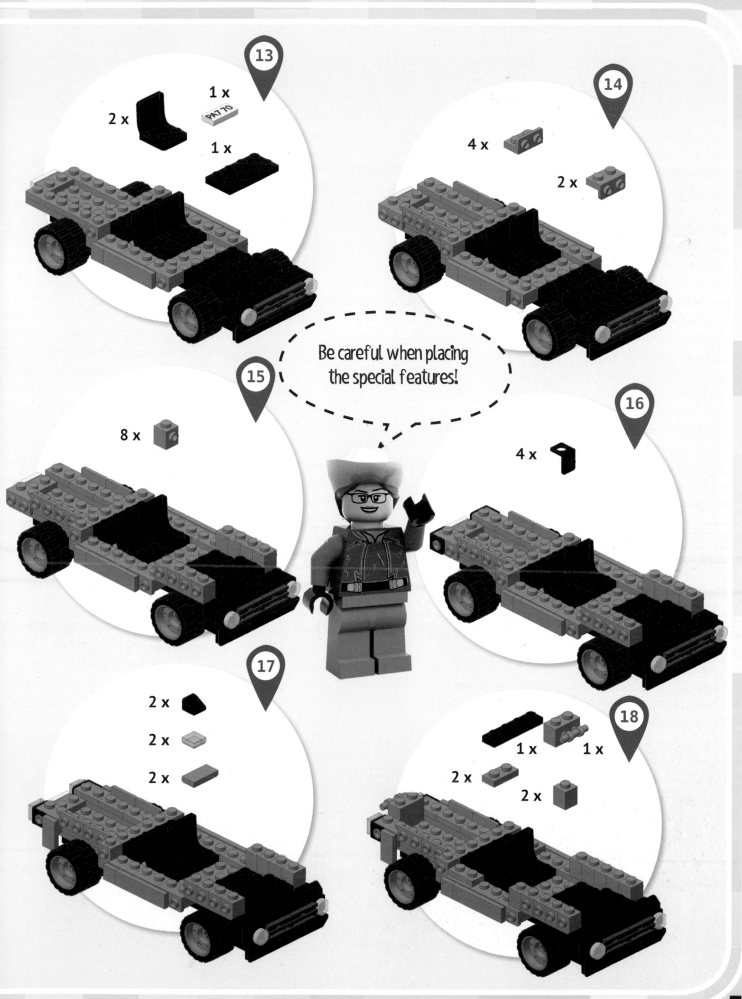

Be careful when placing the special features!

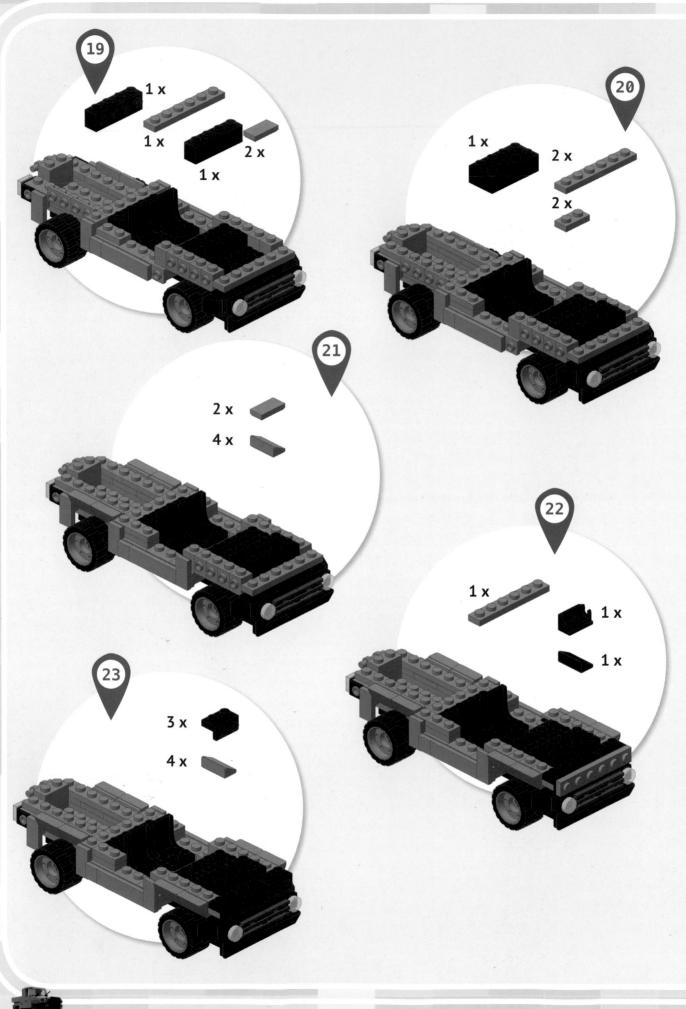

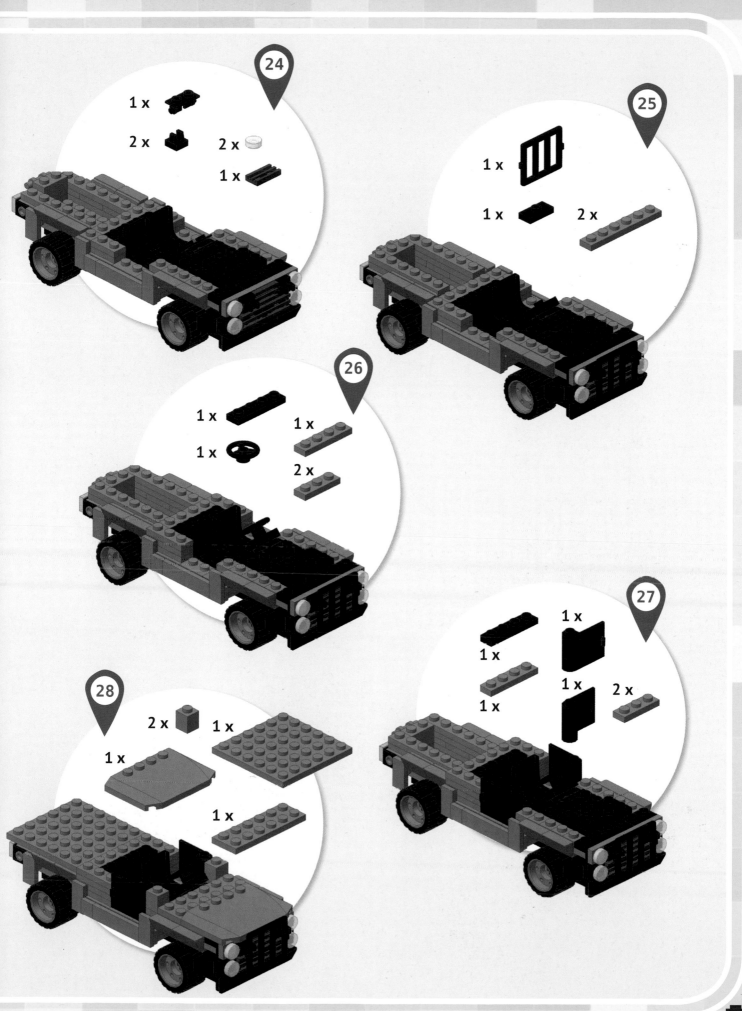

24

1 x

2 x 2 x

1 x

25

1 x

1 x 2 x

26

1 x

1 x

1 x

2 x

27

1 x

1 x

1 x

1 x 2 x

28

2 x 1 x

1 x

1 x

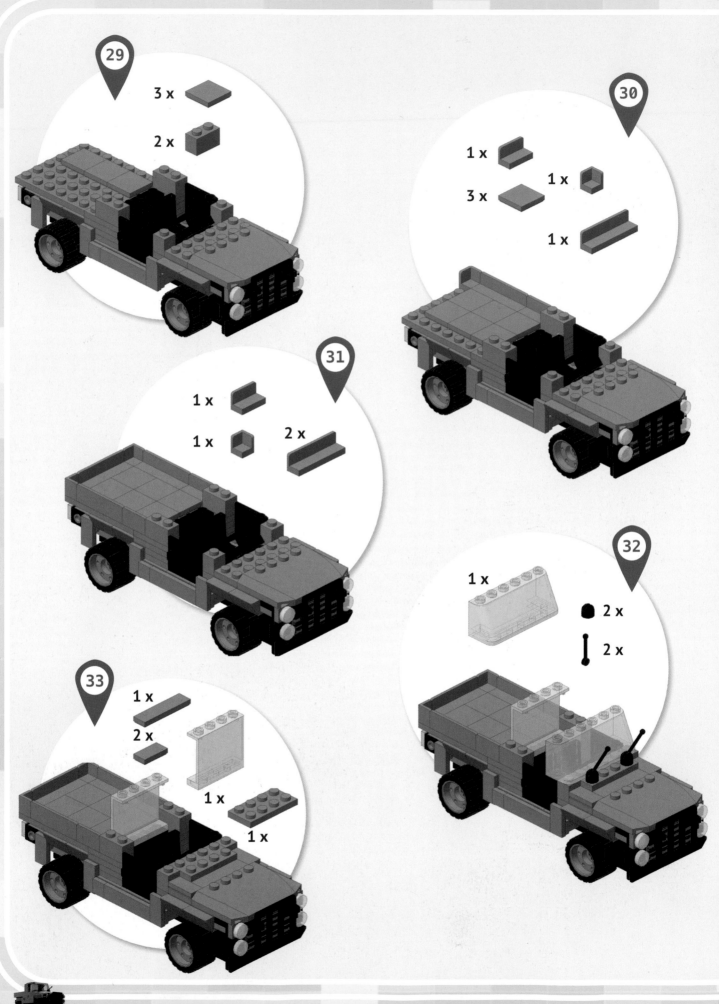

29

3 x
2 x

30

1 x
1 x
3 x
1 x

31

1 x
1 x
2 x

32

1 x
2 x
2 x

33

1 x
2 x
1 x
1 x

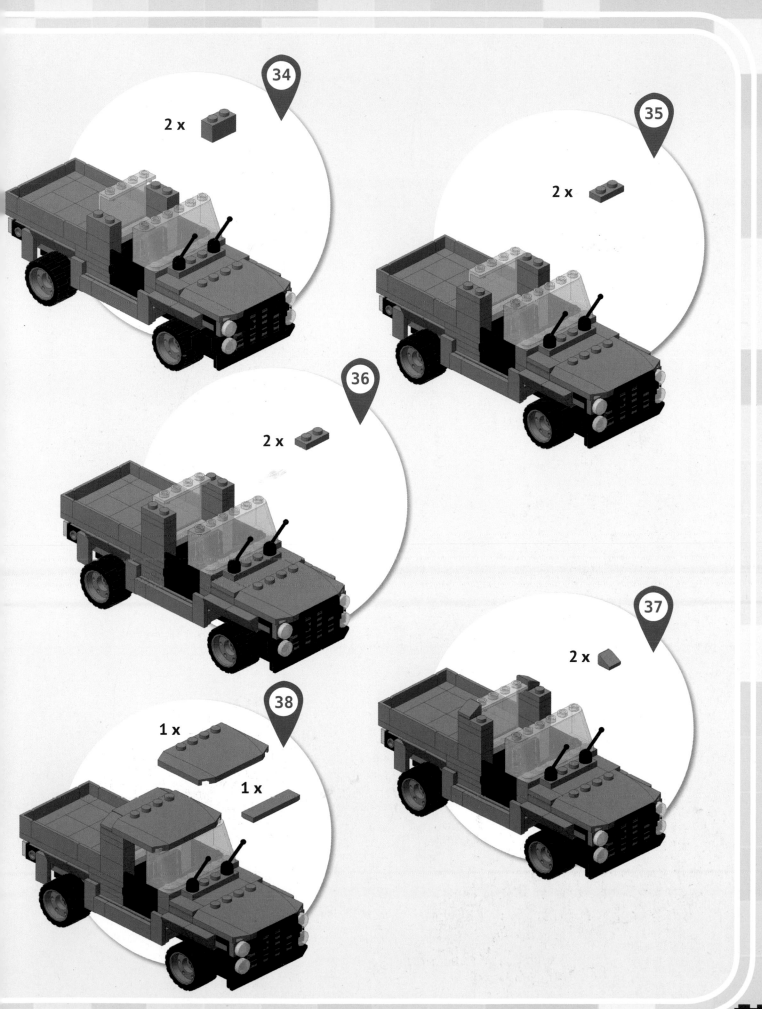

MONSTER TRUCK

As its name suggests, this enormous vehicle with gigantic wheels is a real monster, used in spectacular events to jump over an entire row of cars or for squashing old ones when their time has come. Today you too can build one on a smaller scale. With your shock absorbers, you'll be able to face any kind of crash—and there will be plenty of them....

With a vehicle like this, that's when the fun starts!

Pieces required

1 x 3829c01	2 x 3713	1 x 3023
4 x 3666	1 x 87079	1 x 52031
4 x 54200	1 x 3710	2 x 3738
2 x 3024	4 x 32062	2 x 3032
8 x 50967	3 x 3004	2 x 2431
1 x 4079	2 x 3040	2 x 54200
1 x 3821	2 x 3795	4 x 50967
1 x 85984	3 x 2431	2 x 44294
2 x 3623	2 x 3665	1 x 4592c03
4 x 87580	1 x 3822	8 x 32192

6 x 6553
4 x 55976
4 x 56145
2 x 4864b
1 x 4176
2 x 3005
2 x 4519

DIFFICULTY

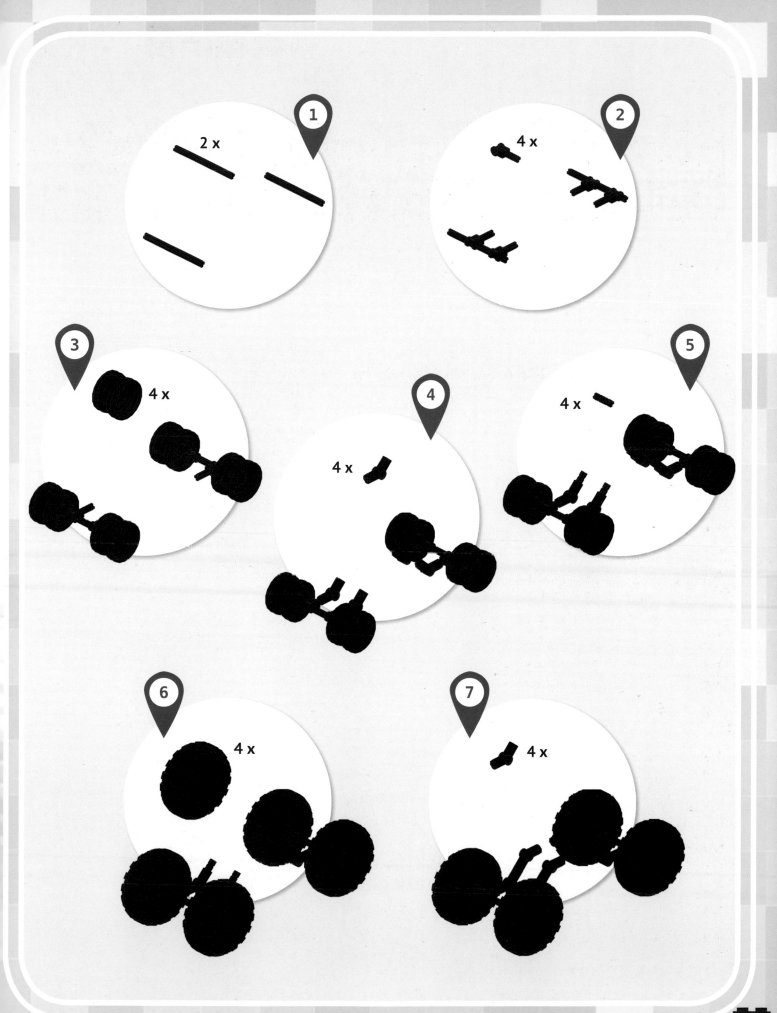

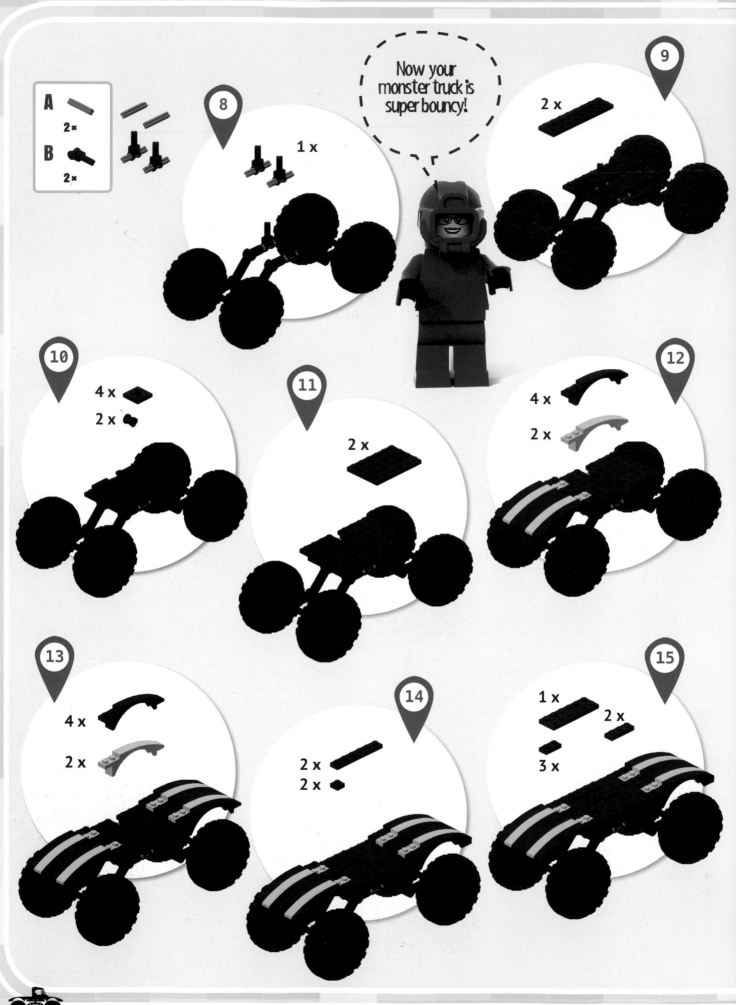

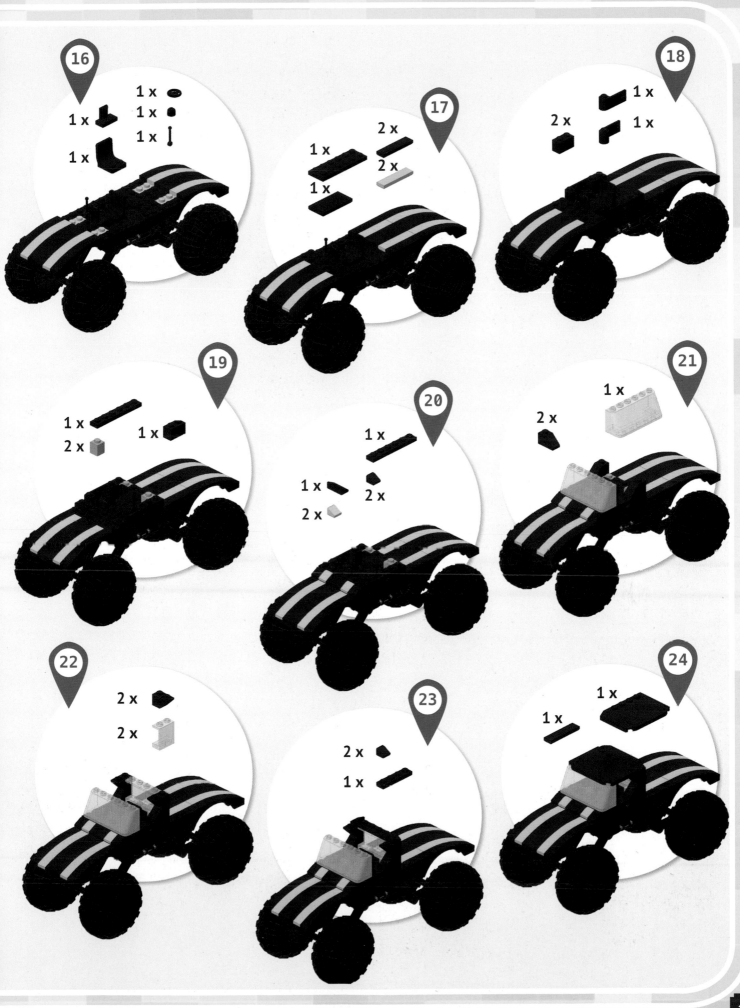

ASPHALT PAVER

Spreading asphalt requires very strong rollers. That's where the asphalt paver comes in. It can flatten anything. This model is moderately simple but involves a few small, complicated details to test a real master builder. Can you identify them? They'll be useful to you for other constructions that you'll encounter in the future.

Did you notice that the wheels are round bricks?

Pieces required

Qty	Part	Qty	Part	Qty	Part	Qty	Part
4 x	4274	12 x	3068b	12 x	3005	2 x	4865
4 x	2450	4 x	85984	2 x	4079	4 x	60474
2 x	3022	4 x	6636	1 x	4592c03	2 x	3038
4 x	32316	4 x	99780	2 x	87580	1 x	3829c01
2 x	2436	1 x	3036	1 x	3003	1 x	6556
2 x	3460	2 x	2456	1 x	52031	2 x	2460
2 x	3710	4 x	44301	1 x	3188	4 x	2780
4 x	44302	3 x	3001	2 x	3004	2 x	3673
2 x	3702	2 x	3040	8 x	87081		
6 x	3795	1 x	3189				

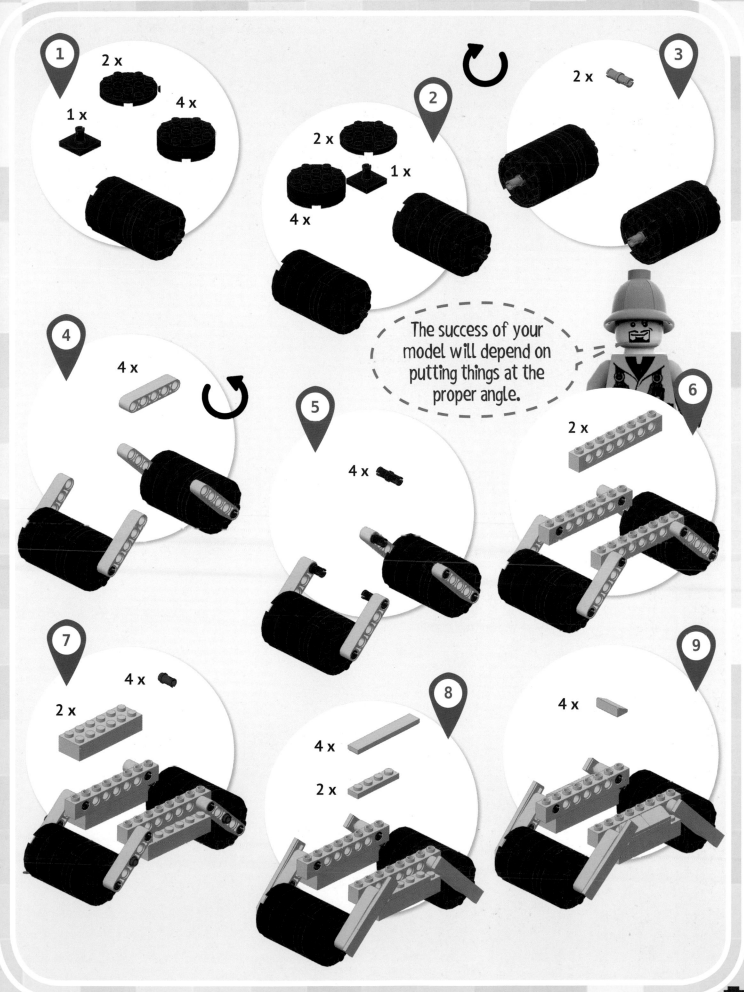

The success of your model will depend on putting things at the proper angle.

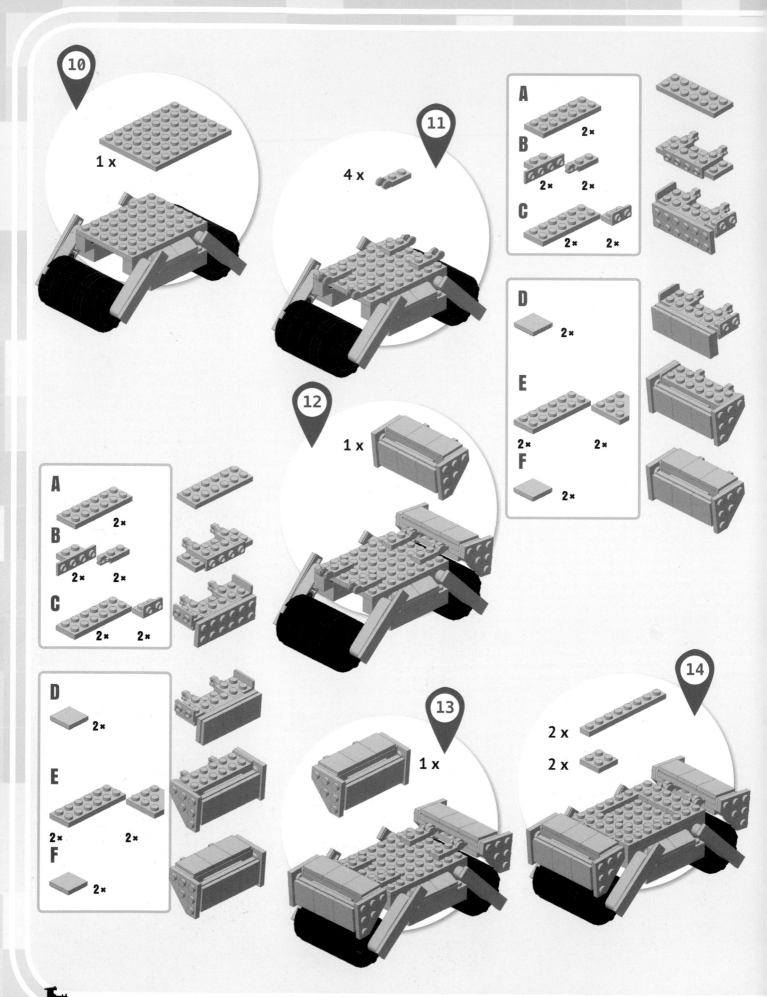

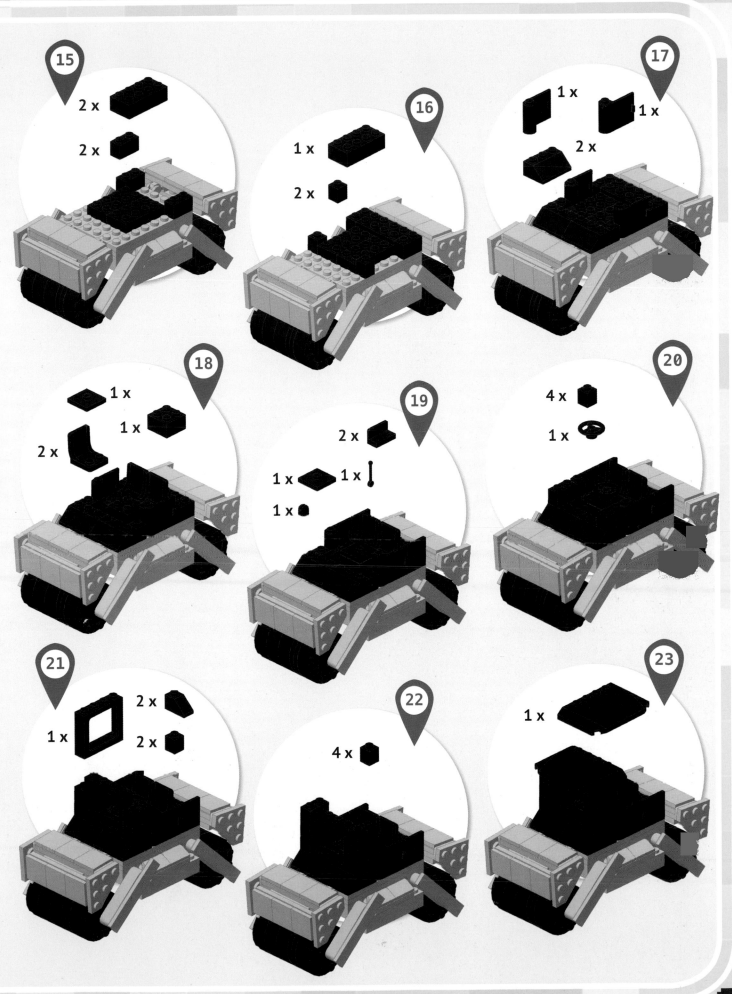

LIMOUSINE

This luxurious vehicle looks like a normal automobile, but it's much longer, and its interior can hold many passengers. Generally, a limousine is driven by an elegant chauffeur and is often equipped with a mini-bar and little tables so everyone can celebrate and have a good time.

You've never seen one around? You'll know one when you see one!

Pieces required

1 x 2456	4 x 50745	2 x 3622	6 x 4079	2 x 98138
2 x 3937	1 x 88930	2 x 87087	1 x 4282	1 x 60602
3 x 3710	6 x 3245a	10 x 50950	2 x 3020	2 x 3004
2 x 3069bpb125	2 x 3832	1 x 3829c01	2 x 2436	2 x 54200
12 x 11477	2 x 85984	2 x 3189	1 x 3023	1 x 4865
2 x 3958	2 x 3188	4 x 3024	1 x 85984	2 x 58181
4 x 3665	3 x 3795	2 x 4081b	1 x 2412a	2 x 54200
2 x 3938	3 x 99780	2 x 3020	2 x 99780	4 x 13971
2 x 3009	7 x 11211	3 x 52031	1 x 3010	2 x 6249
2 x 3005	8 x 3023	2 x 3010	1 x 2877	
1 x 60593	6 x 3004	1 x 93273	1 x 3070b	
2 x 3666		4 x 61254		

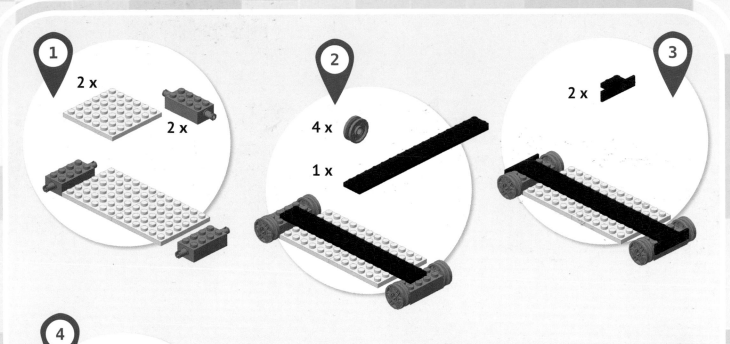

1 2 x 2 x

2 4 x 1 x

3 2 x

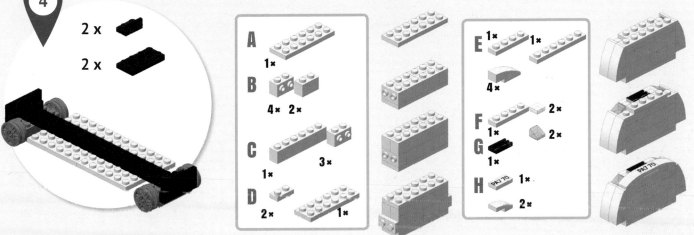

4 2 x 2 x

A 1x
B 4x 2x
C 1x 3x
D 2x 1x

E 1x 1x 4x
F 1x 2x 2x
G 1x
H PA7 70 1x 2x

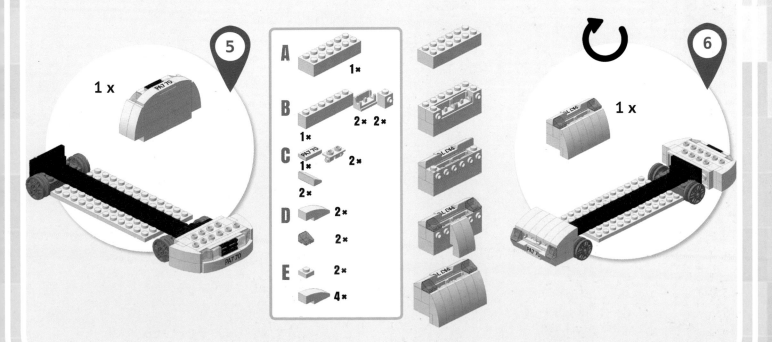

5 1 x

A 1x
B 1x 2x 2x
C PA7 70 1x 2x 2x
D 2x 2x
E 2x 4x

6 1 x

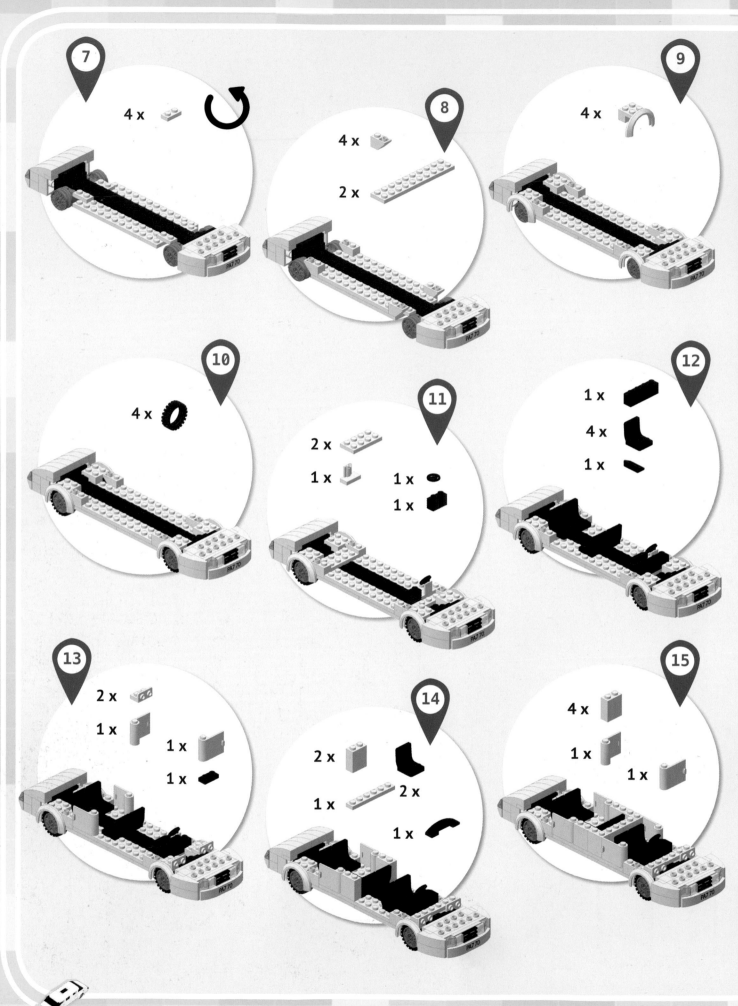

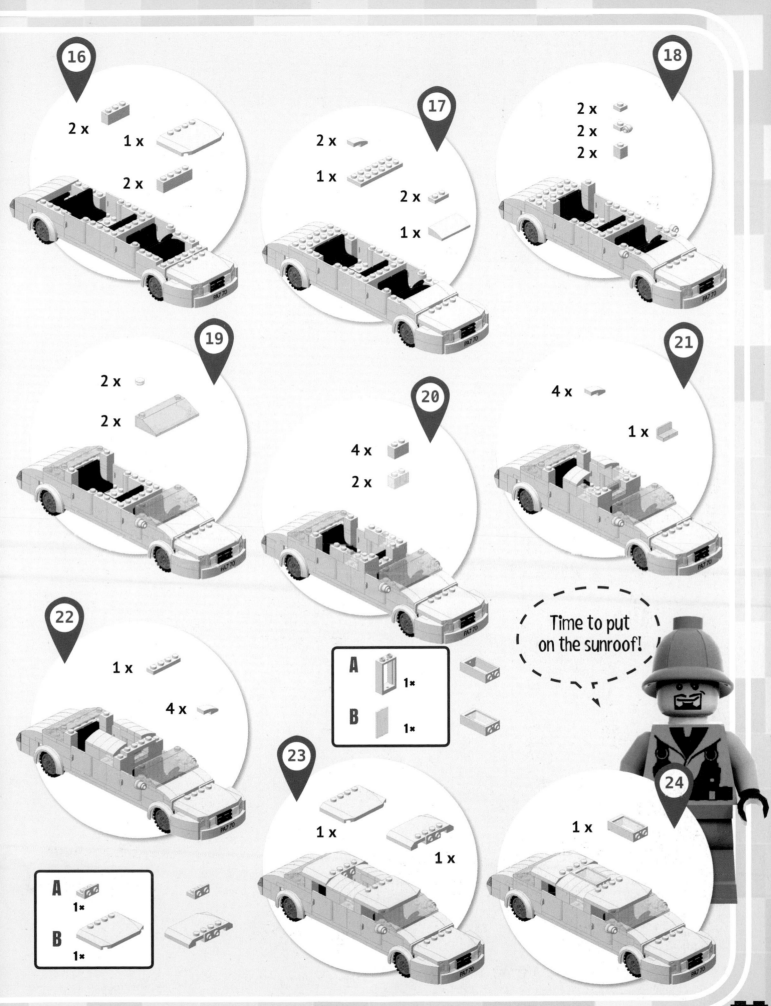

Time to put on the sunroof!

AMBULANCE

Even the little people in your LEGO® city can get sick. In that case, you'll need an ambulance to take them to the hospital right away. This model is equipped with a seat for the doctor, a stretcher, and medical instruments to help the poor patient. The colors are those of a classic ambulance. Turn on the siren and speed through the streets of your city.

Everyone needs to move over and let the ambulance through!

Pieces required

1 x 3008	1 x 3039	2 x 4073	3 x 4079	1 x 4282	
5 x 3710	1 x 85984	2 x 15712	2 x 50950		
1 x 3037	4 x 2420	1 x 3032	4 x 4488	1 x 4176	
1 x 2436b	1 x 3188	1 x 3189	2 x 44302	2 x 3024	
2 x 88072	2 x 3795	2 x 3024	4 x 50745	1 x 3023	4 x 3070b
4 x 3665	1 x 3039pb041	3 x 3660	2 x 44300	4 x 3069b	5 x 4215b
2 x 3941	3 x 3023	3 x 3020	4 x 3710	2 x 3005	4 x 6014
1 x 3009	1 x 6636	4 x 2921	2 x 11477	2 x 3460	1 x 99207
12 x 3005	8 x 87079	2 x 52031	2 x 3795	6 x 3010	2 x 85984
1 x 3001	2 x 3622	5 x 3010	2 x 2412a	2 x 3710	
4 x 3666	4 x 63868	1 x 3032	4 x 6015	1 x 3032	
1 x 93140	2 x 87544	1 x 3829c01	2 x 3070b	4 x 3666	
2 x 4286	4 x 3040	1 x 3666	1 x 3660		

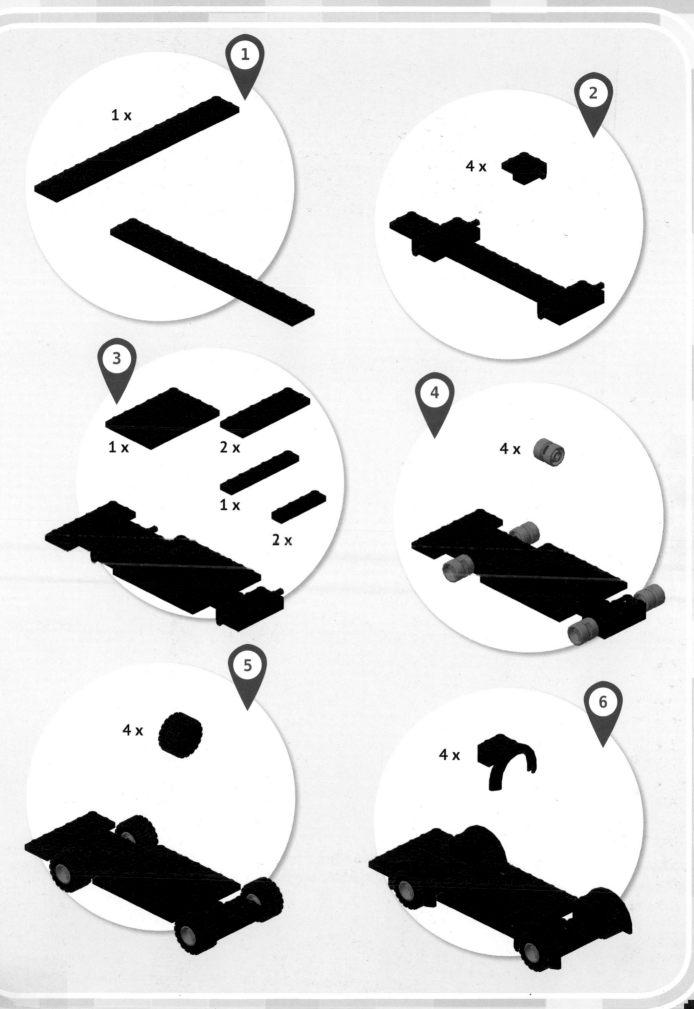

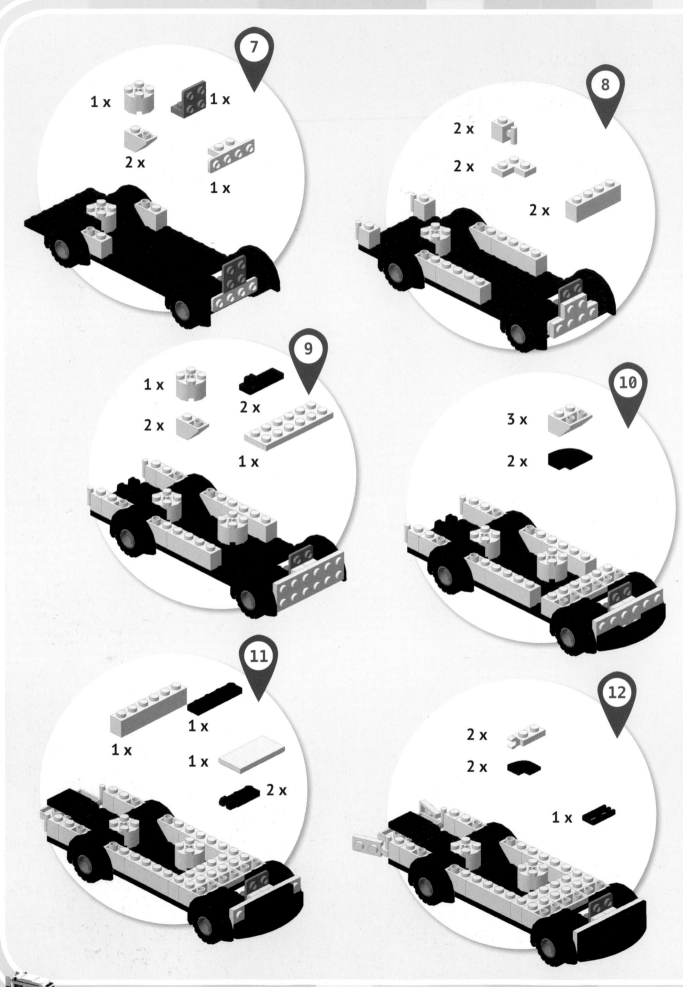

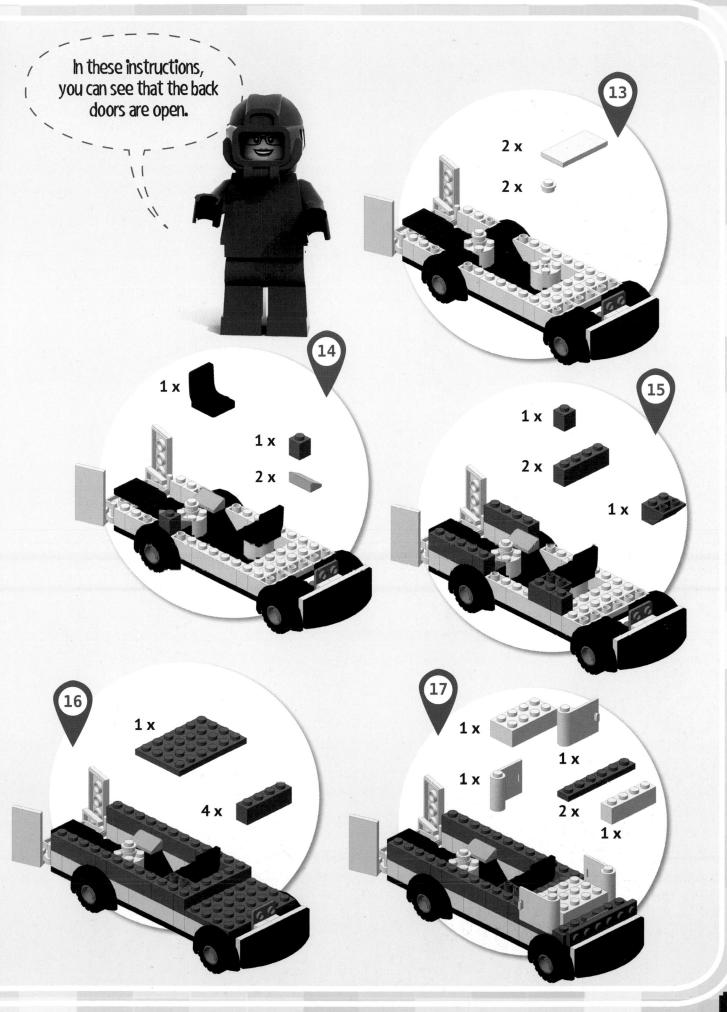

In these instructions, you can see that the back doors are open.

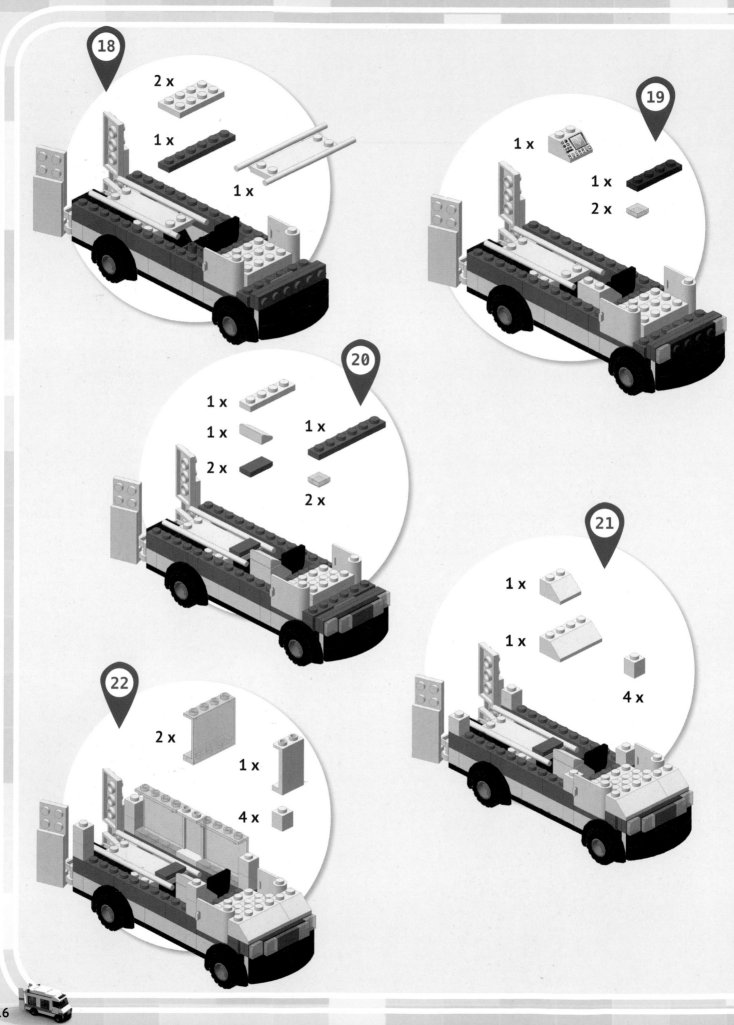

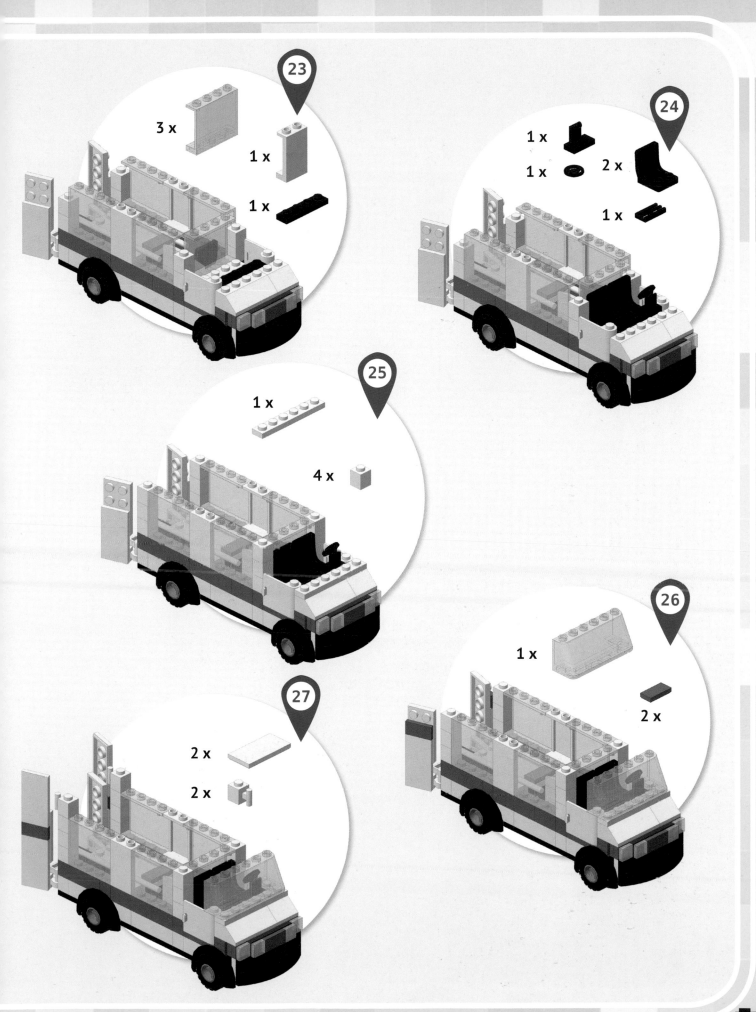

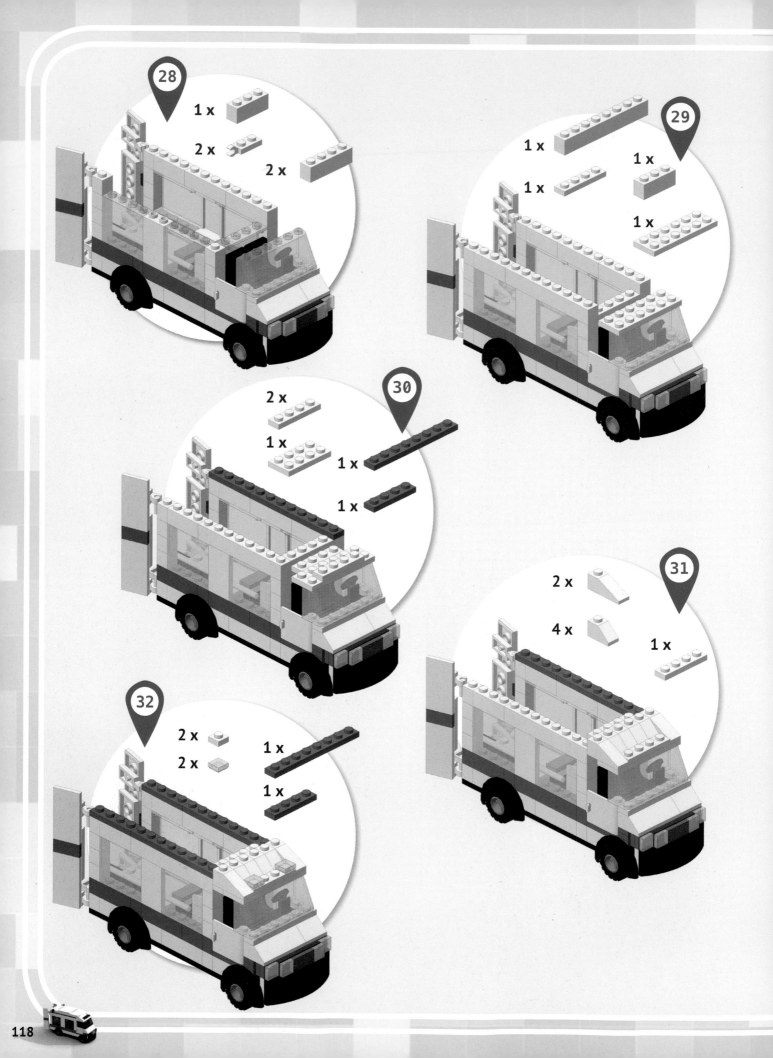

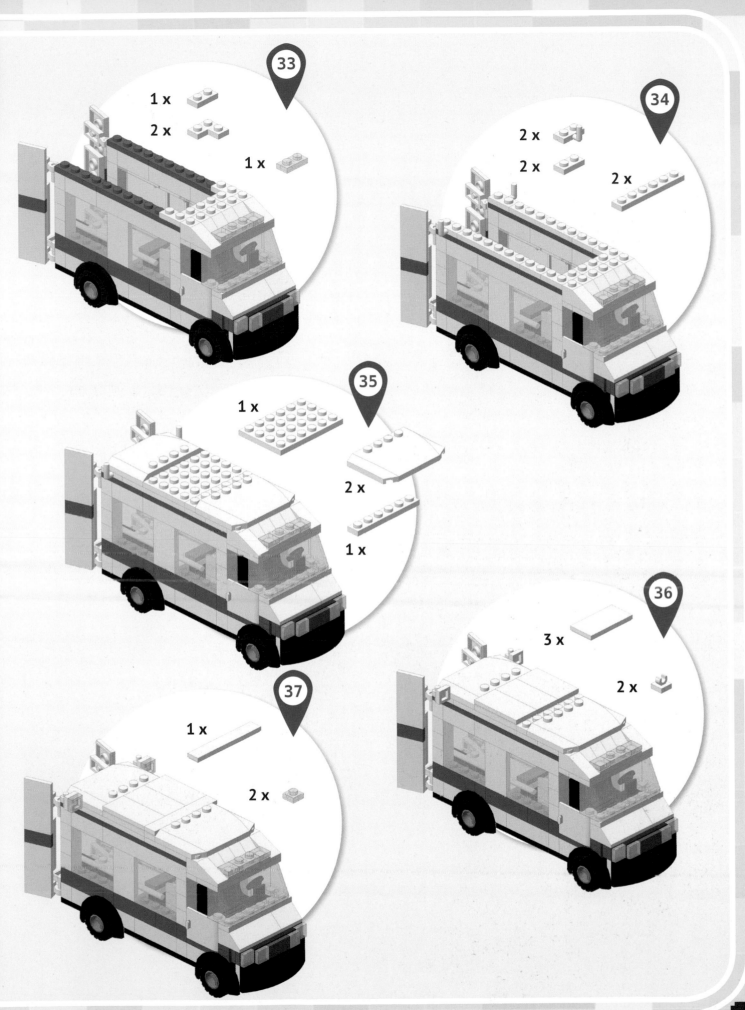

AIRPLANE

This little plane, easy to maneuver, is usually used for training professional pilots or anyone else who is passionate about learning to fly. If you want to experience the joy of soaring through the air aboard a plane and become a real pilot, this model is made for you.

Test yourself and build it!

Pieces required

3 x 3710	2 x 85984	1 x 3003	2 x 4859
1 x 2399	1 x 3031	2 x 2431	1 x 3010
2 x 3710b	1 x 47398	1 x 2458	2 x 4162
4 x 3039	1 x 3795	2 x 3069b	2 x 4079
2 x 3002	6 x 3023	1 x 47397	1 x 4617
2 x 3068b	4 x 6636	1 x 54383	3 x 3139
1 x 3832	4 x 63864	4 x 3794	6 x 87552
1 x 54384	2 x 3004	1 x 99781	1 x 2437
2 x 4854	1 x 2340	3 x 3464	1 x 3069bpx19
2 x 4856	2 x 45677	2 x 3623	3 x 2415

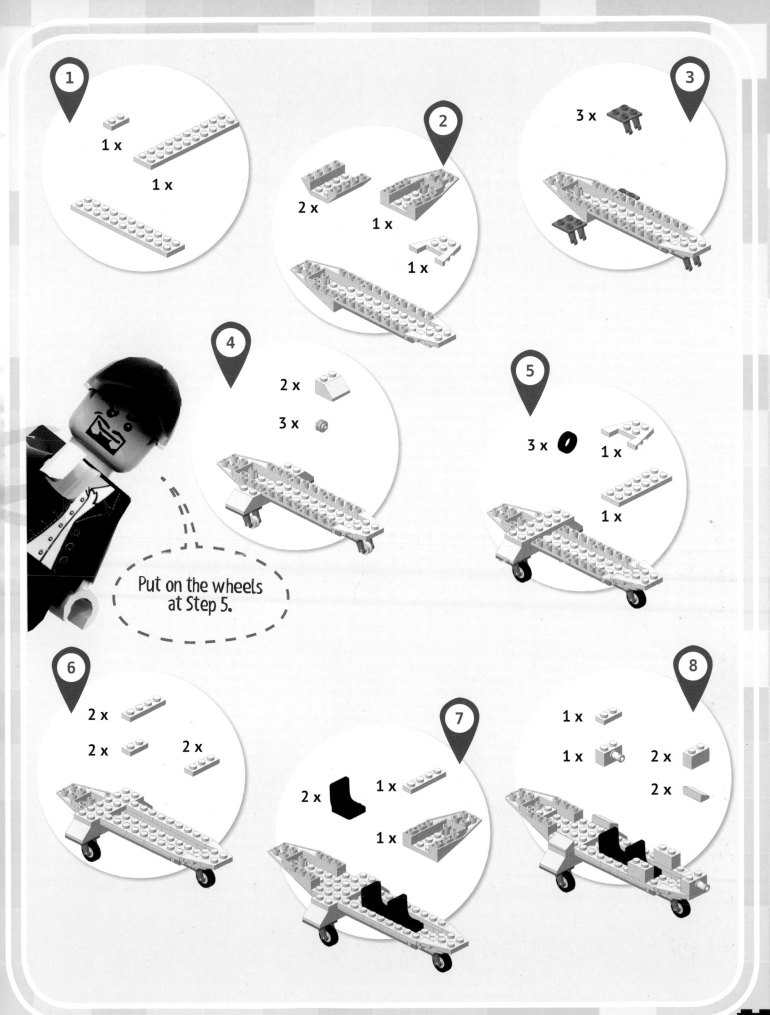

Put on the wheels at Step 5.

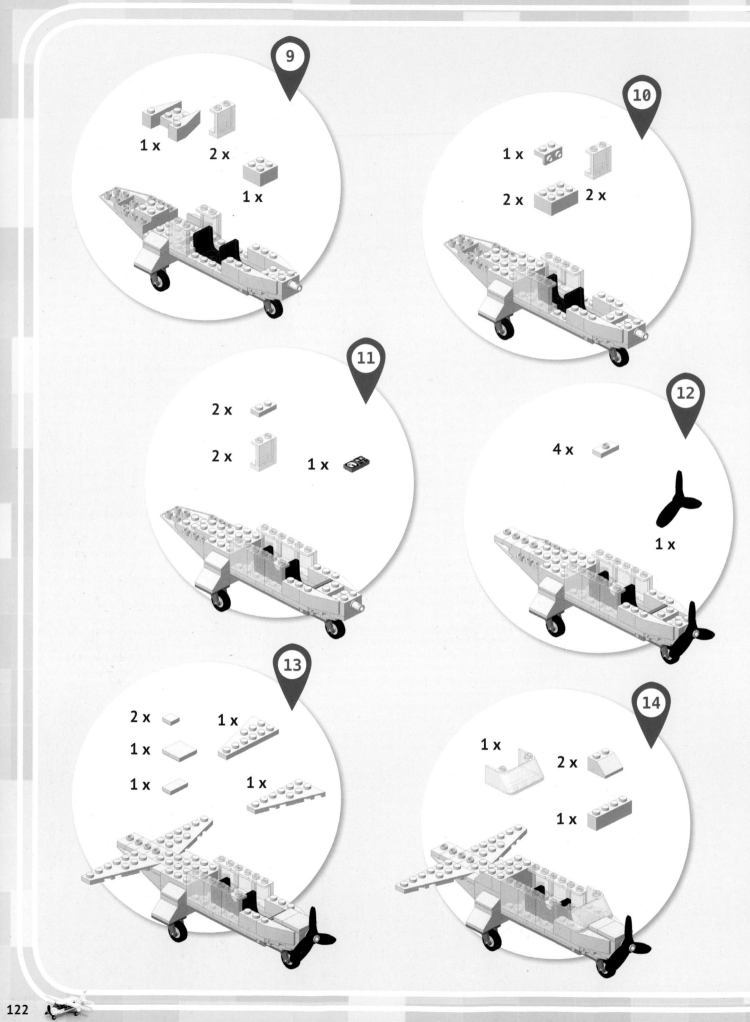

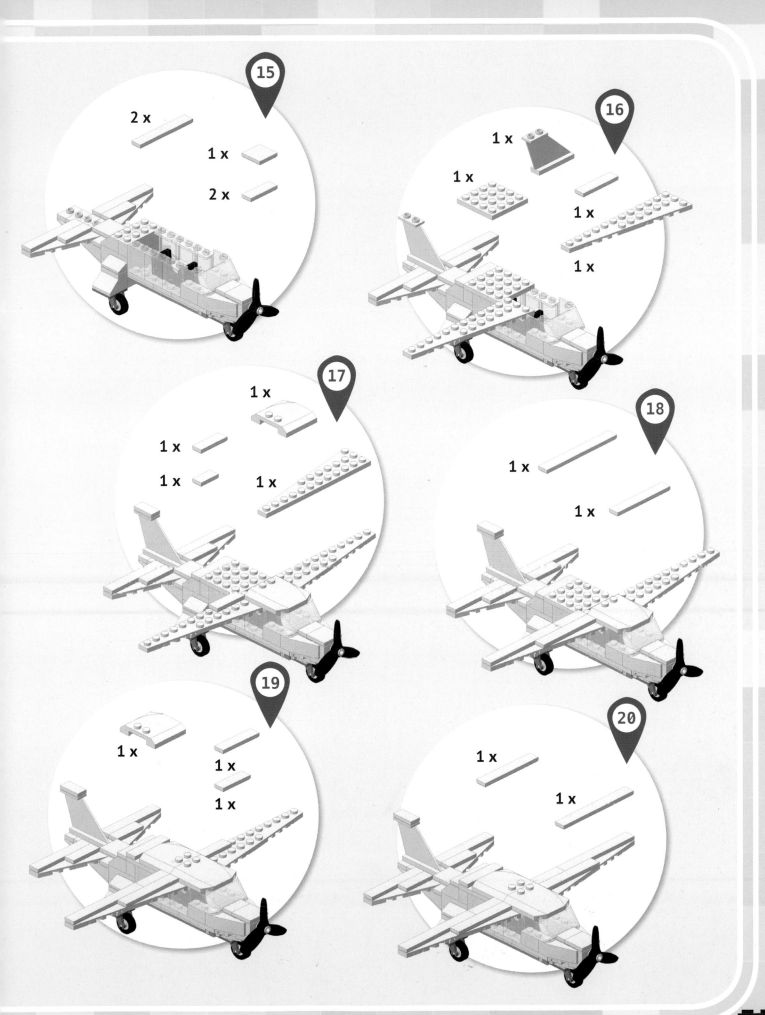

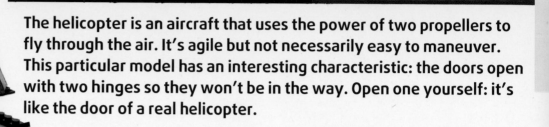

HELICOPTER

The helicopter is an aircraft that uses the power of two propellers to fly through the air. It's agile but not necessarily easy to maneuver. This particular model has an interesting characteristic: the doors open with two hinges so they won't be in the way. Open one yourself: it's like the door of a real helicopter.

You can change the way the door opens if you like, but remember to turn off the blades after you land!

Pieces required

3 x 42023	1 x 88292	2 x 2458	2 x 4592c03
1 x 3794	1 x 3004	2 x 63864	1 x 92842
2 x 51739	1 x 44126	1 x 3031	1 x 3298
4 x 54200	6 x 3795	1 x 3795	1 x 30248
2 x 3024	4 x 11477	1 x 3665	2 x 4477
2 x 3070b	4 x 3023	2 x 3069b	
1 x 3623	2 x 3069b	1 x 4477	2x 4215b
1 x 3010	1 x 60481	2 x 4107487	1 x 30251
2 x 6636	2 x 2412a	1 x 3069b	
4 x 2429c01	1 x 87087	2 x 4079	
2 x 50950	2 x 2460	2 x 2479	

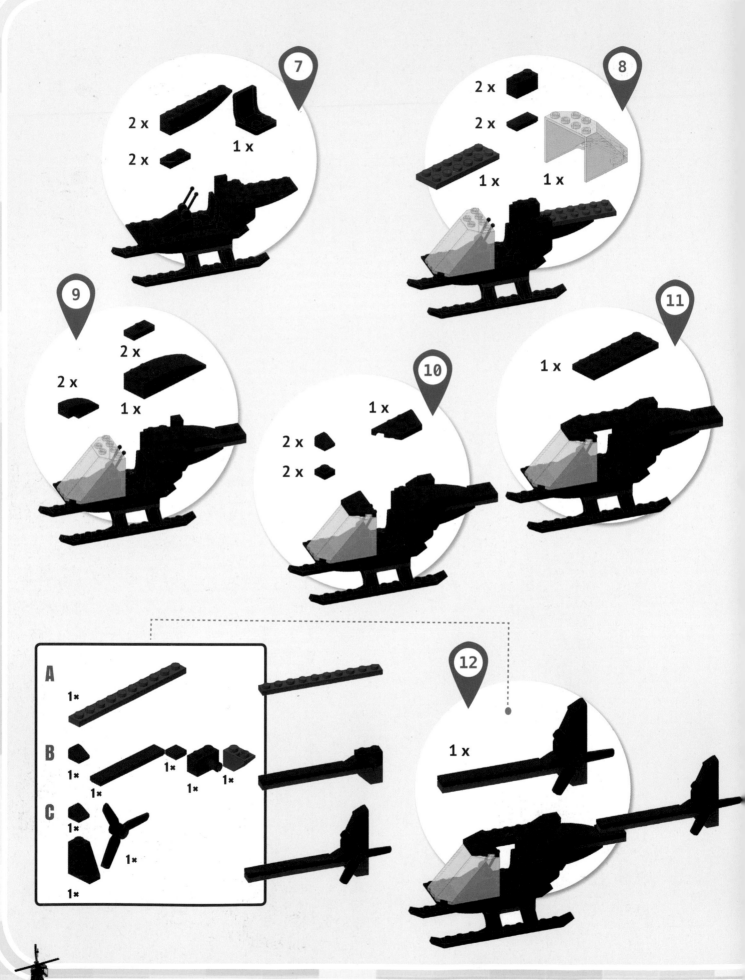

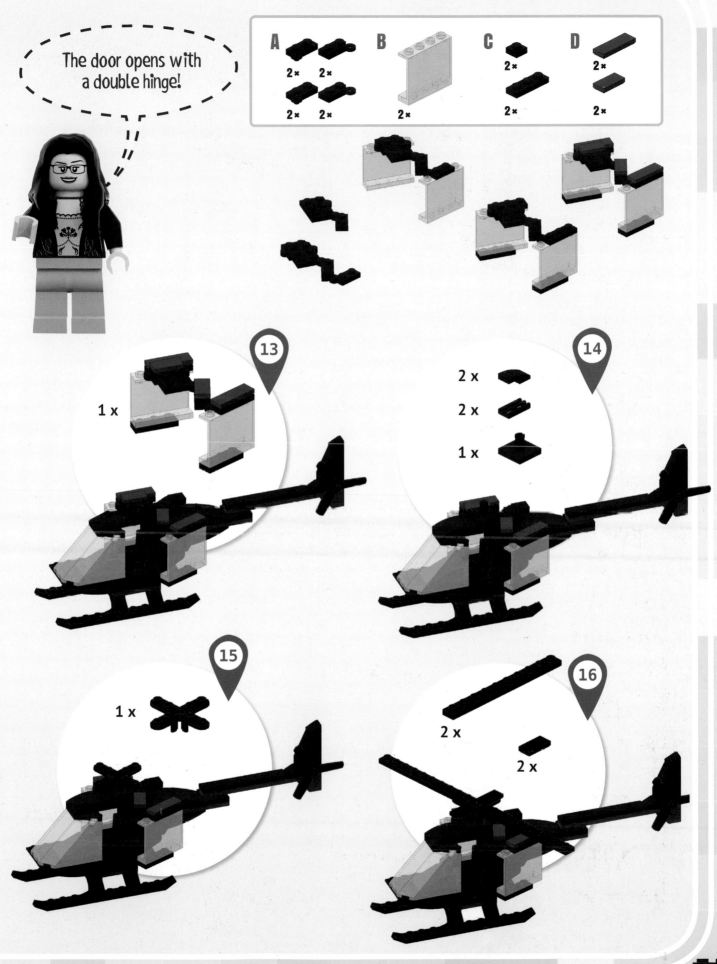

The door opens with a double hinge!

LEVEL 5

You did it! You're a real engineer. Now you definitely have the ability to build the last six fantastic models and create your own project.

Congratulations! We're going to hear about you in the media!

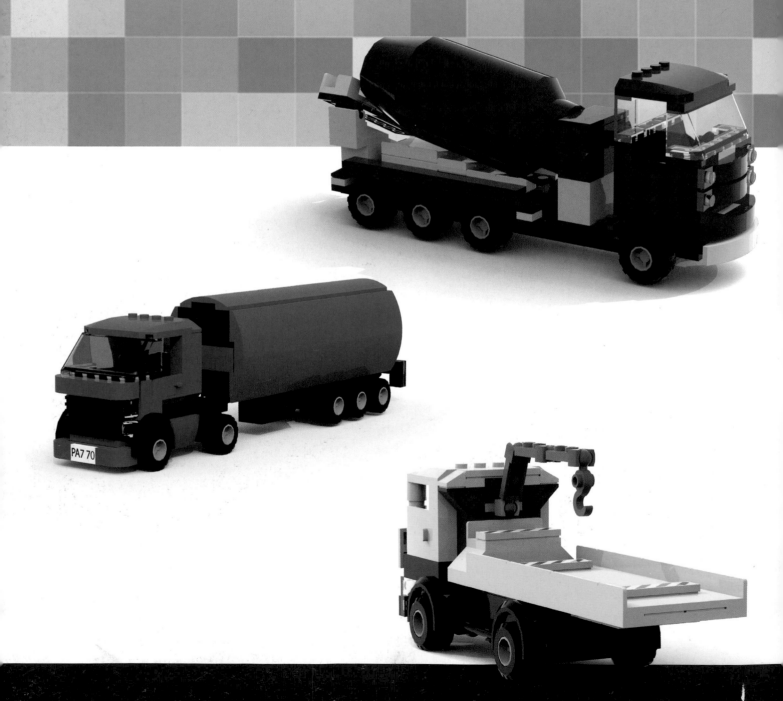

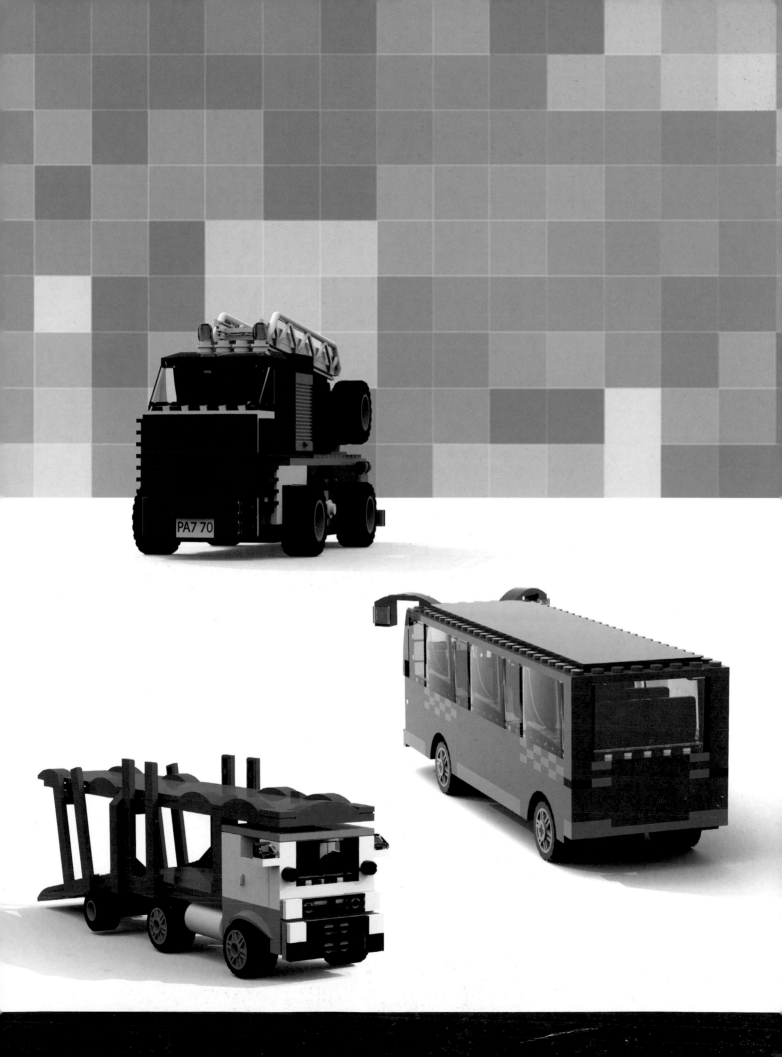

FLATBED TOW TRUCK

When a car doesn't run anymore, it's time to call a flatbed tow truck. This one has an inclined ramp like real ones. Try to build one by yourself: you can change the color and the details as you wish to create different versions, and you can even use other vehicles you have built for head-on collisions....

That's one of the great things about the pieces: there's no limit to what you can invent.

Pieces required

3 x 3010	12 x 3068b	2 x 50950	1 x 3028	
2 x 3665	2 x 54200	3 x 3020		
1 x 3004	6 x 3794	1 x 95120	2 x 3023	
1 x 3032	1 x 3003	2 x 60471	6 x 87087	4 x 6014
1 x 3189	1 x 3031	8 x 63868	2 x 3068b	1 x 14704
1 x 2431	1 x 52031	4 x 87697	2 x 2420	3 x 14419
8 x 3005	1 x 3188	1 x 3001	5 x 3023	1 x 30395
3 x 2431p52	2 x 3062b	2 x 2357	2 x 6636	1 x 2445
2 x 3024	2 x 4865	2 x 3022	2 x 3009	2 x 3031
4 x 50950	1 x 3032	4 x 4488	2 x 30374	
2 x 3039	1 x 3829c01	4 x 50745	5 x 3010	
7 x 30413	1 x 4592c03	2 x 11477	2 x 87552	

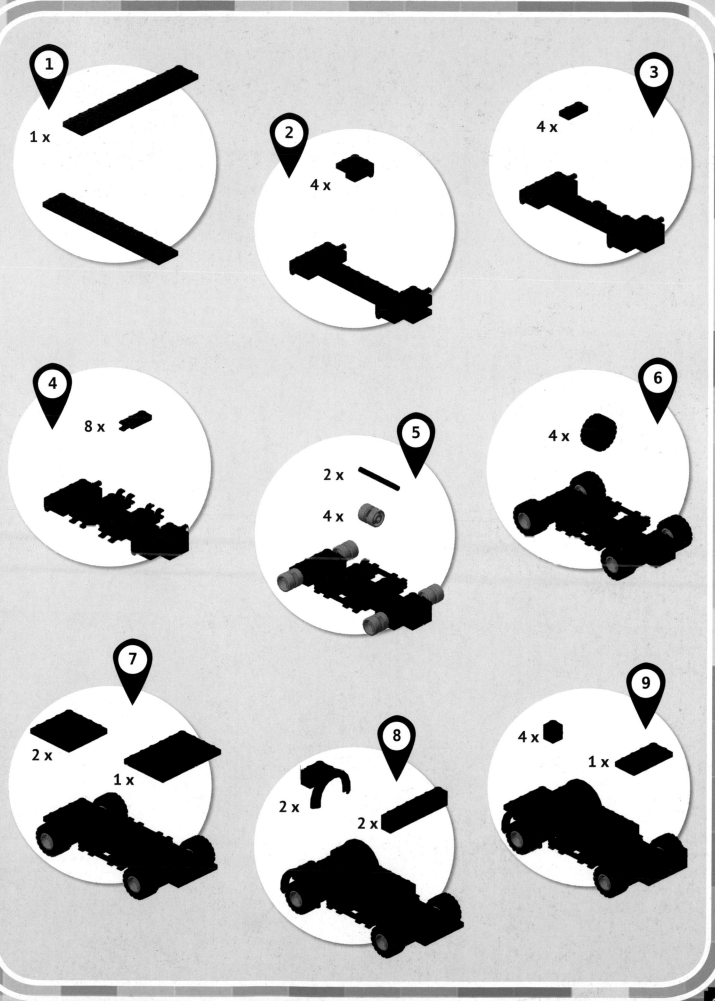

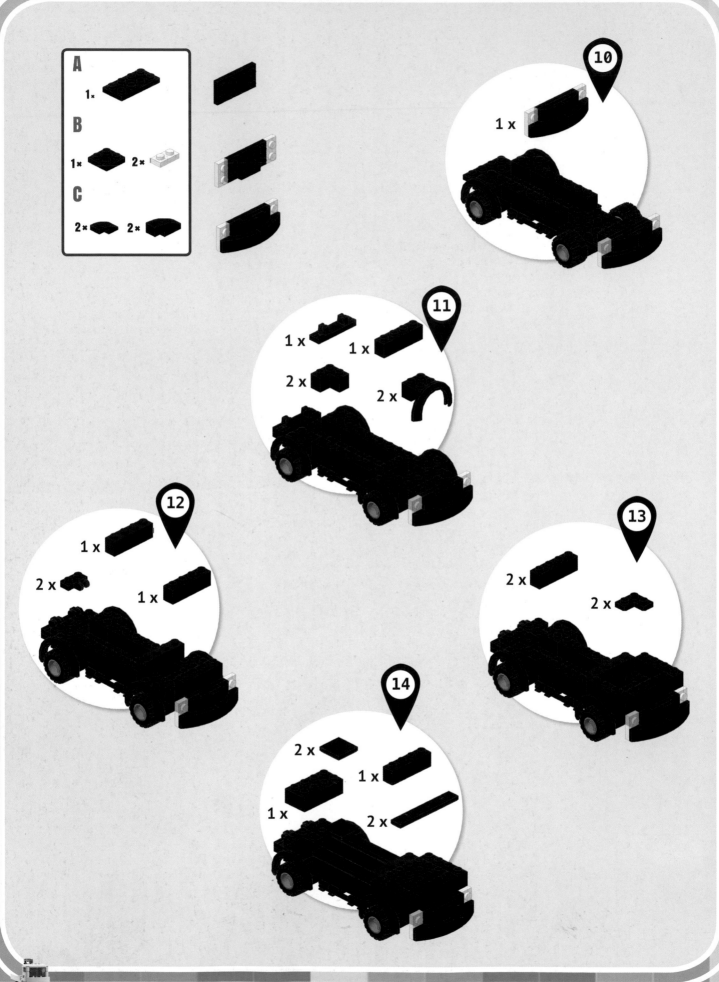

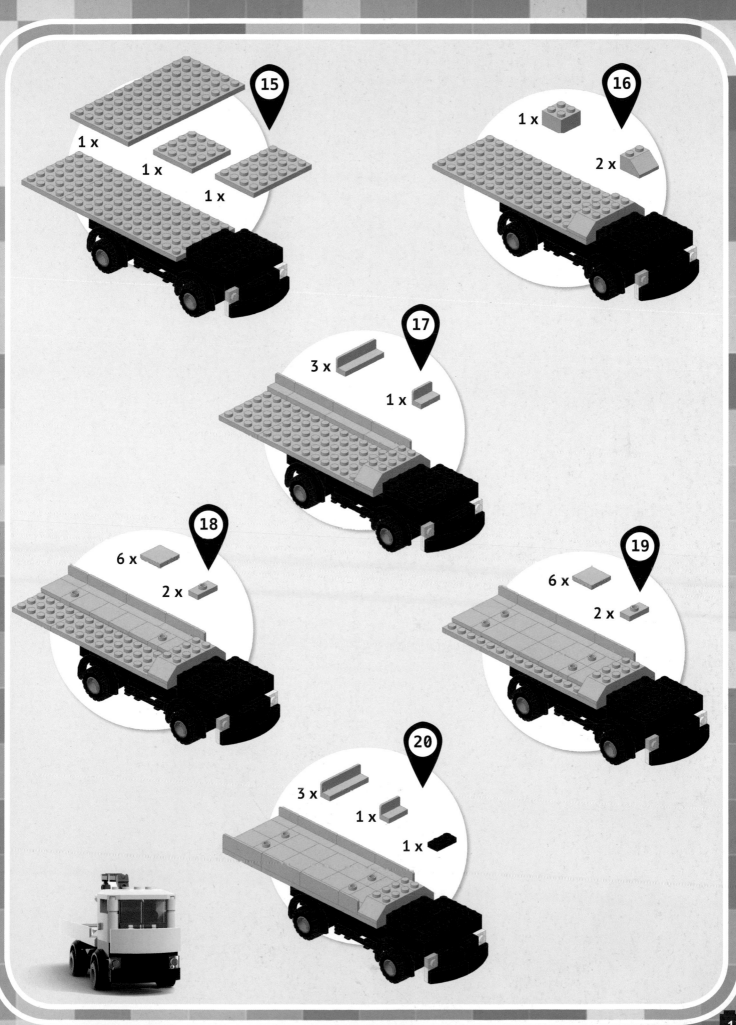

15

1 x
1 x
1 x

16

1 x
2 x

17

3 x
1 x

18

6 x
2 x

19

6 x
2 x

20

3 x
1 x
1 x

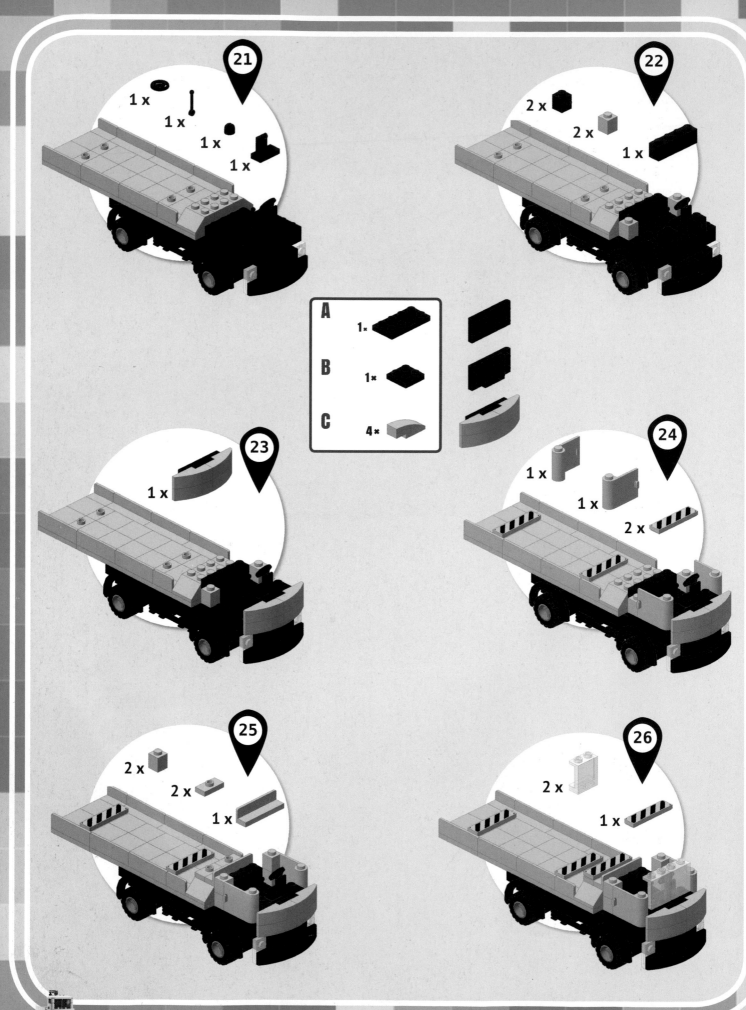

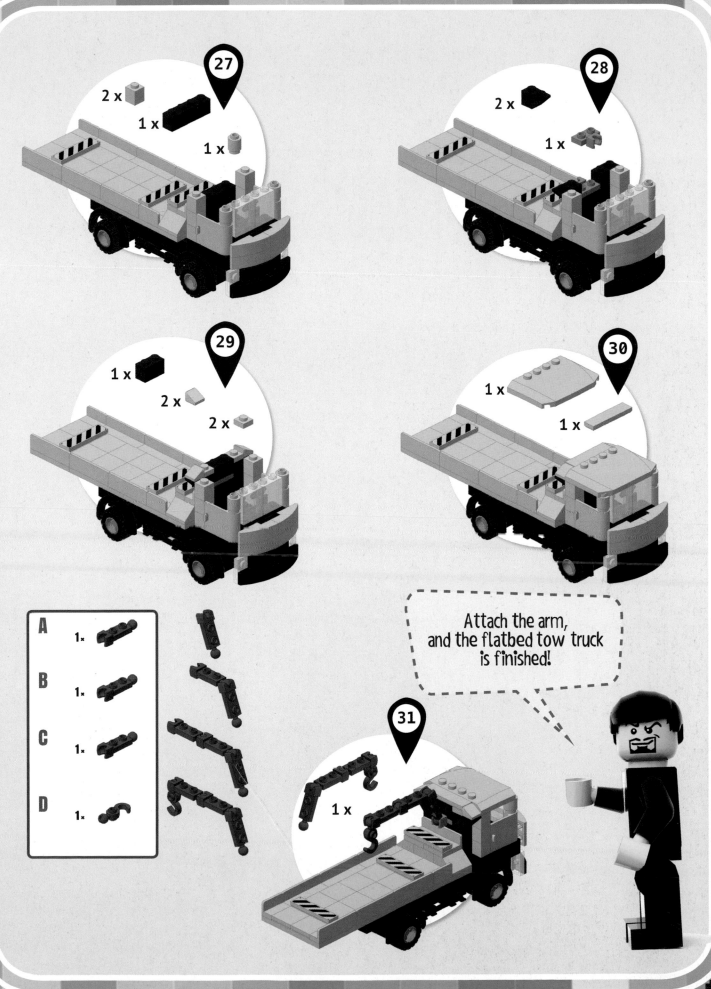

Attach the arm, and the flatbed tow truck is finished!

TRACTOR-TRAILER

Do you have to transport other vehicles? Then you'll need a tractor-trailer! It's one of the most complicated projects in the book, but it has the advantage of being easily personalized by changing the rear supports and adjusting the angle of the bed, which, as you can see, actually inclines. You can also change the color in any way you want, according to your needs.

And you can easily vary the height of the upper deck so the tractor-trailer can accommodate any of your other creations!

DIFFICULTY

Pieces required

4 x 3070b	4 x 3024	2 x 3062b	1 x 3958
2 x 6192	29 x 87079	1 x 3460	1 x 85984
2 x 3005	2 x 3040	4 x 2436	4 x 30648
6 x 2357	19 x 3069b	8 x 4162	1 x 2456
1 x 3188	6 x 11477	9 x 93273	2 x 6015
2 x 2420	2 x 92946	12 x 3005	1 x 3022
4 x 3023	2 x 3034	11 x 3023	2 x 4079
1 x 3004	2 x 63864	1 x 3829c01	2 x 4488
2 x 87087	2 x 60478	2 x 4592c03	4 x 2412a
1 x 3189	2 x 54200	1 x 3020	2 x 3069b
1 x 3010	2 x 63868	2 x 3710	3 x 99780

3 x 4864b

2 x 54200

2 x 3070b

1 x 3031

1 x 3795

4 x 2420

136

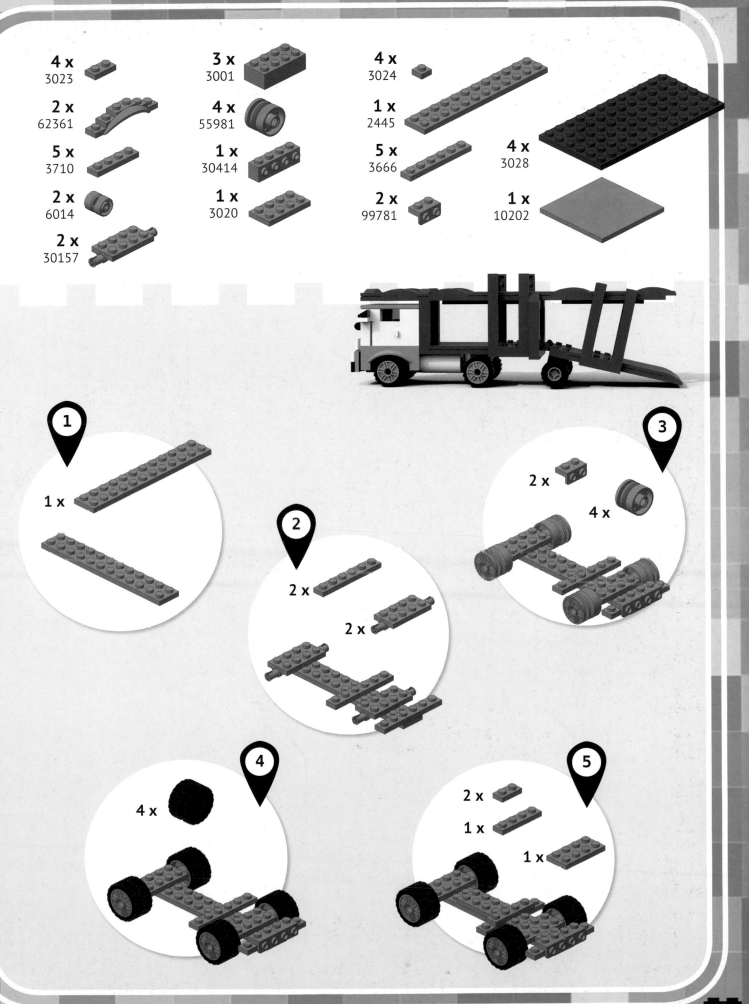

4 x 3023

3 x 3001

4 x 3024

2 x 62361

4 x 55981

1 x 2445

5 x 3710

1 x 30414

5 x 3666

4 x 3028

2 x 6014

1 x 3020

2 x 99781

1 x 10202

2 x 30157

1

1 x

2

2 x

2 x

3

2 x

4 x

4

4 x

5

2 x

1 x

1 x

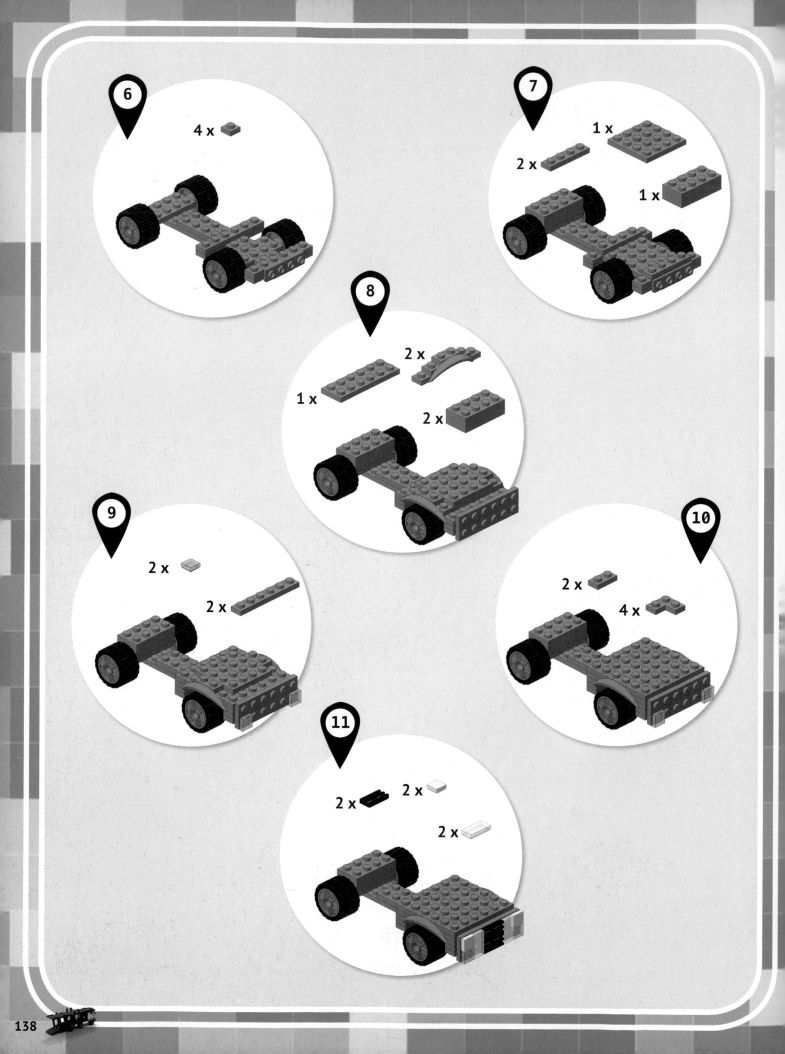

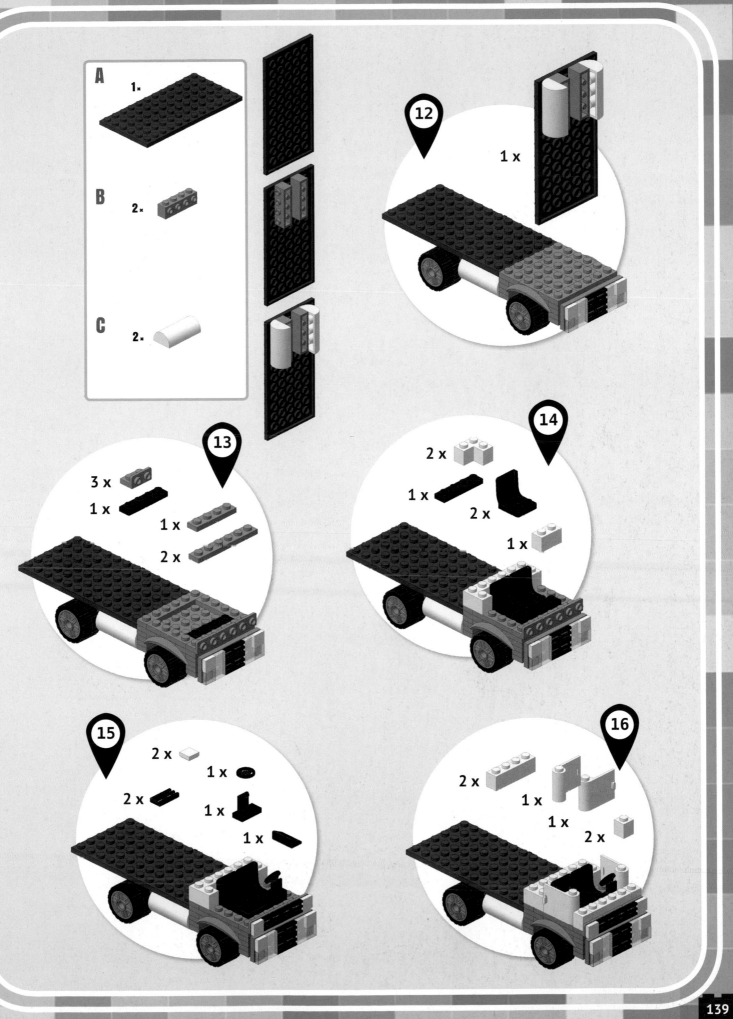

A 1×

B 2×

C 2×

12 1×

13 3× 1× 1× 2×

14 2× 1× 2× 1×

15 2× 1× 2× 1× 1×

16 2× 1× 1× 2×

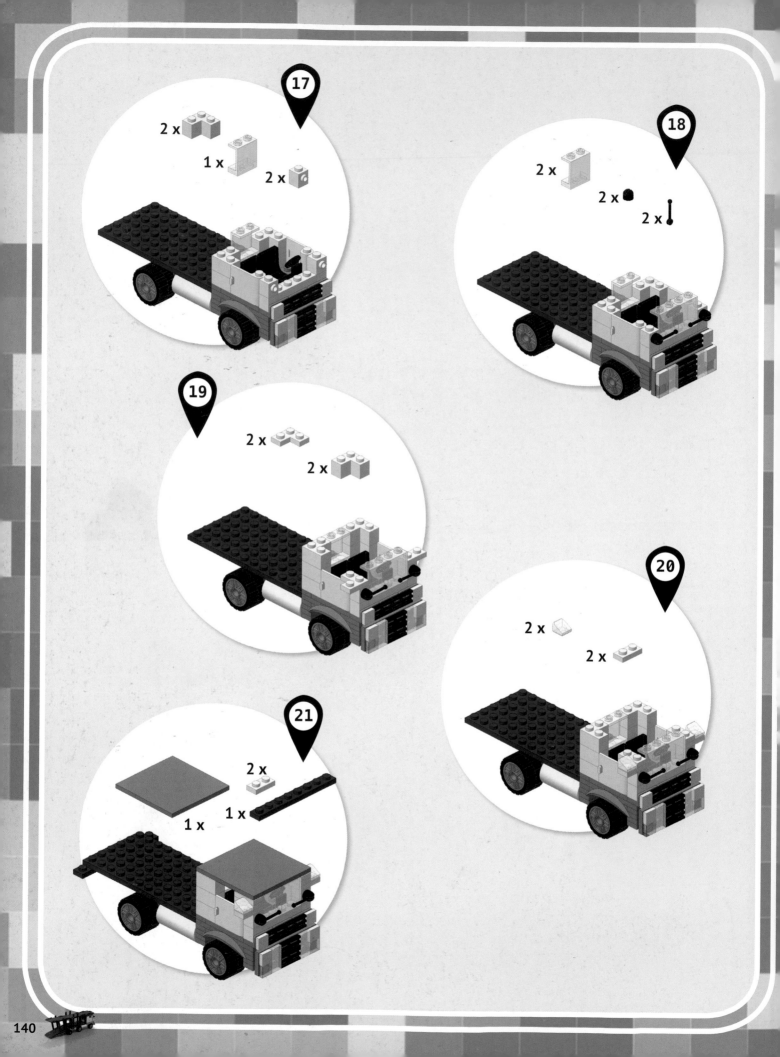

17

2 x

1 x

2 x

18

2 x

2 x

2 x

19

2 x

2 x

20

2 x

2 x

21

2 x

1 x

1 x

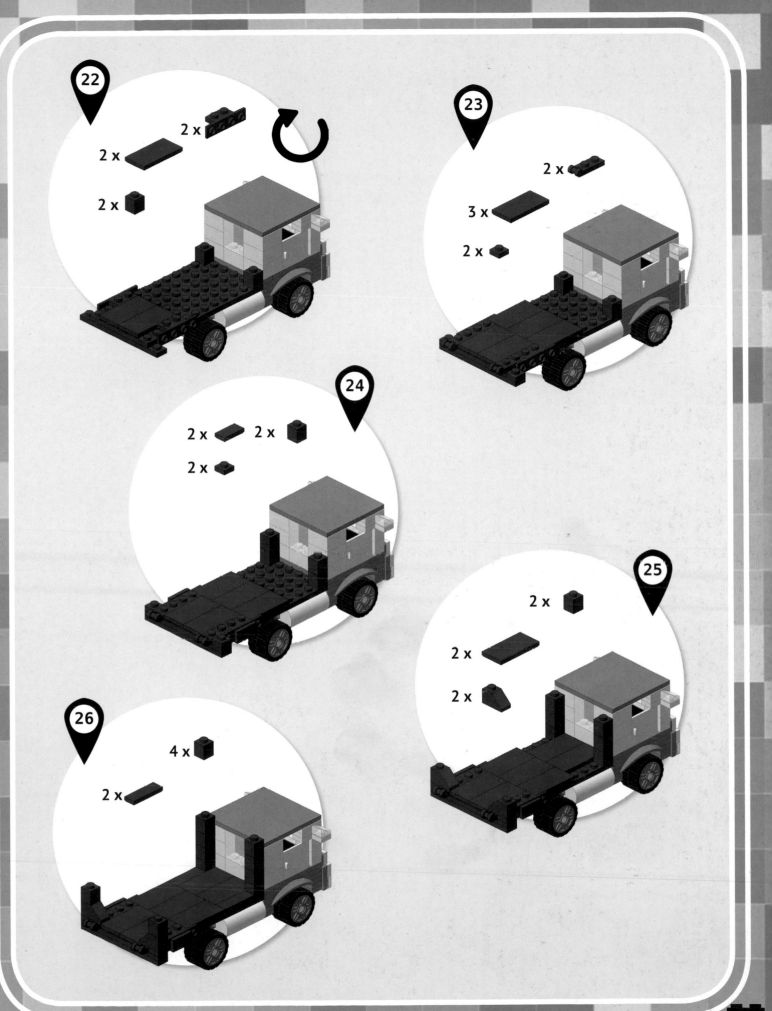

22

2 x

2 x

2 x

23

2 x

3 x

2 x

24

2 x 2 x

2 x

25

2 x

2 x

2 x

26

4 x

2 x

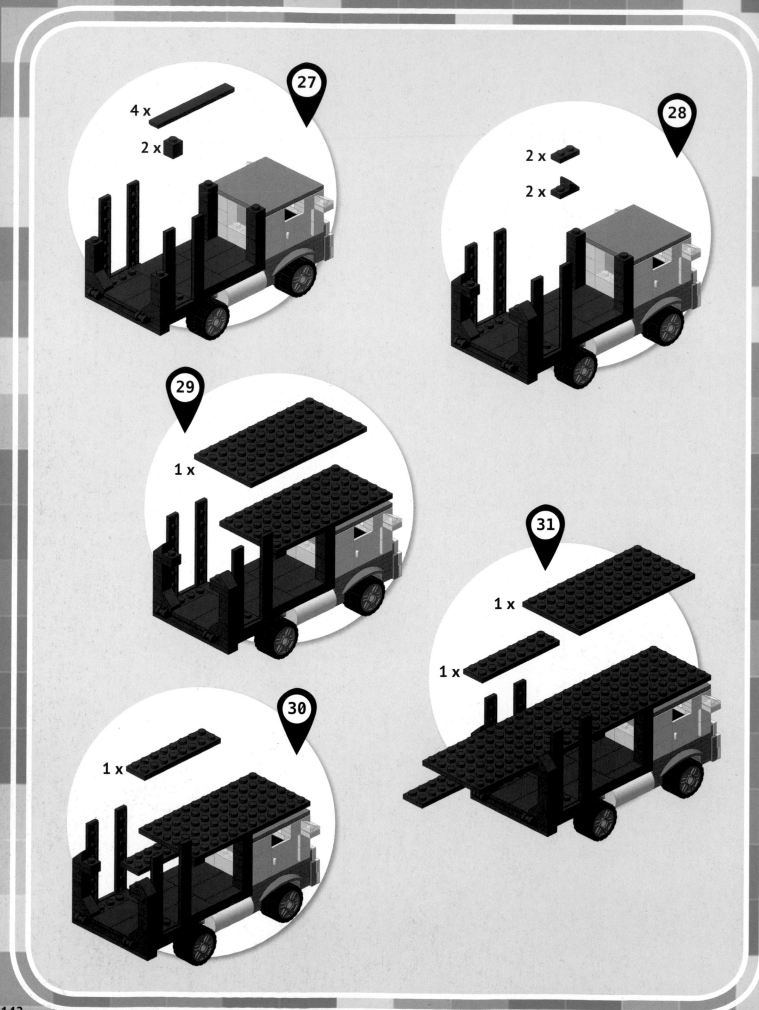

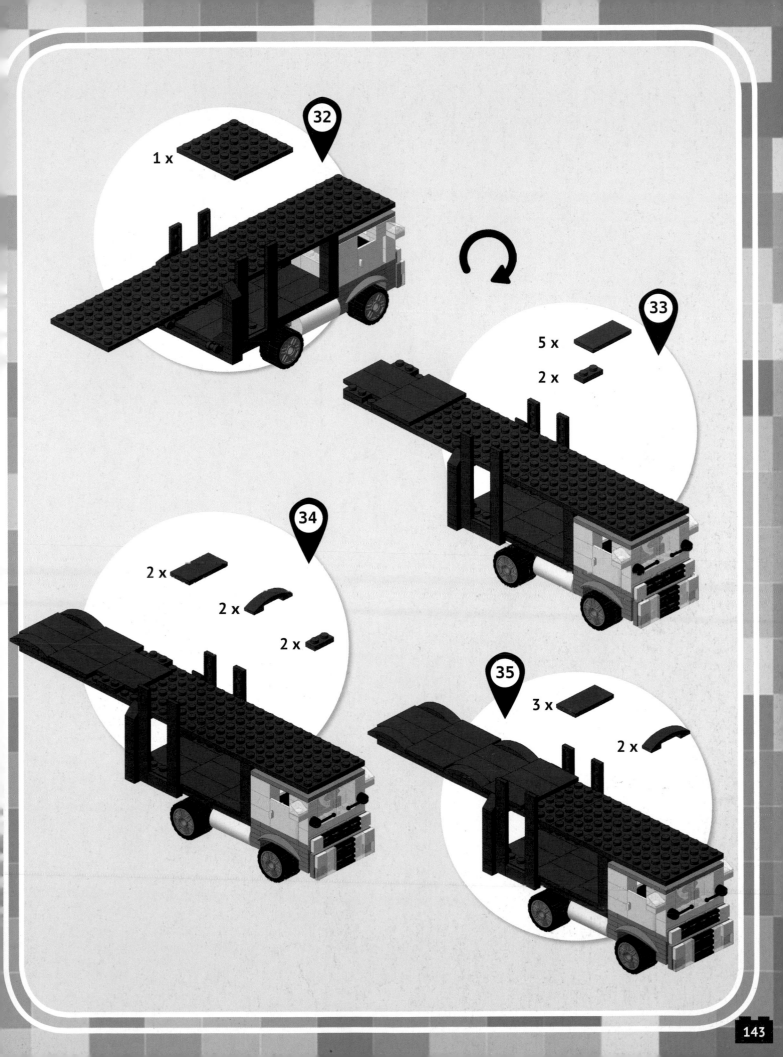

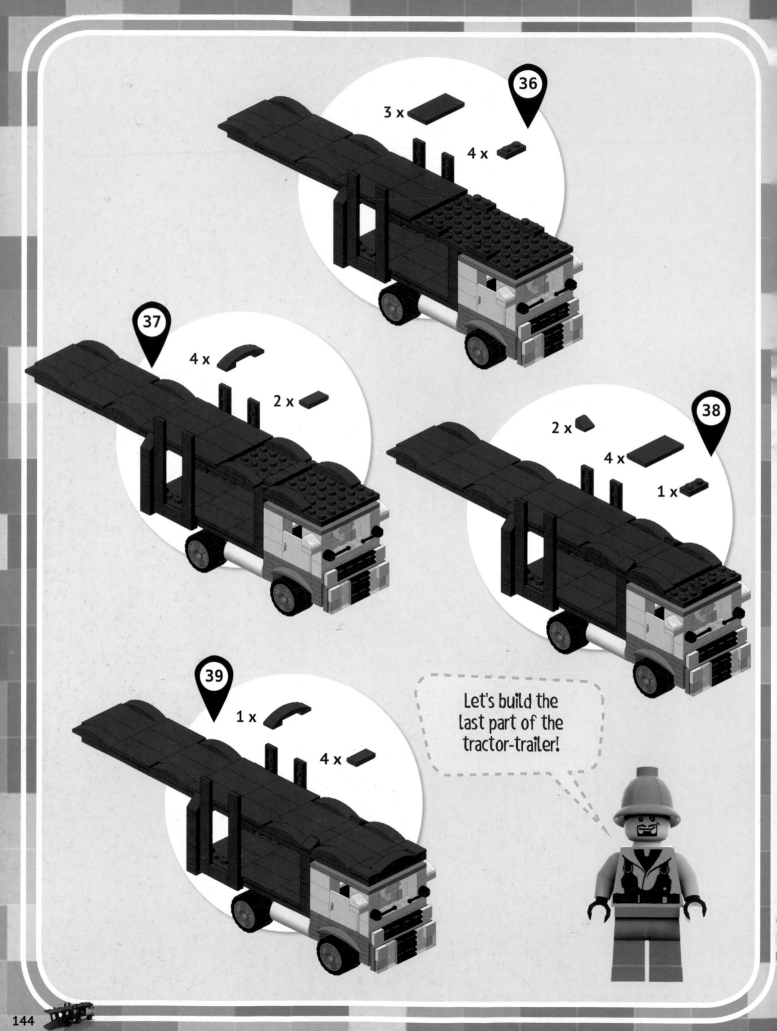

36

3 x

4 x

37

4 x

2 x

38

2 x

4 x

1 x

39

1 x

4 x

Let's build the
last part of the
tractor-trailer!

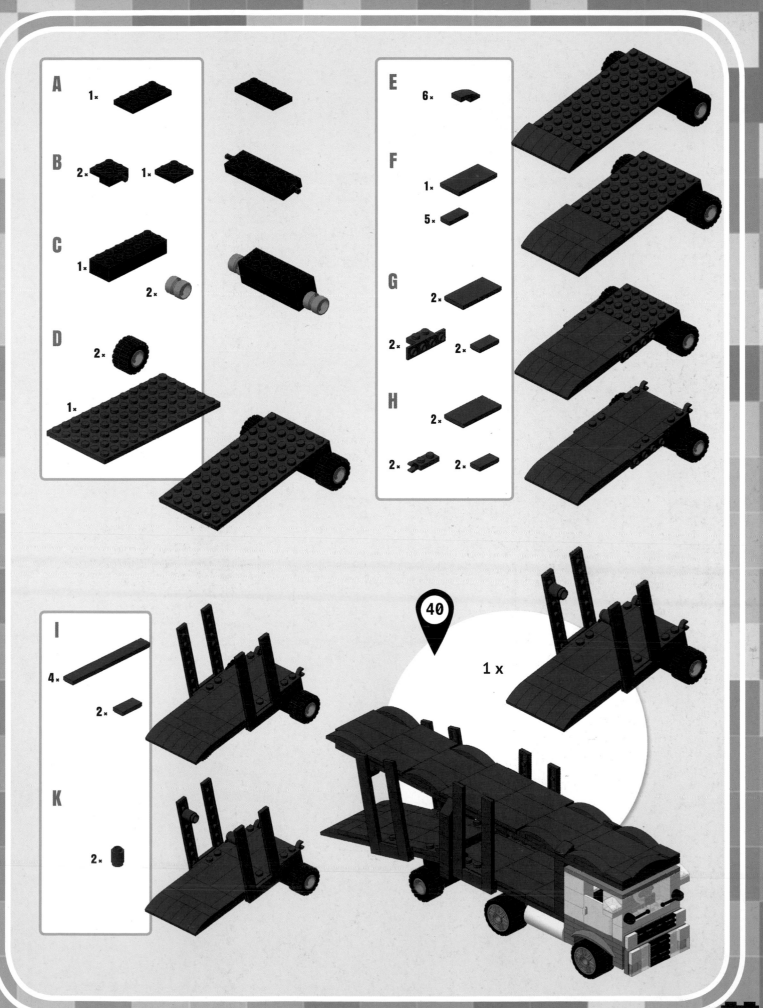

A 1×

B 2× 1×

C 1× 2×

D 2× 1×

E 6×

F 1× 5×

G 2× 2× 2×

H 2× 2× 2×

I 4× 2×

K 2×

40 1×

CEMENT MIXER

This vehicle for the construction industry is actually a cement-mixing machine mounted on a truck chassis. The cement mixer has a rotating drum that kneads and mixes the components of cement or concrete. To prevent the mixture from solidifying, the mixer rotates constantly.

The cement mixer is a real challenge, but you have to have one in your city!

Pieces required

2 x 3189	1 x 3034	5 x 3004	4 x 3068b	2 x 4592c03
1 x 3829c01	1 x 3001	1 x 3188	1 x 3069b	4 x 3022
3 x 3010	4 x 3666	1 x 3795	1 x 3031	3 x 3020
1 x 3937	4 x 54200	1 x 87081	2 x 6231	8 x 4488
2 x 50950	1 x 3022	2 x 3023	10 x 85984	1 x 64230
2 x 6134	3 x 30414	1 x 52031	1 x 3004	1 x 3937
6 x 2431	2 x 4150	3 x 11211	6 x 4865	1 x 2460
4 x 11477	1 x 2436	5 x 3032	2 x 3298	
4 x 4070	1 x 87079	4 x 3024	9 x 3034	
1 x 3009	1 x 3031	2 x 50950	2 x 3001	

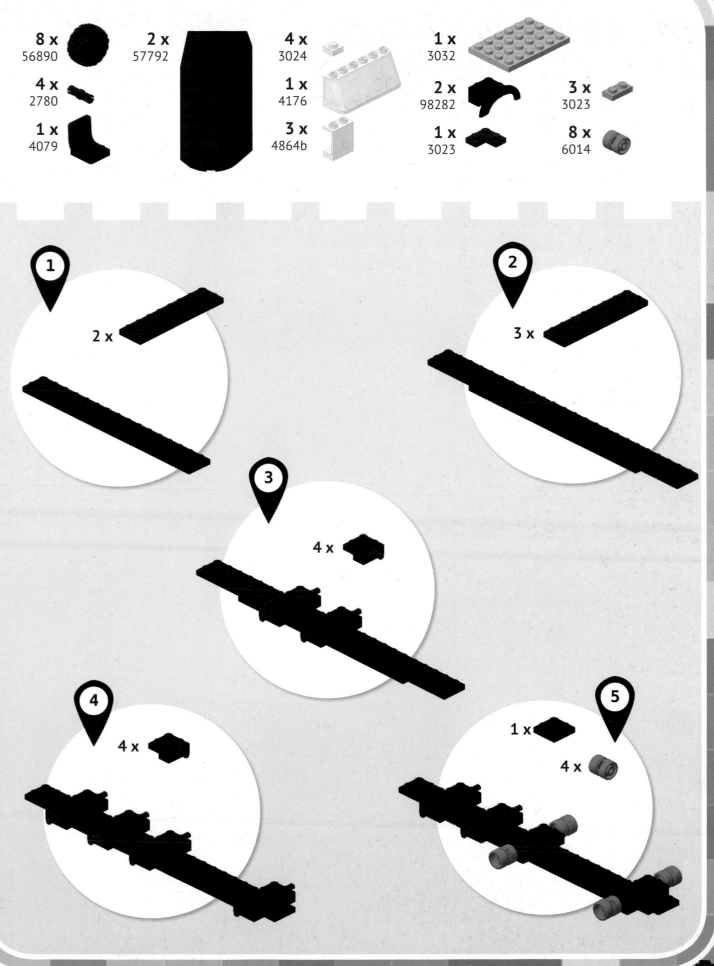

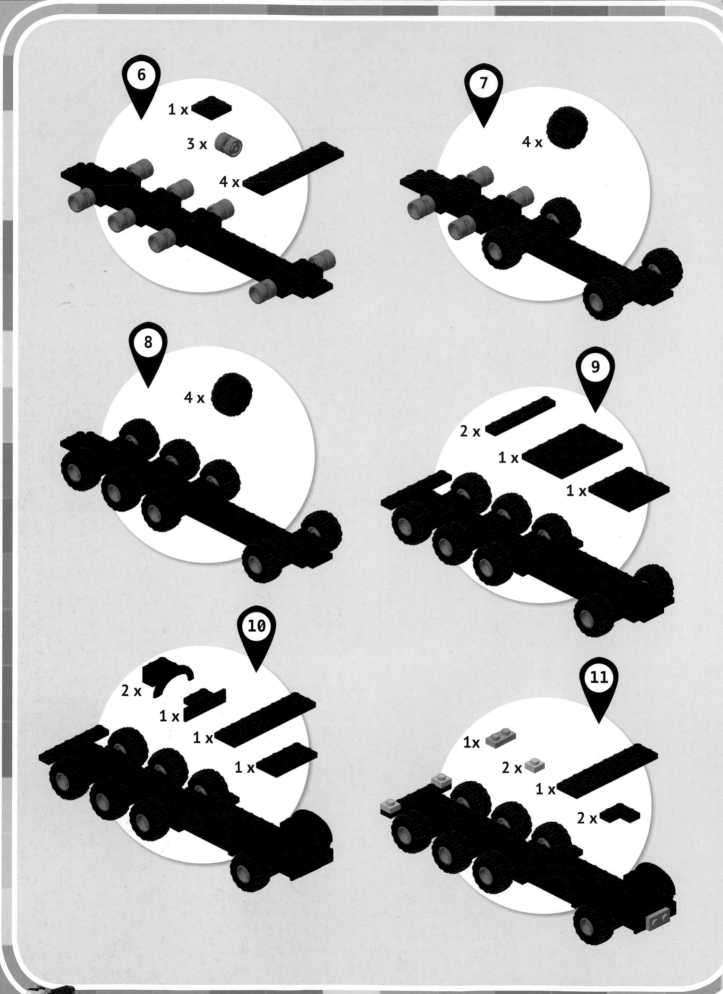

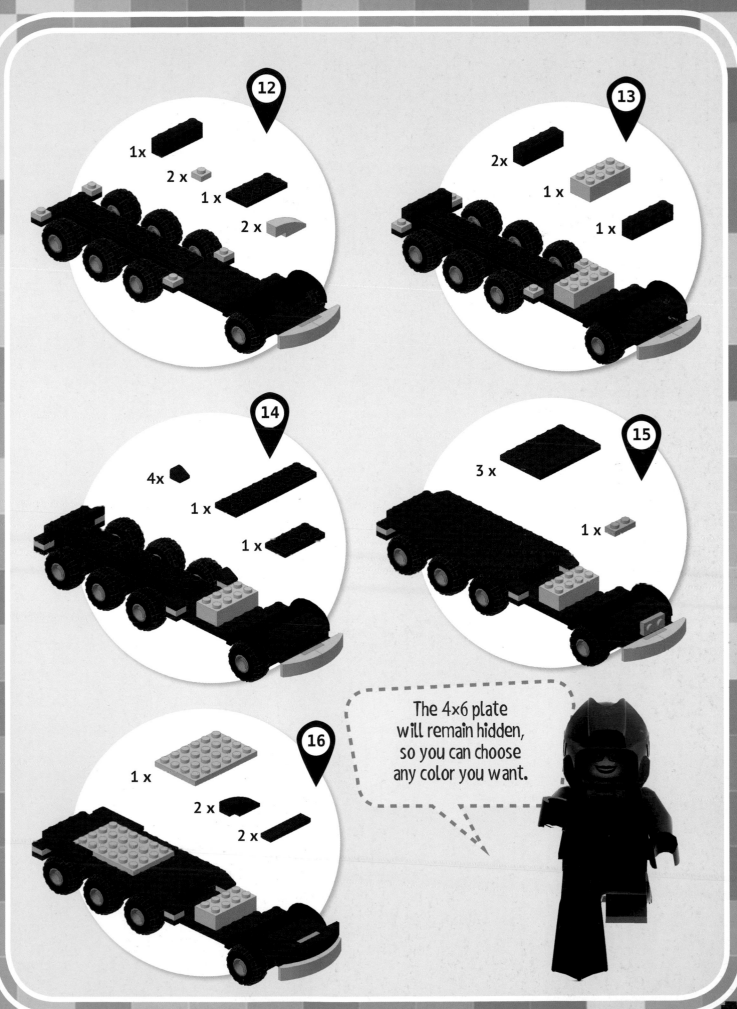

The 4×6 plate will remain hidden, so you can choose any color you want.

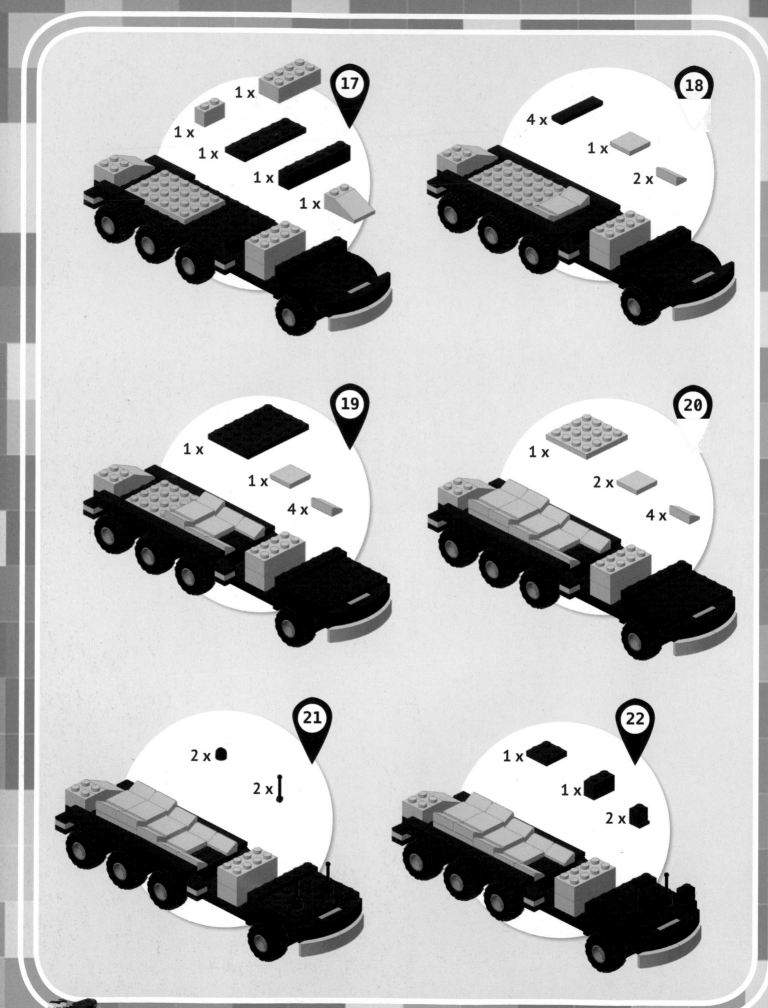

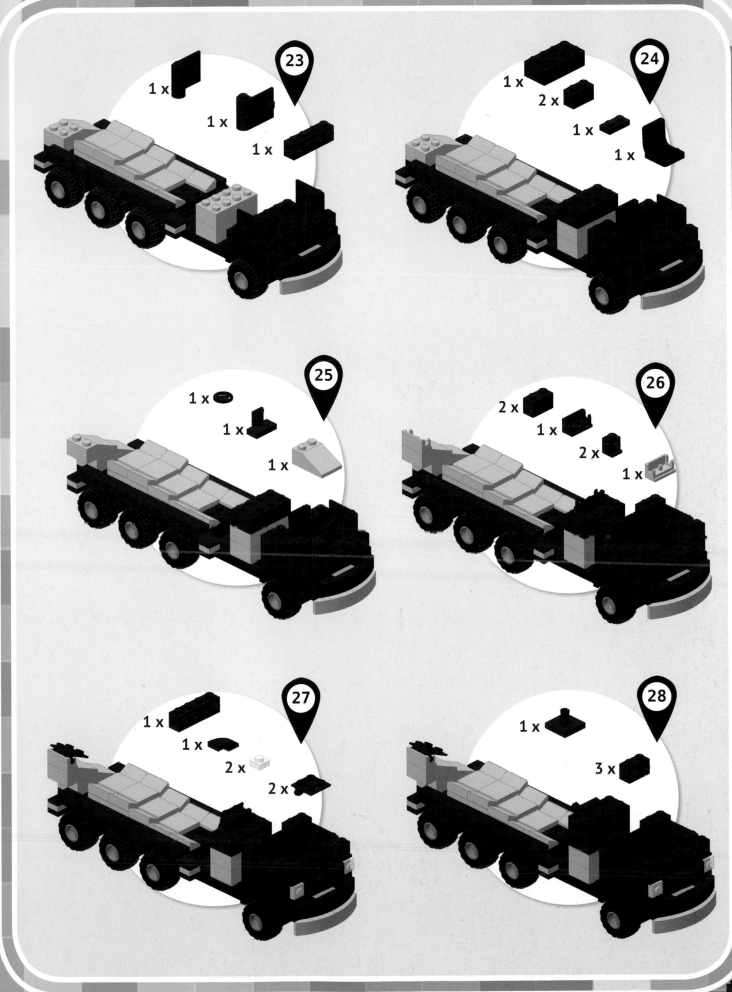

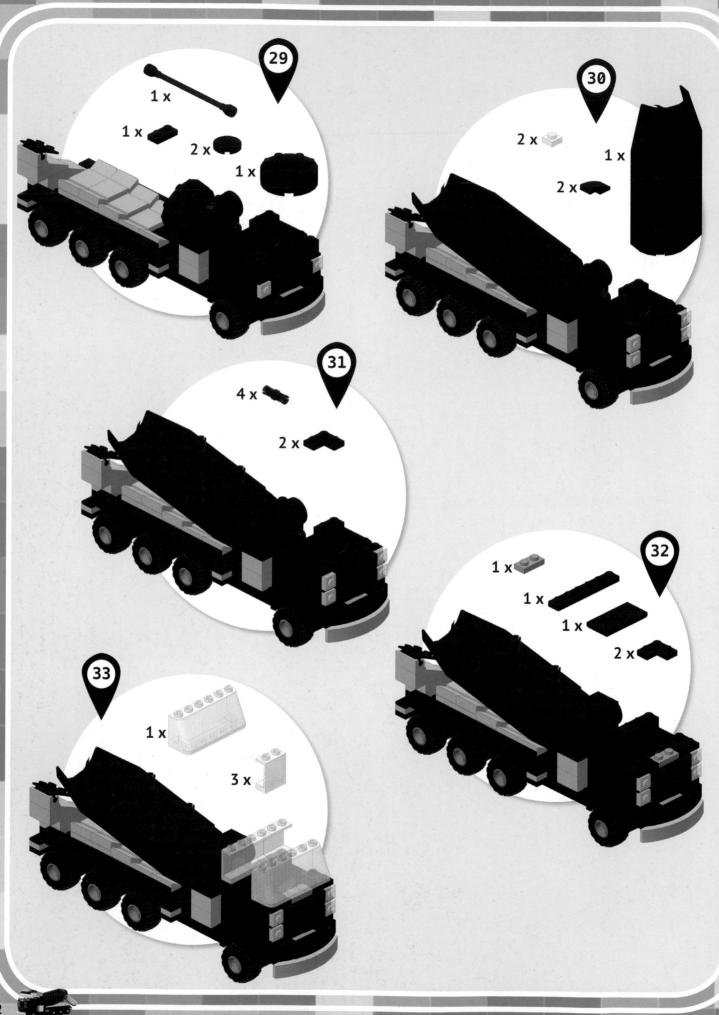

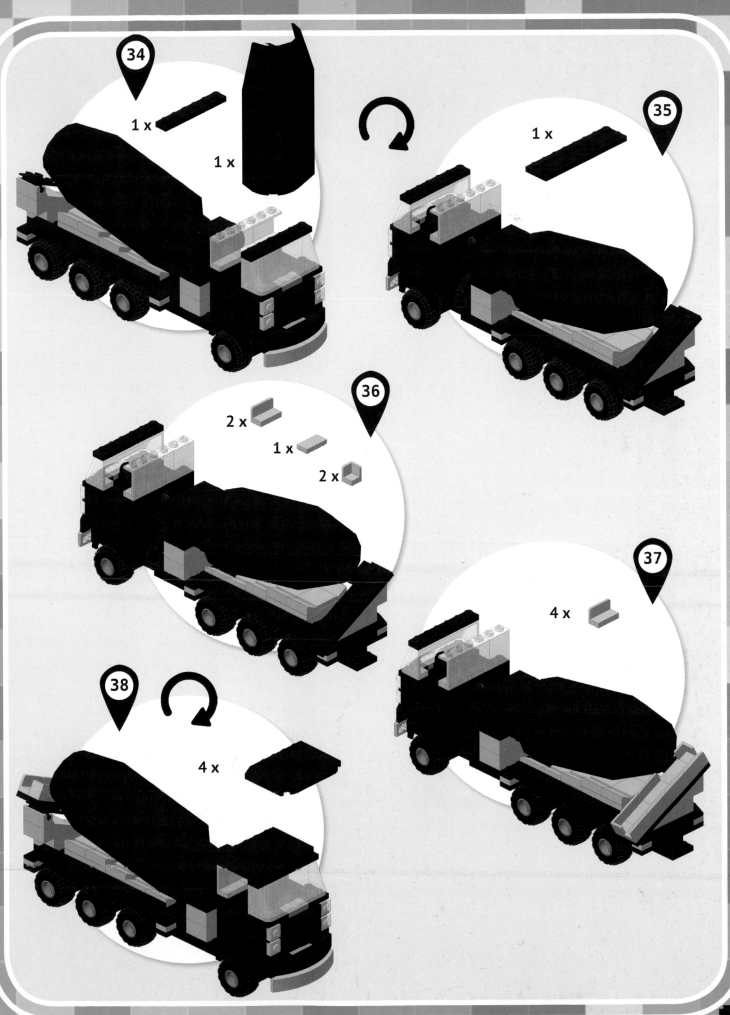

TANK TRUCK

This vehicle, composed of a cab and a trailer, generally transports liquids, contained in a big reservoir on top of the trailer. This model is very big and one of the most complicated that you'll find in the book, but once you've finished it, you'll have a real big rig to add to the parking lot in your city!

There's a delivery of milk or gasoline now arriving in the tank truck!

Pieces required

2 x 3069bpb125	1 x 3010	3 x 3020	2 x 2356	
80 x 50950	1 x 52031	2 x 3623	1 x 32523	10 x 4488
4 x 3660	2 x 2431	1 x 3747	10 x 6015	1 x 2436
1 x 3821	2 x 3005	1 x 3937	1 x 3938	2 x 50745
8 x 3623	10 x 3023	5 x 3710	2 x 2460	3 x 3035
2 x 3710	4 x 6091	3 x 3003	1 x 3795	1 x 3031
46 x 11477	6 x 3004	4 x 11477	1 x 3034	2 x 3832
1 x 3822	2 x 3003	14 x 87087	2 x 3005	2 x 2420
1 x 2456	2 x 3040	30 x 3004	2 x 3666	1 x 4210
2 x 3070b	1 x 3069b	2 x 3070b	9 x 3794	8 x 3023
2 x 54200	2 x 3024	1 x 2476a	2 x 4079	
1 x 30414	1 x 4209	1 x 2456	2 x 3022	

20 x
93274

4 x
3029

1 x
92583

1 x
2445

2 x
54200

2 x
54200

2 x
4864b

1 x
15068

1 x
30663

3 x
3010

10 x
6014

6 x
2412a

2 x
3070b

2 x
3070b

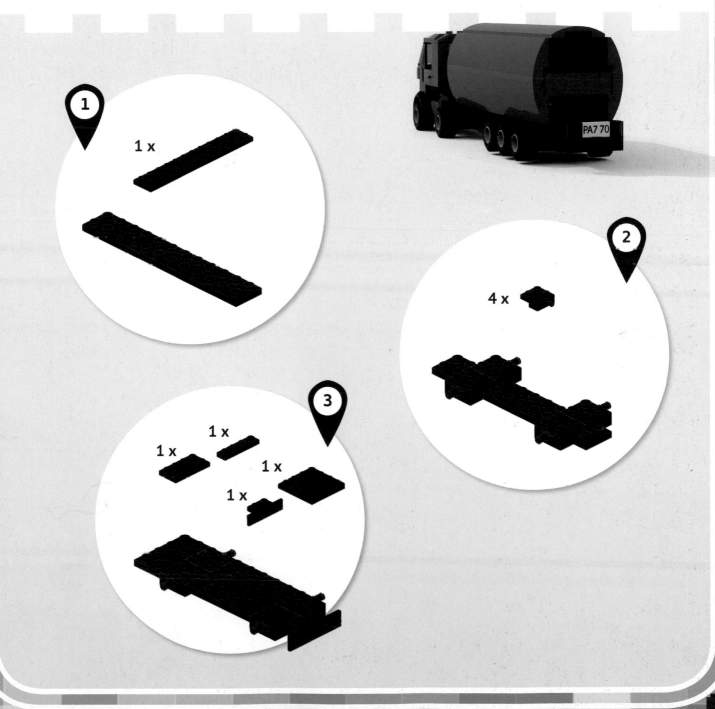

1
1 x

2
4 x

3
1 x
1 x
1 x
1 x

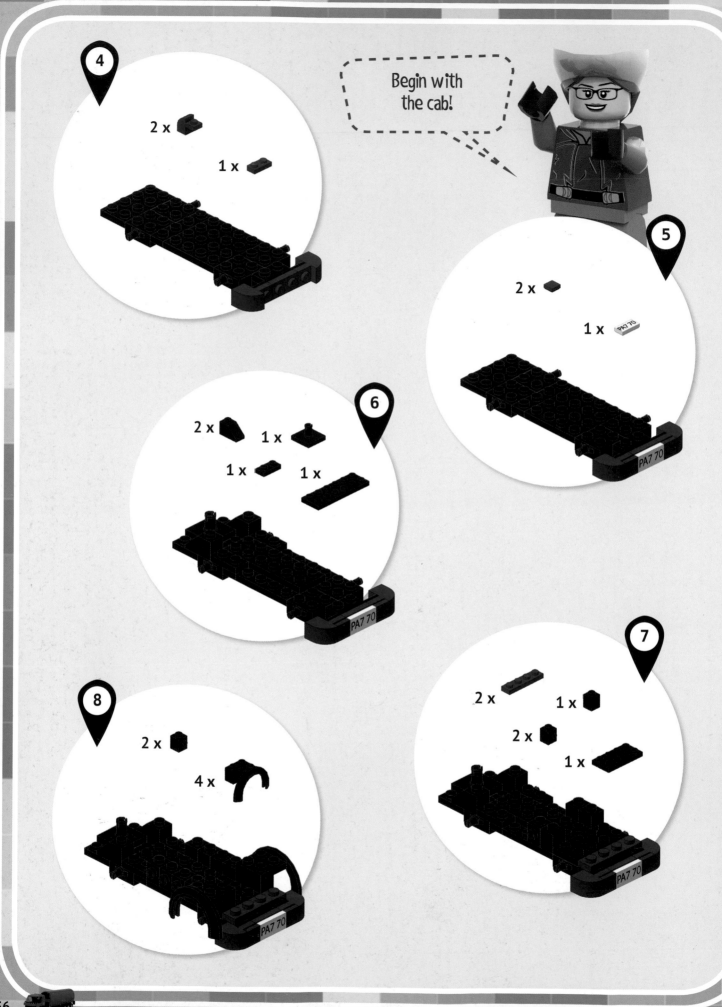

Begin with the cab!

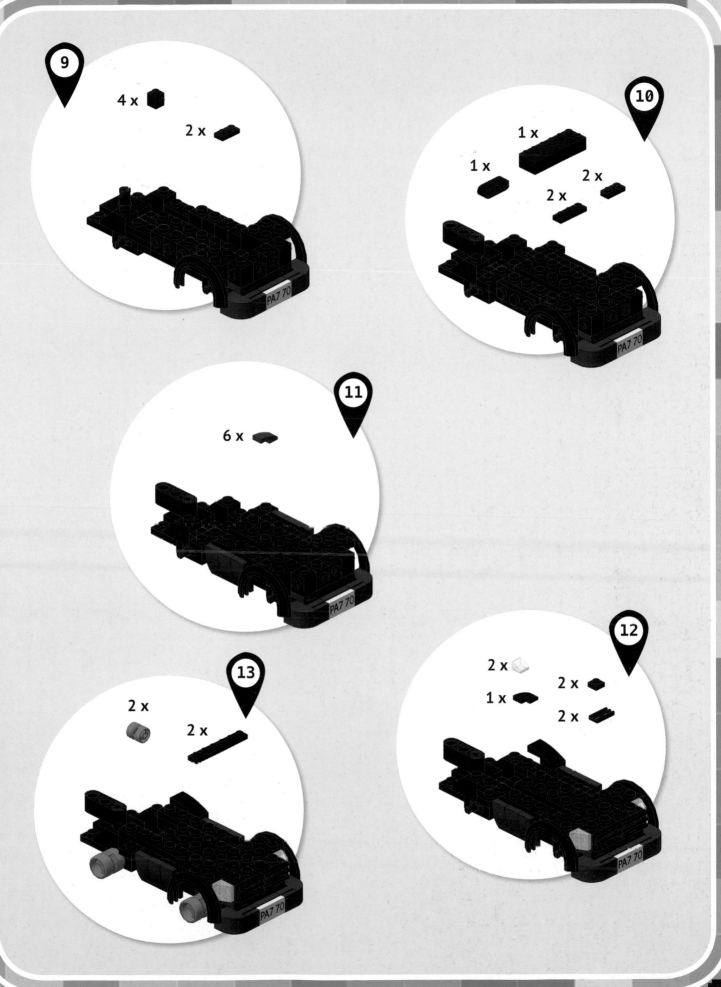

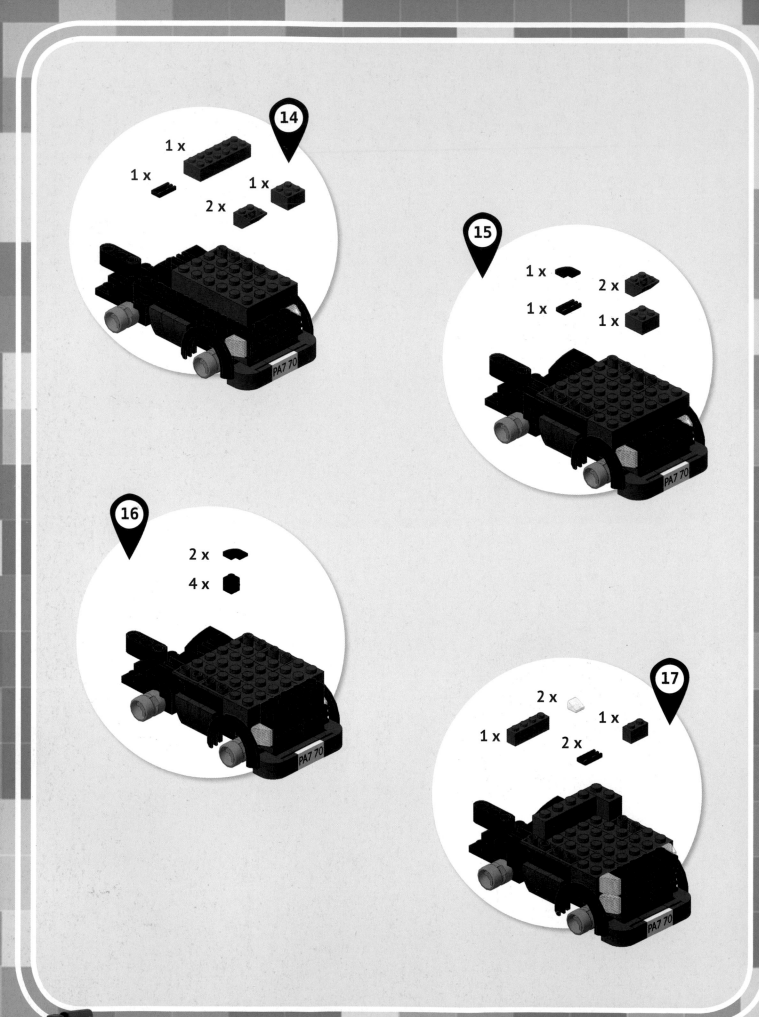

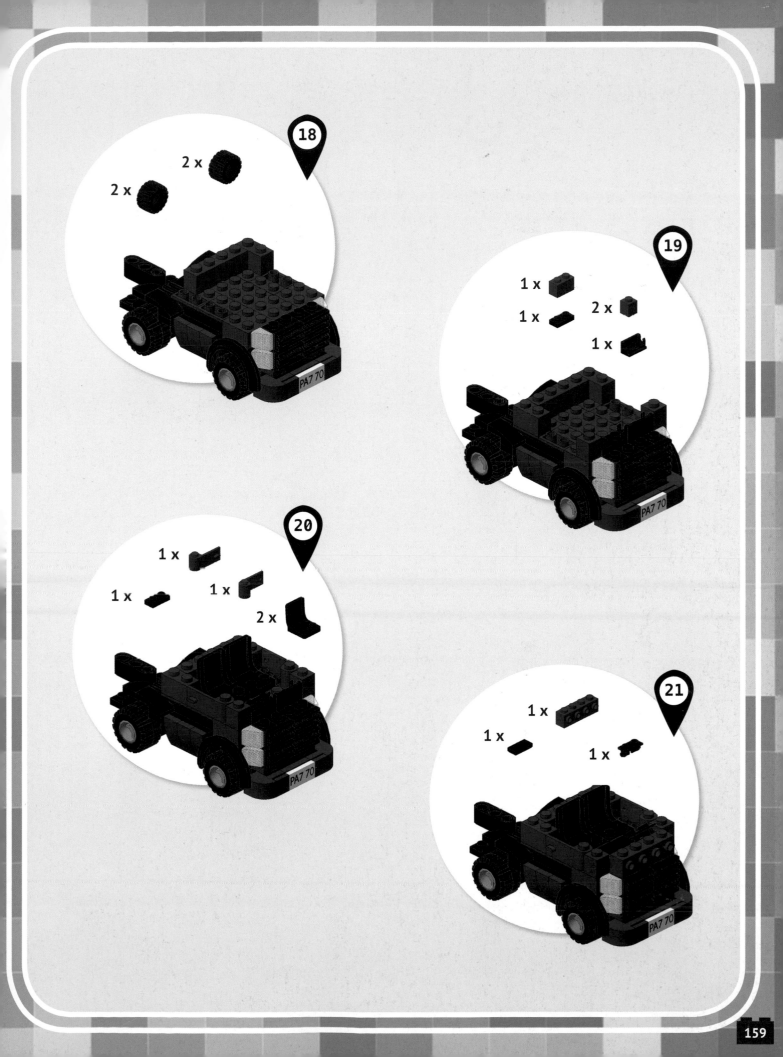

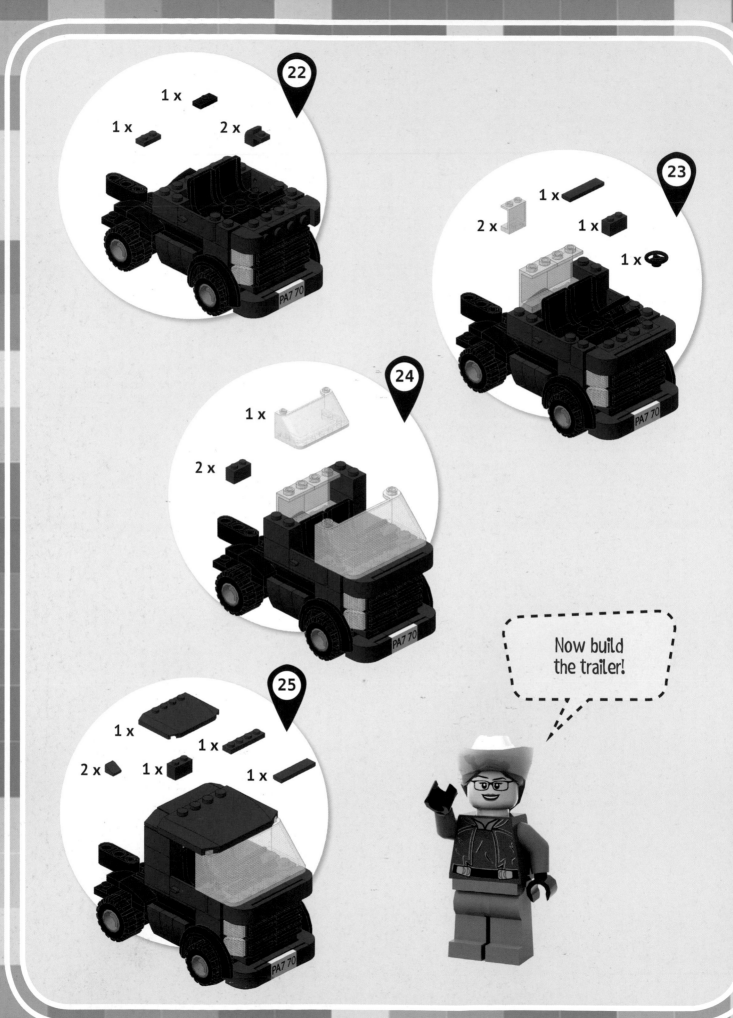

Now build
the trailer!

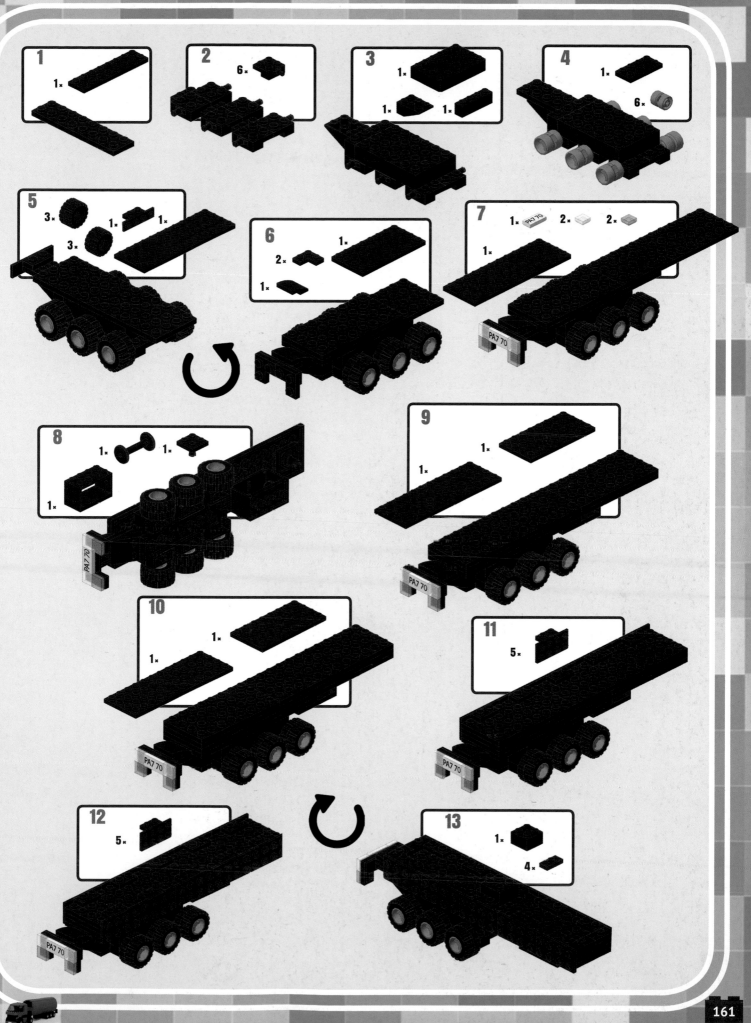

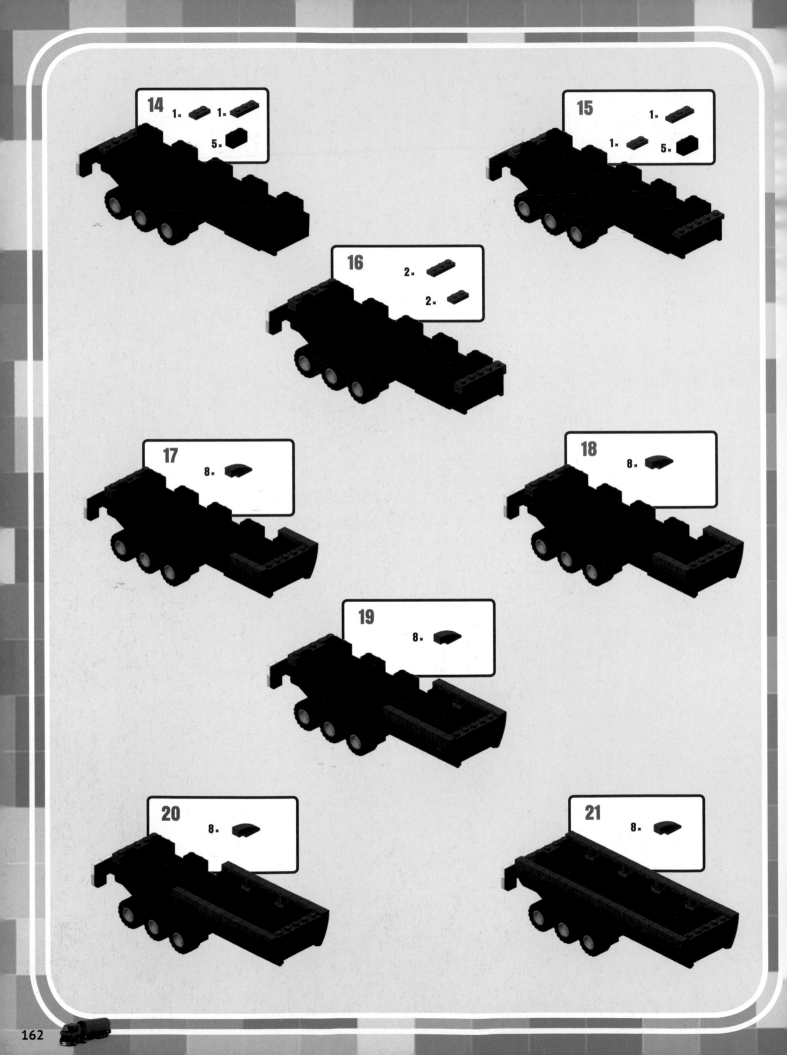

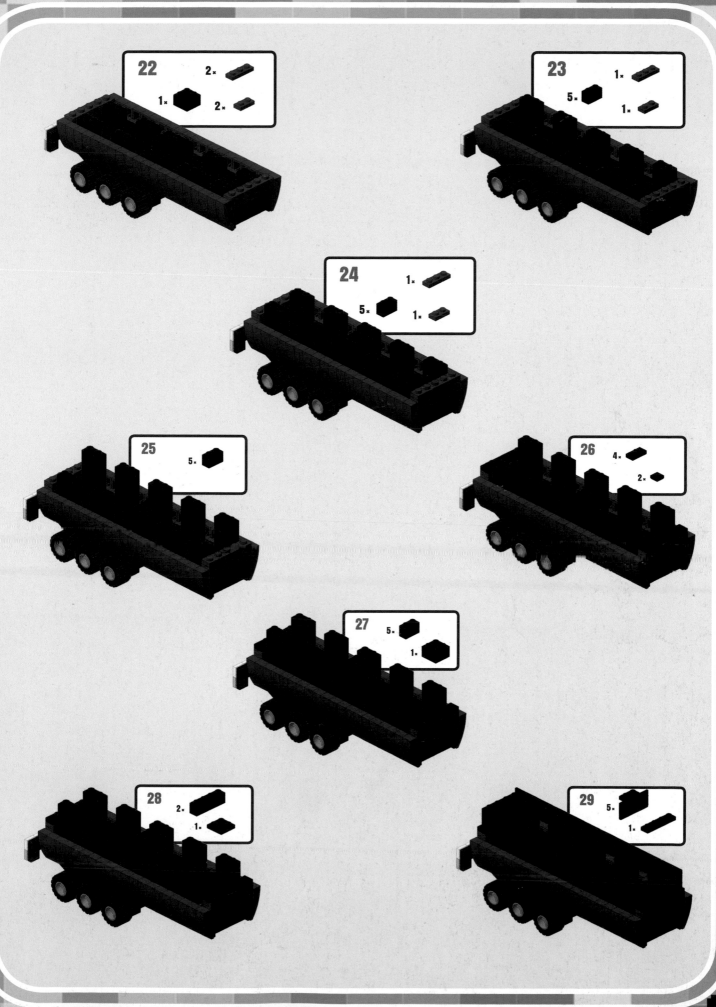

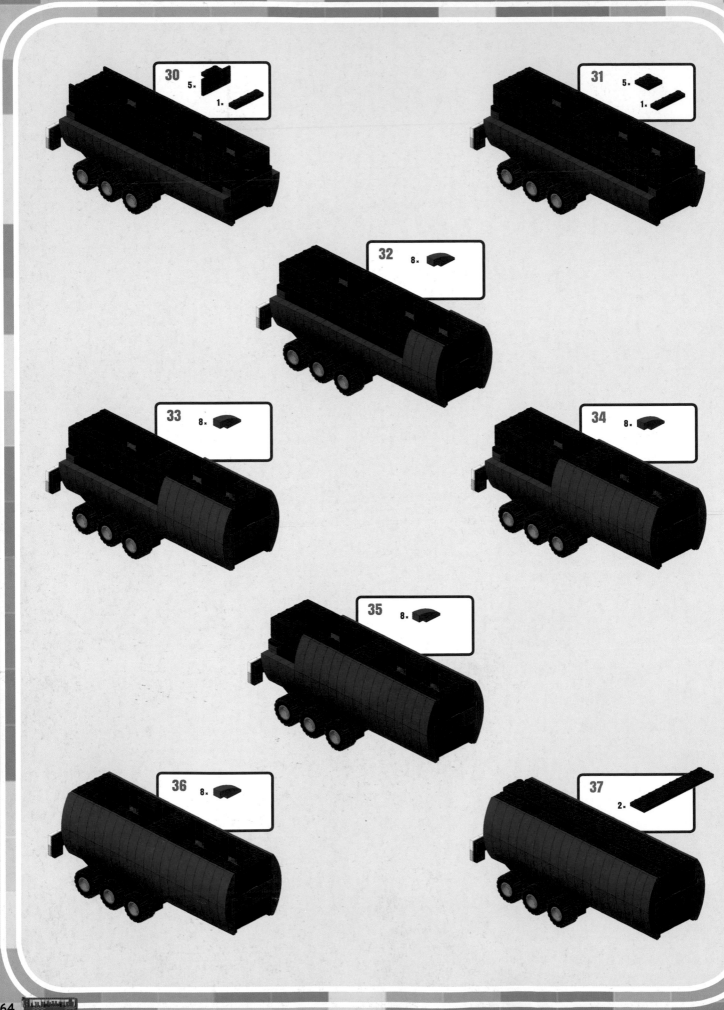

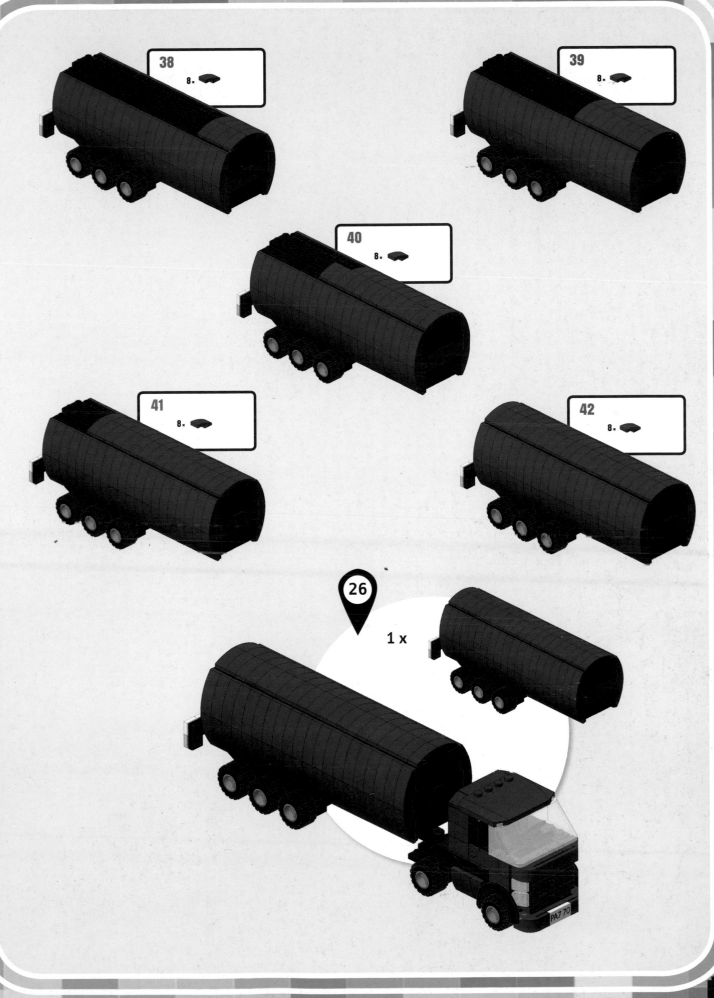

38 8×

39 8×

40 8×

41 8×

42 8×

26 1 x

PA7 70

FIRE TRUCK

Oh, no! A house is on fire and we need the firefighters! They're certainly not arriving on foot.... They need to come in their truck, a fast vehicle with a thousand uses. It has hatchets, extinguishers, a siren, a rotating, extendable ladder ... everything they need to fight fires.

You can add a hose to your truck to make it even more realistic!

Pieces required

1 x 3710	1 x 3020	2 x 3062b	1 x 3245a
1 x 3069bpb125	1 x 3623	13 x 3010	2 x 4599
3 x 44728	1 x 3189	7 x 3710	1 x 3001
2 x 99781	40 x 3024	8 x 11477	4 x 2357
2 x 99780	4 x 3070b	3 x 2431	2 x 3666
2 x 6636	1 x 4209	1 x 93273	2 x 54200
2 x 85861	2 x 3020	6 x 3005	2 x 3022
4 x 4073	2 x 3660	1 x 3021	8 x 63868
4 x 3069b	2 x 15573	2 x 4070	2 x 30414
2 x 3024	3 x 6154	18 x 87087	6 x 60478

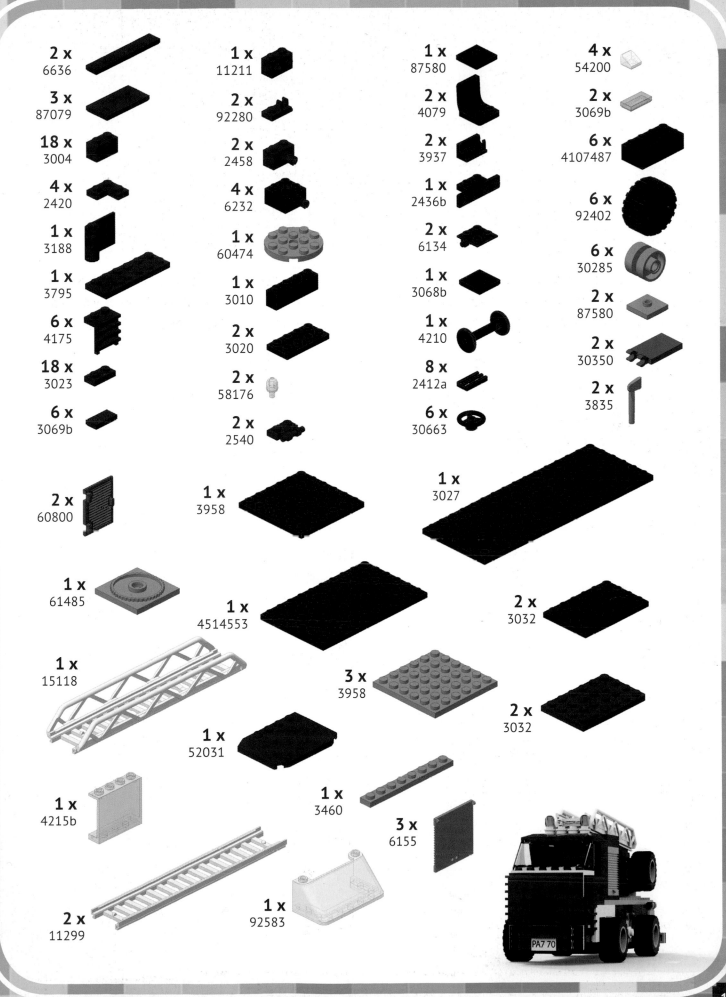

2 x 6636

3 x 87079

18 x 3004

4 x 2420

1 x 3188

1 x 3795

6 x 4175

18 x 3023

6 x 3069b

1 x 11211

2 x 92280

2 x 2458

4 x 6232

1 x 60474

1 x 3010

2 x 3020

2 x 58176

2 x 2540

1 x 87580

2 x 4079

2 x 3937

1 x 2436b

2 x 6134

1 x 3068b

1 x 4210

8 x 2412a

6 x 30663

4 x 54200

2 x 3069b

6 x 4107487

6 x 92402

6 x 30285

2 x 87580

2 x 30350

2 x 3835

2 x 60800

1 x 3958

1 x 3027

1 x 61485

1 x 4514553

2 x 3032

1 x 15118

3 x 3958

1 x 52031

2 x 3032

1 x 4215b

1 x 3460

3 x 6155

2 x 11299

1 x 92583

PA7 70

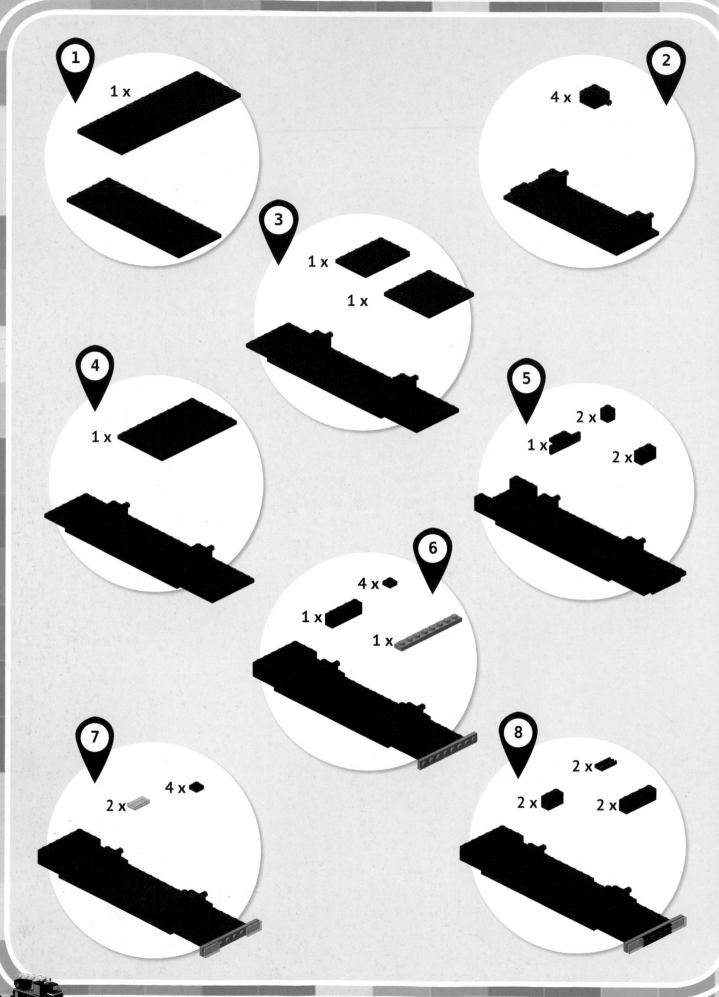

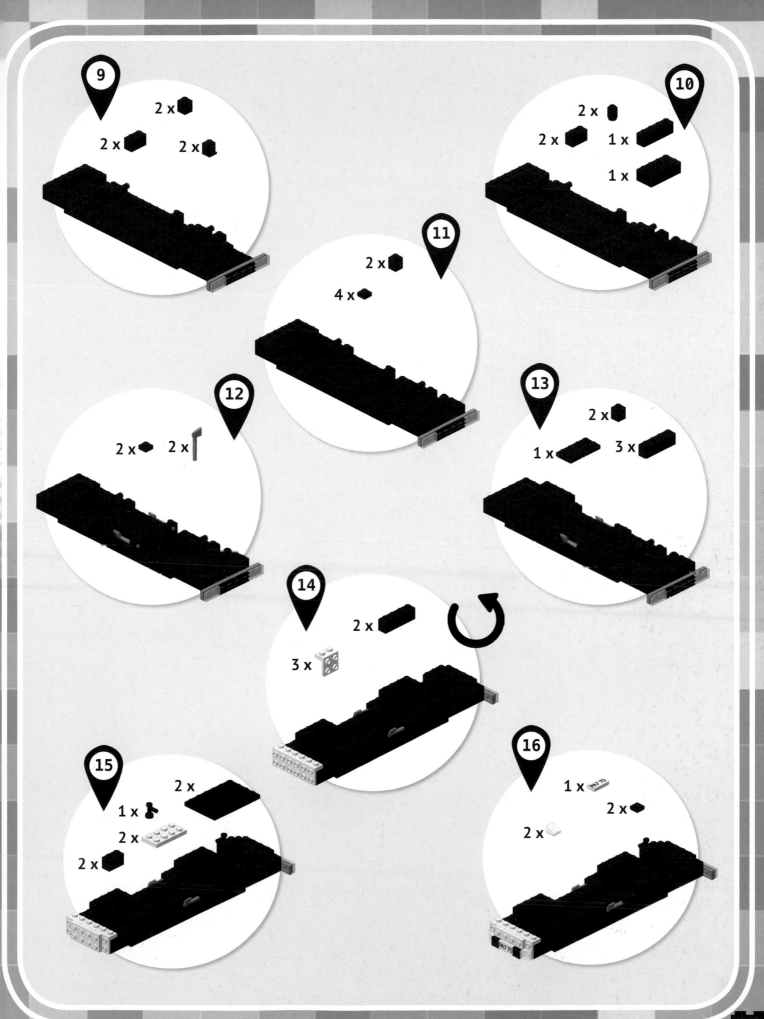

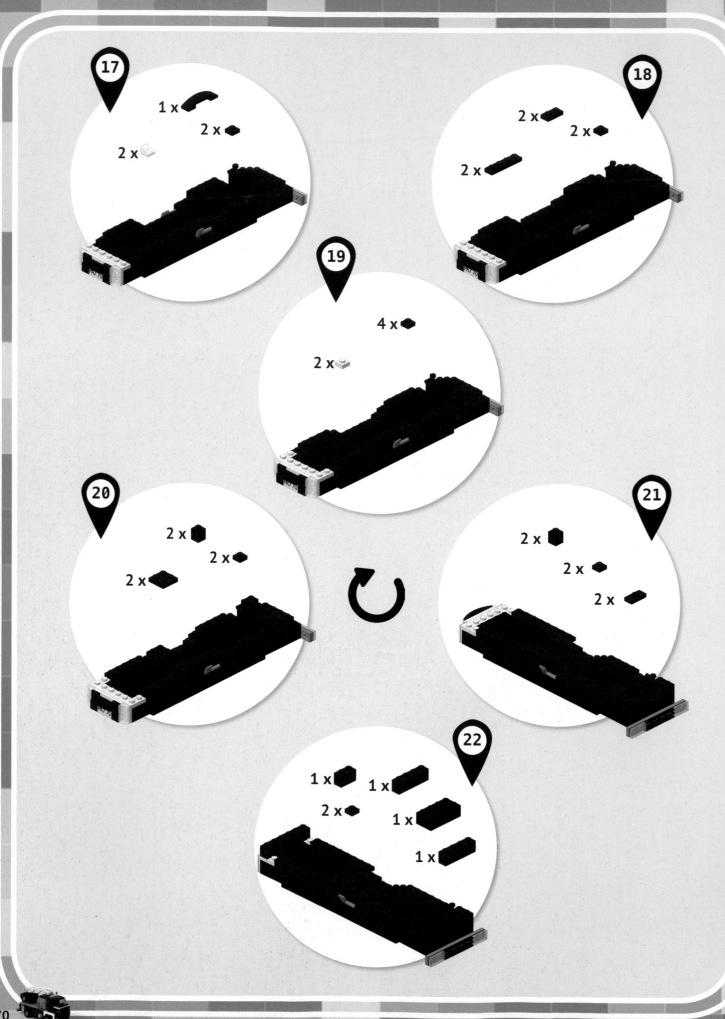

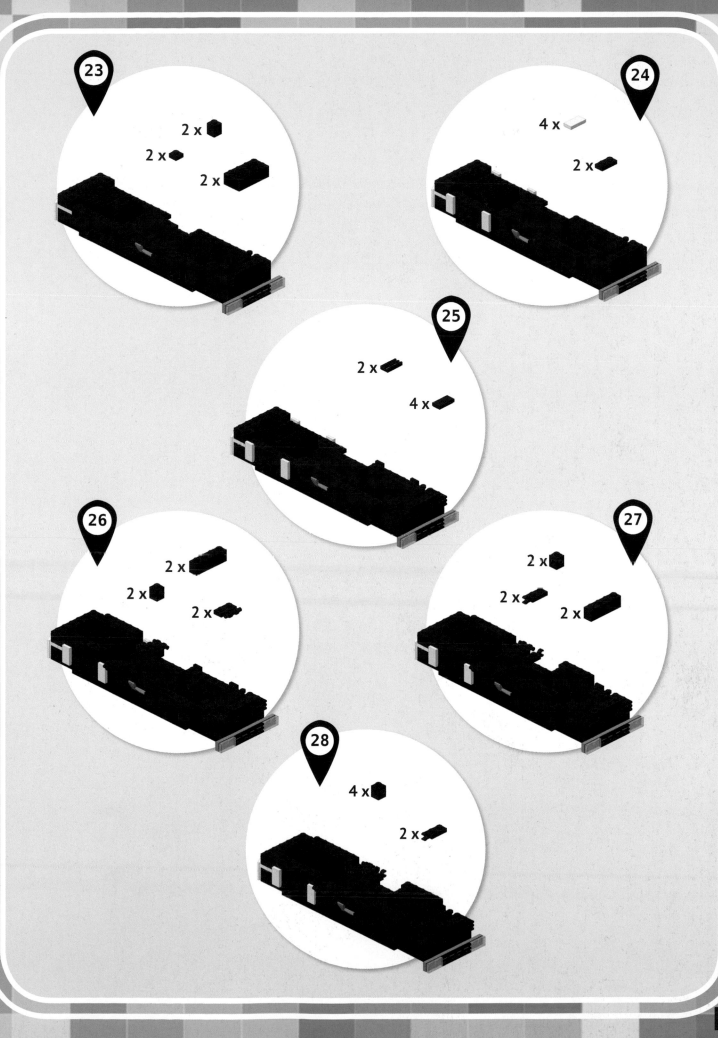

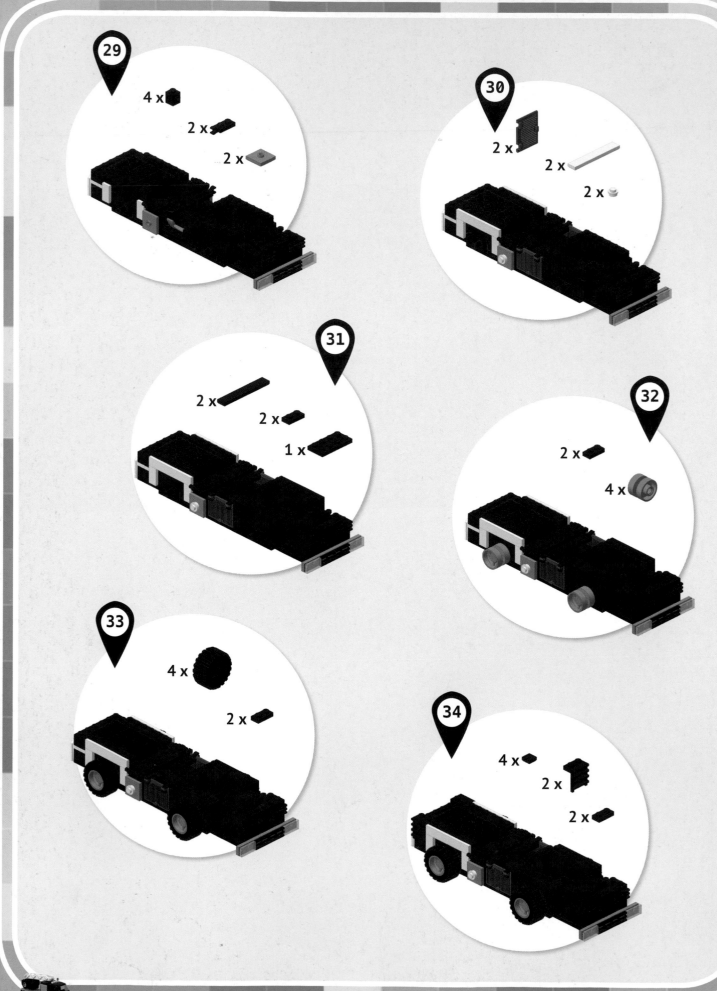

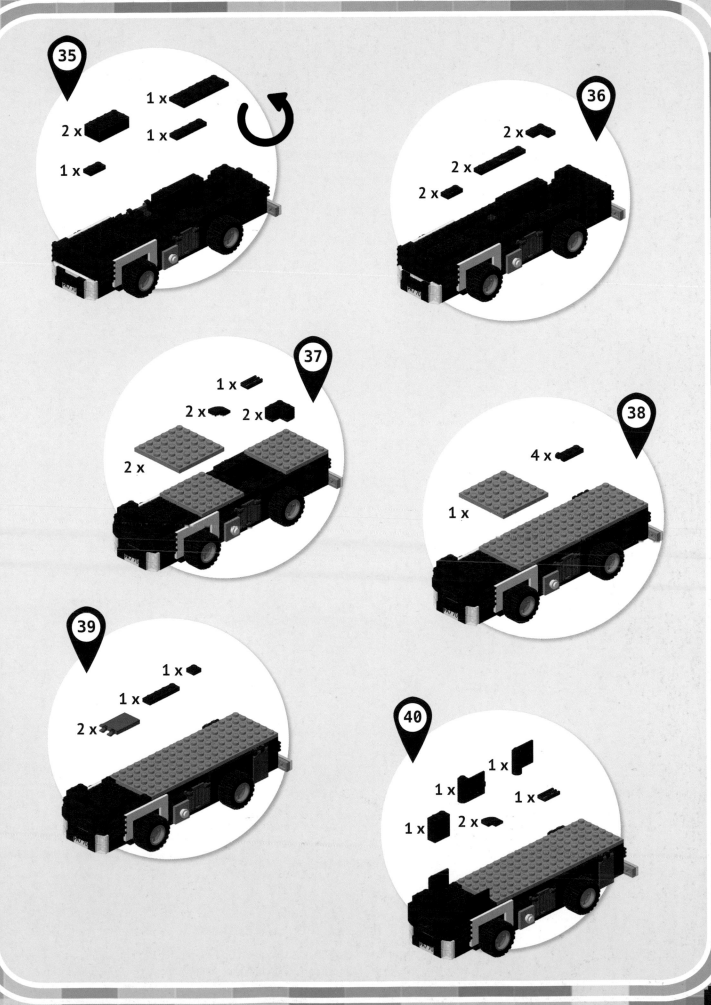

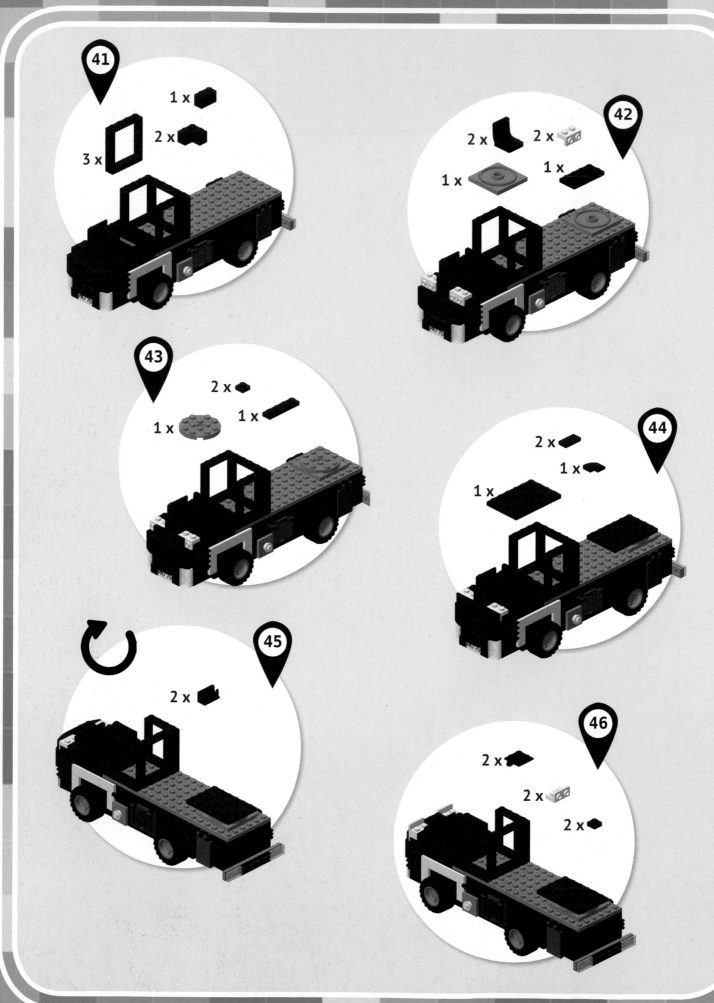

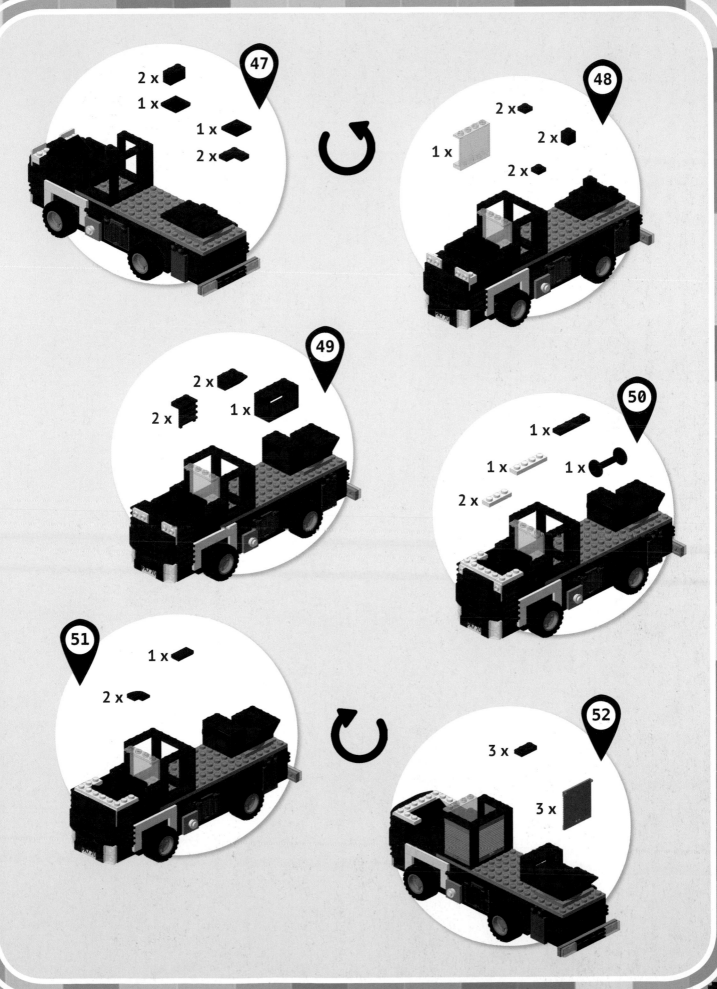

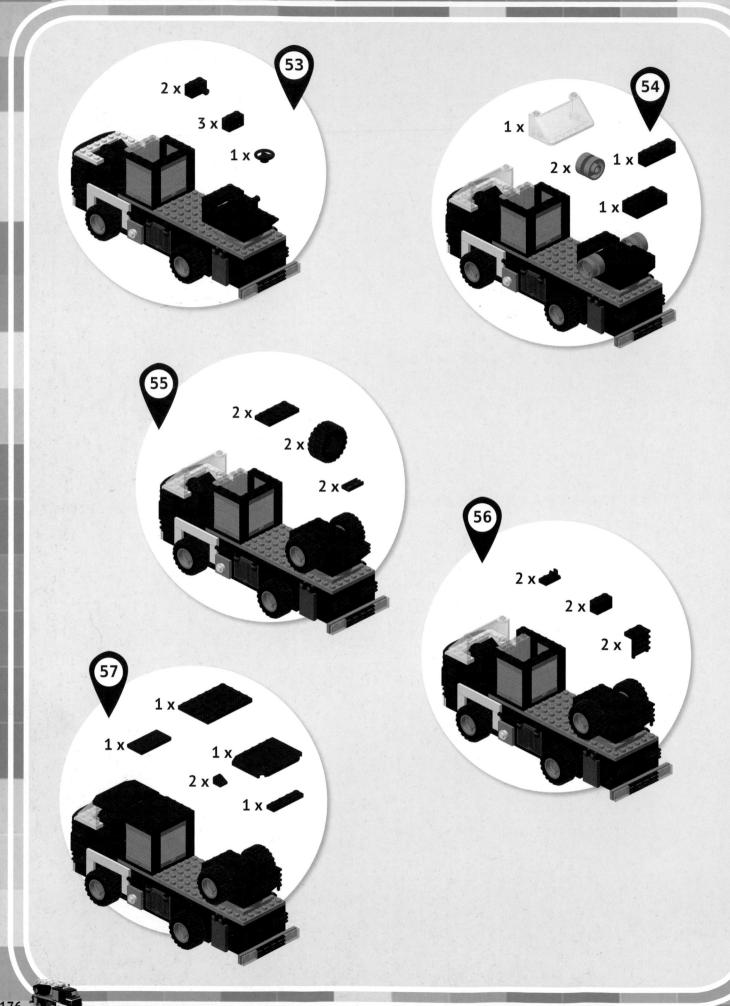

53

2 x

3 x

1 x

54

1 x

2 x

1 x

1 x

55

2 x

2 x

2 x

56

2 x

2 x

2 x

57

1 x

1 x

1 x

1 x

2 x

1 x

58

2 x

59

1 x

2 x

60

1 x

3 x

The ladder extends
and rotates.

62

1 x

2 x

61

1 x

2 x

TRAM

A tram is a useful form of public transportation that runs on tracks. It's a little like a train, but it's used only inside the city. It's ecological and fast, basically a subway that moves on the surface. The model here is a modern one. At one time, trams were very different from today's, and they were not always joined together.

You can move the joints, open the doors, or take out the passengers. Do whatever you like!

Pieces required

3 x 3464	4 x 3068b	2 x 3795	16 x 3005
2 x 3032	8 x 3004	8 x 3023	1 x 3464
2 x 30350	24 x 6636	4 x 63864	16 x 54200
32 x 3005	4 x 3010	1 x 30383	4 x 87552
48 x 3024	4 x 6019	4 x 4592c03	24 x 2431
8 x 50950	6 x 3069b	2 x 44302	2 x 3710
8 x 2921	6 x 3666	1 x 2881	2 x 63082
14 x 3710	4 x 3794	6 x 4079	8 x 11477
4 x 2429c01	5 x 3022	1 x 92582	2 x 3731
68 x 87087	4 x 3070b	1 x 44301	30 x 44728
12 x 11477	4 x 2453	2 x 3028	
2 x 3958			

2 x 11289
1 x 3032
6 x 3666
4 x 2415
8 x 3024
14 x 87079
2 x 3020
4 x 3068b

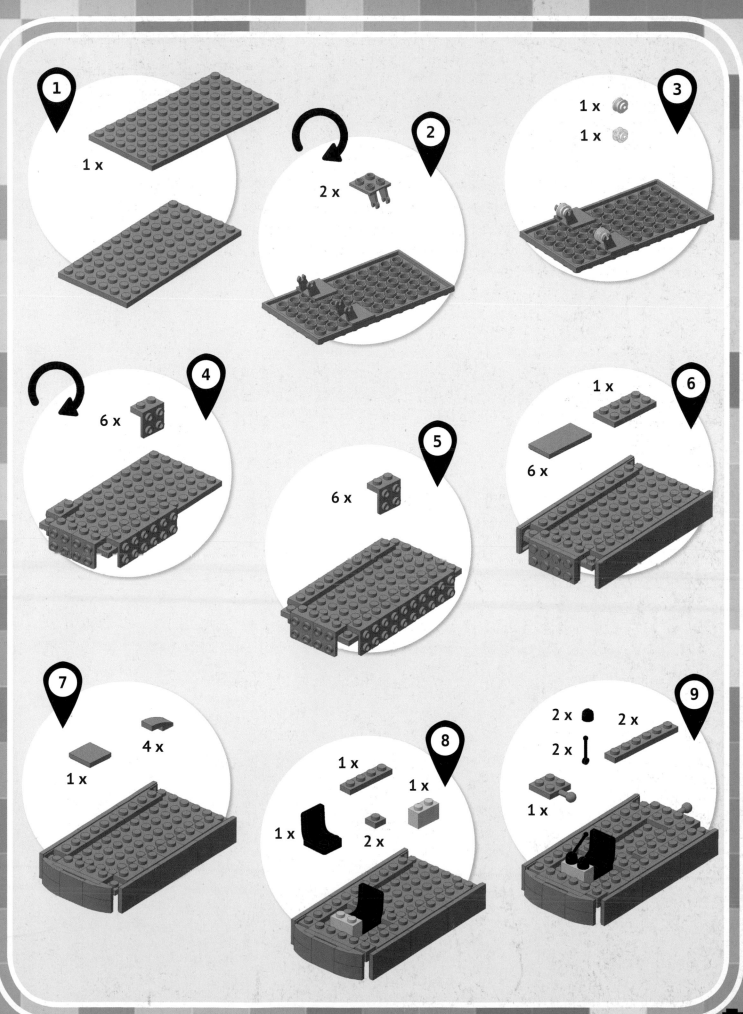

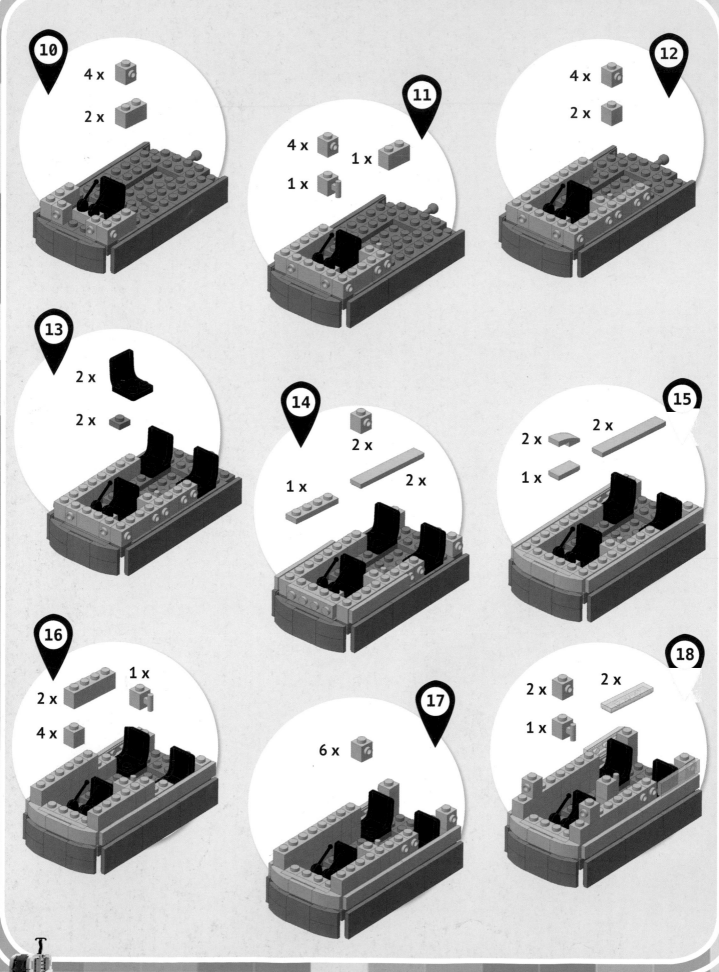

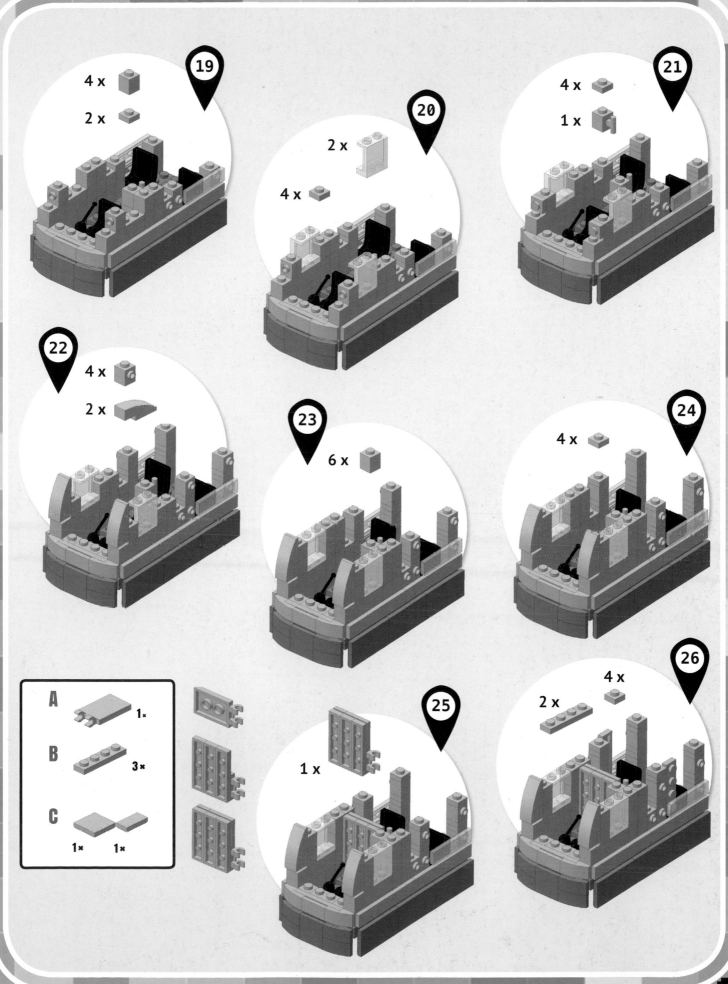

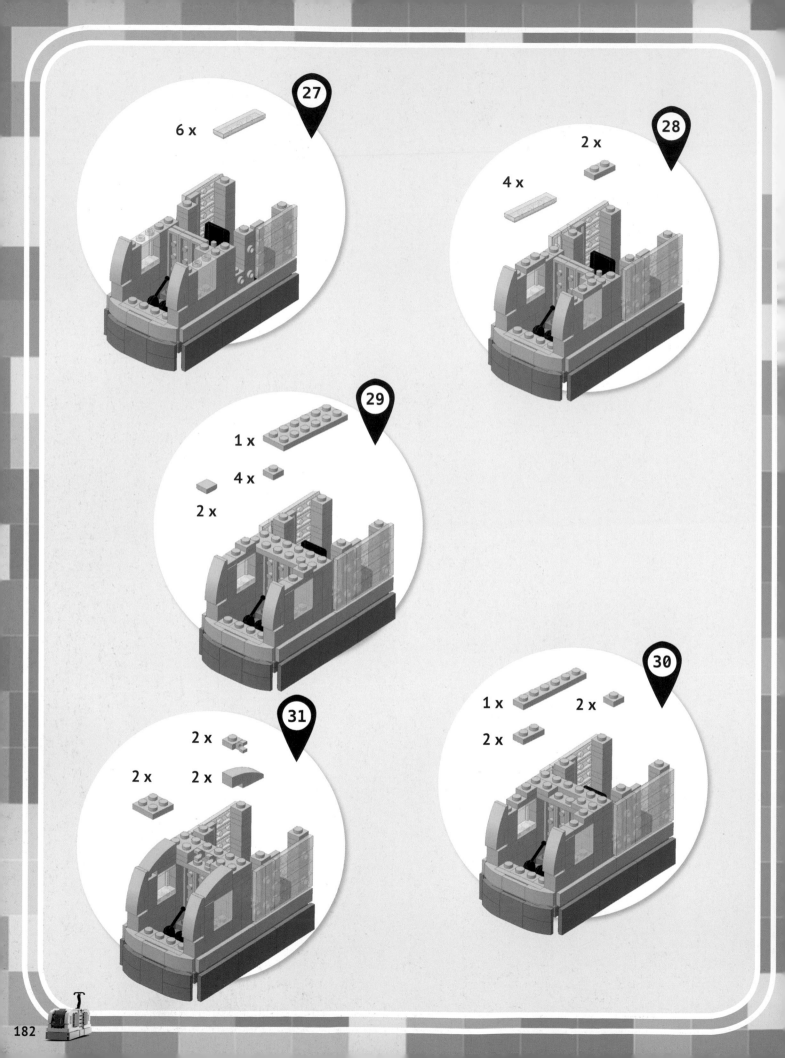

27

6 x

28

2 x

4 x

29

1 x

4 x

2 x

30

1 x 2 x

2 x

31

2 x

2 x 2 x

2 x

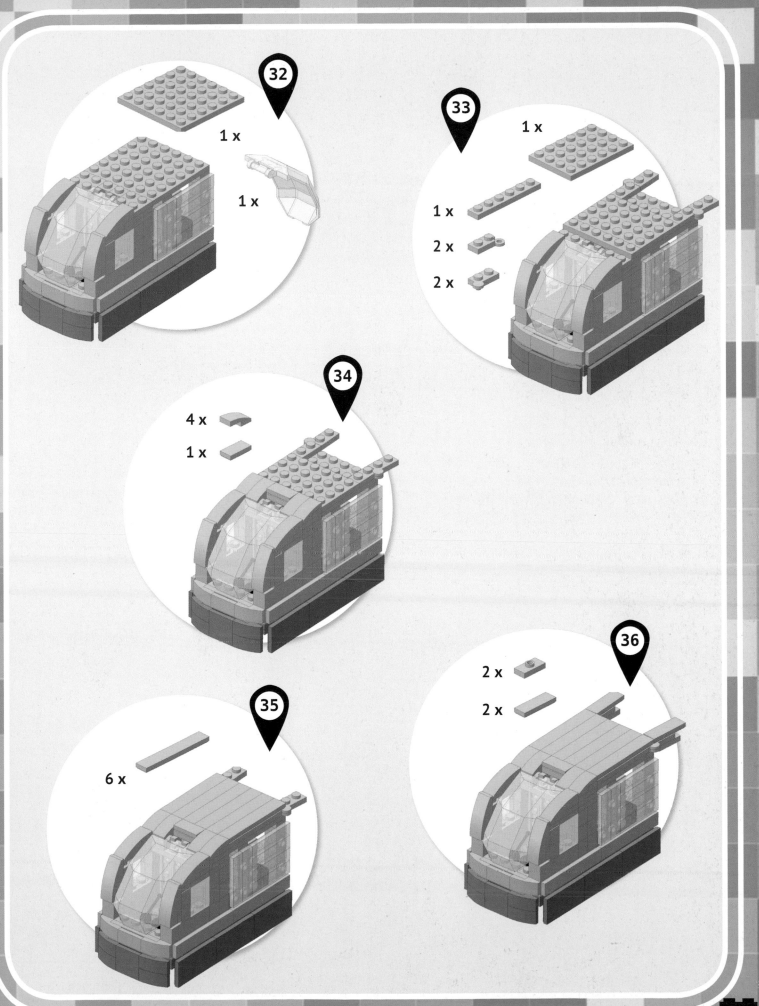

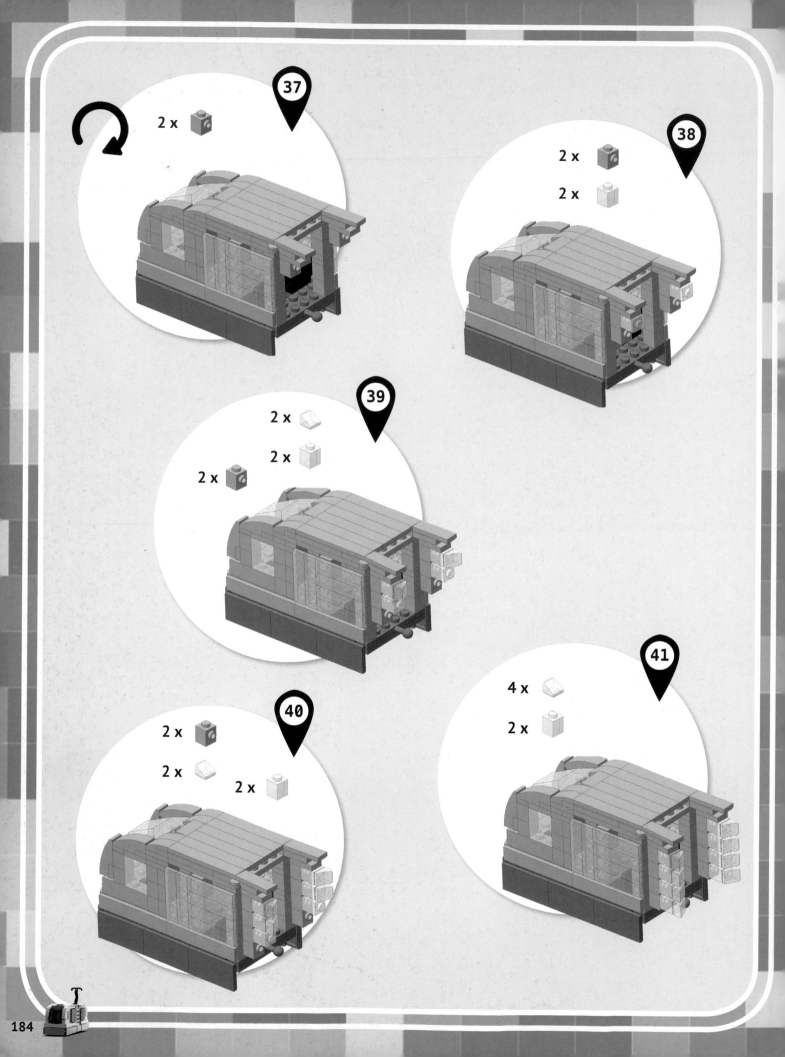

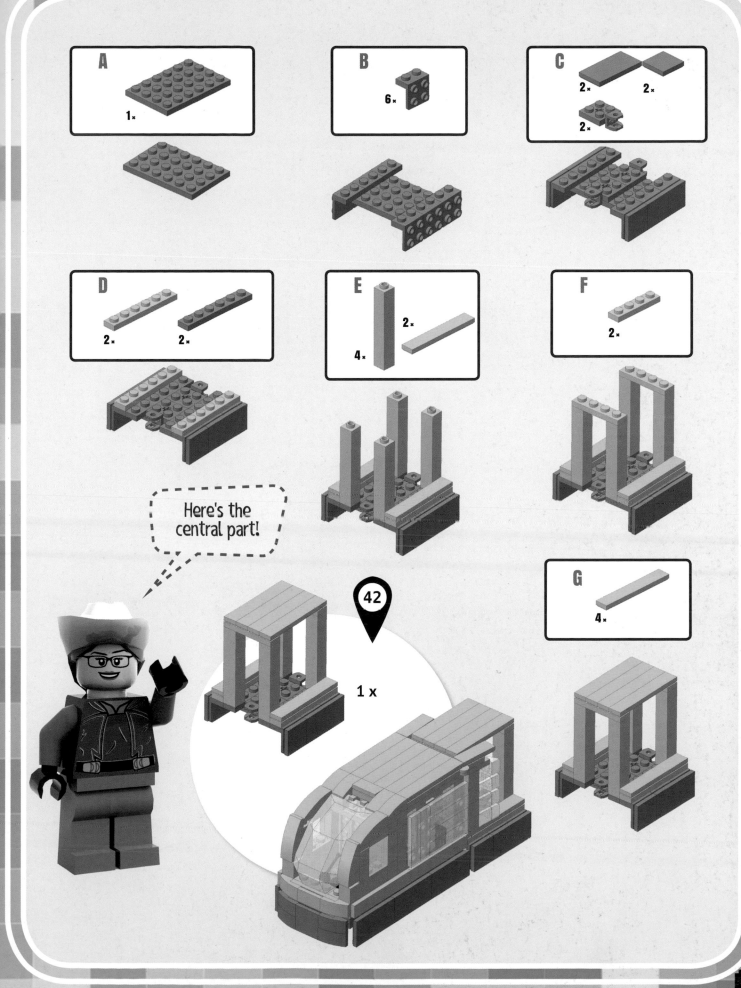

A
1×

B
6×

C
2× 2× 2×

D
2× 2×

E
4× 2×

F
2×

G
4×

Here's the central part!

42
1×

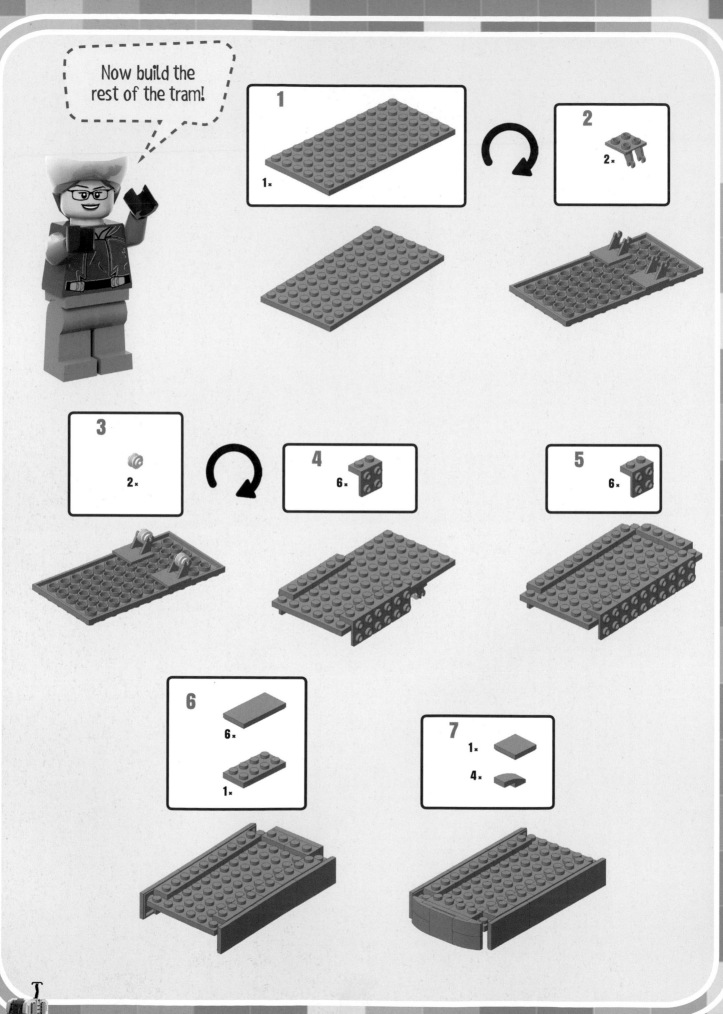

Now build the rest of the tram!

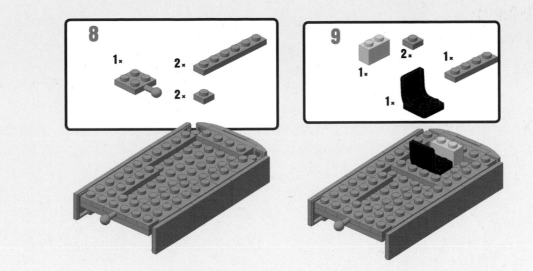

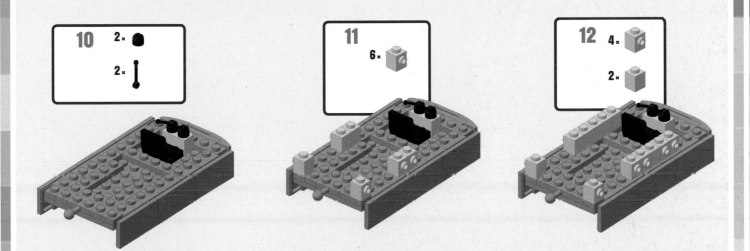

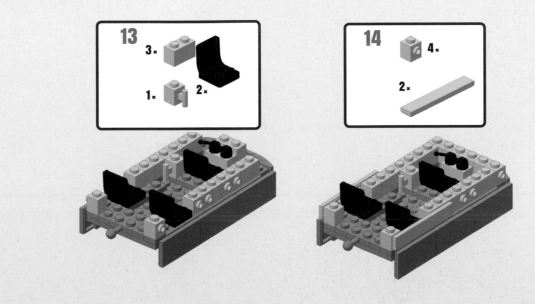

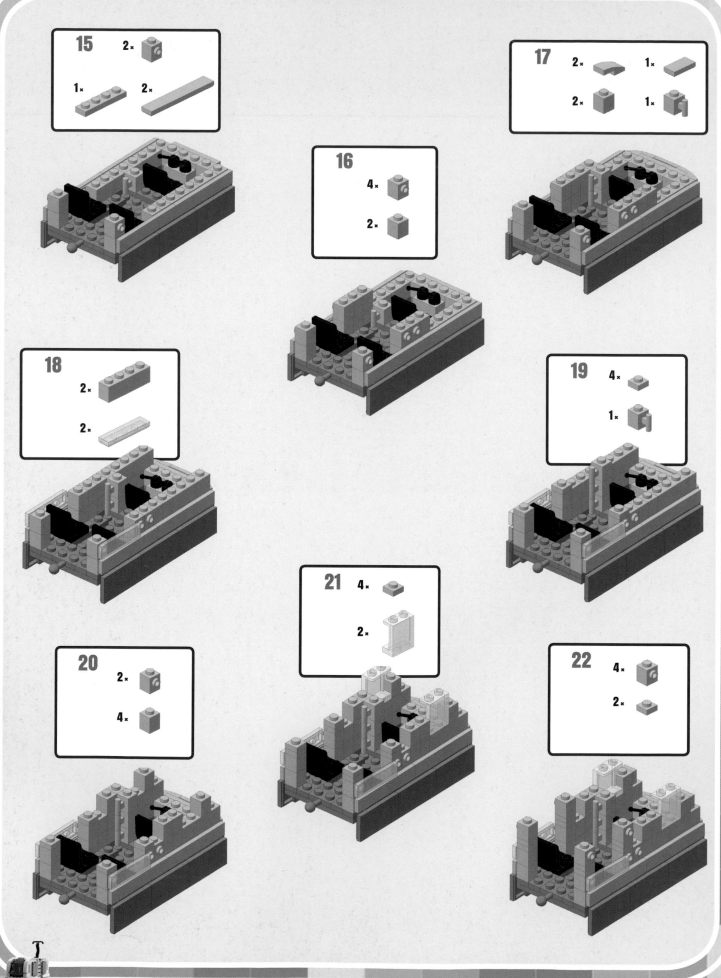

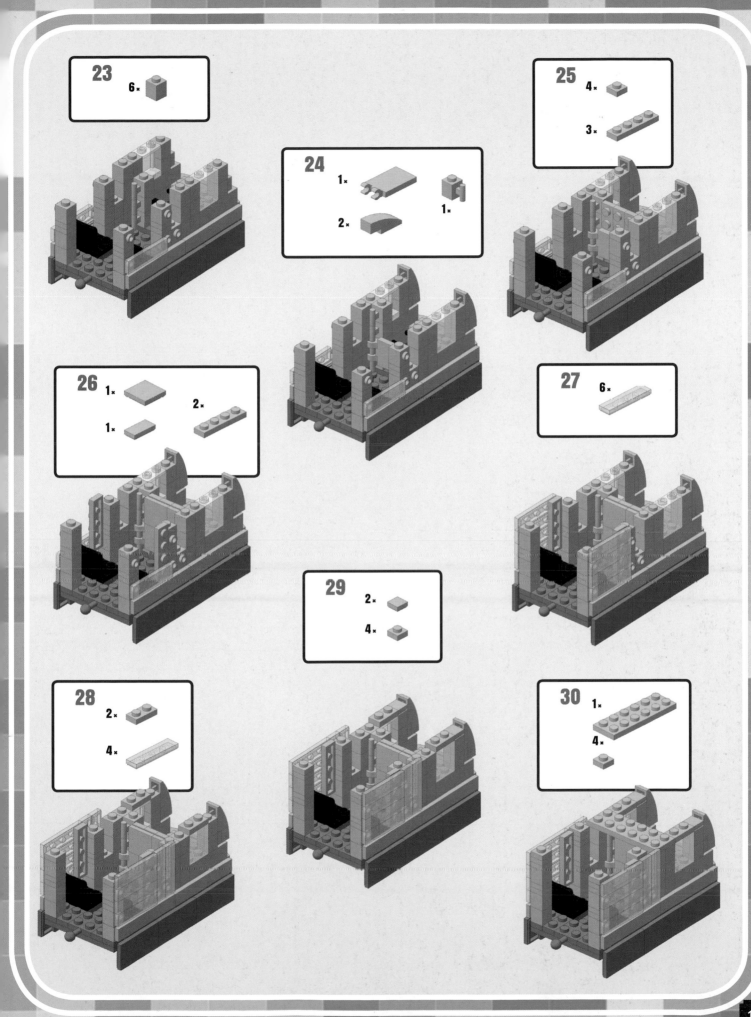

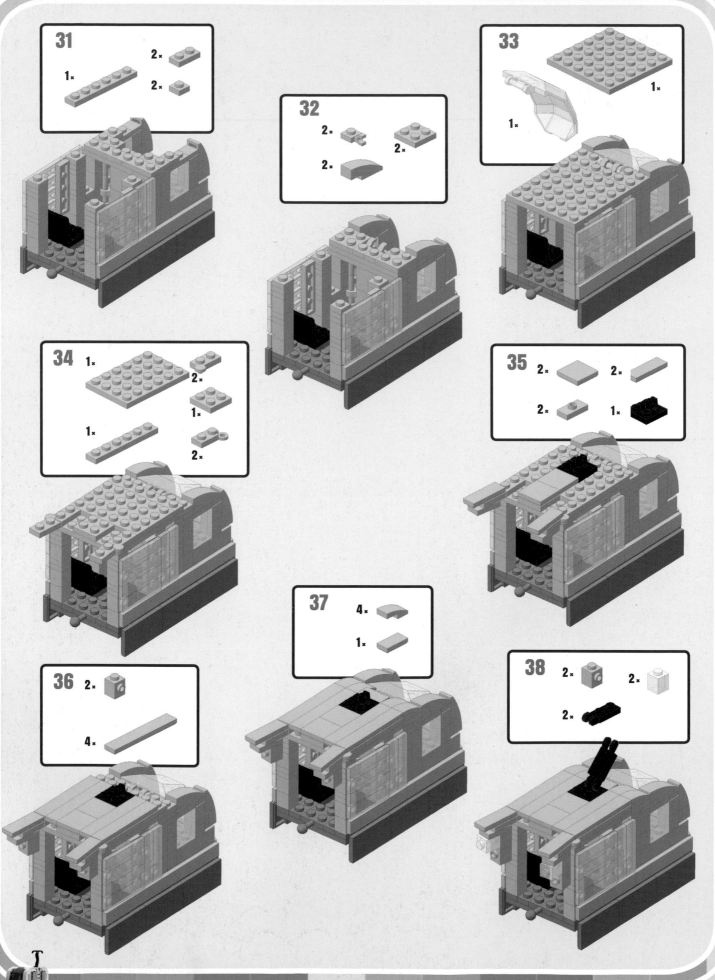

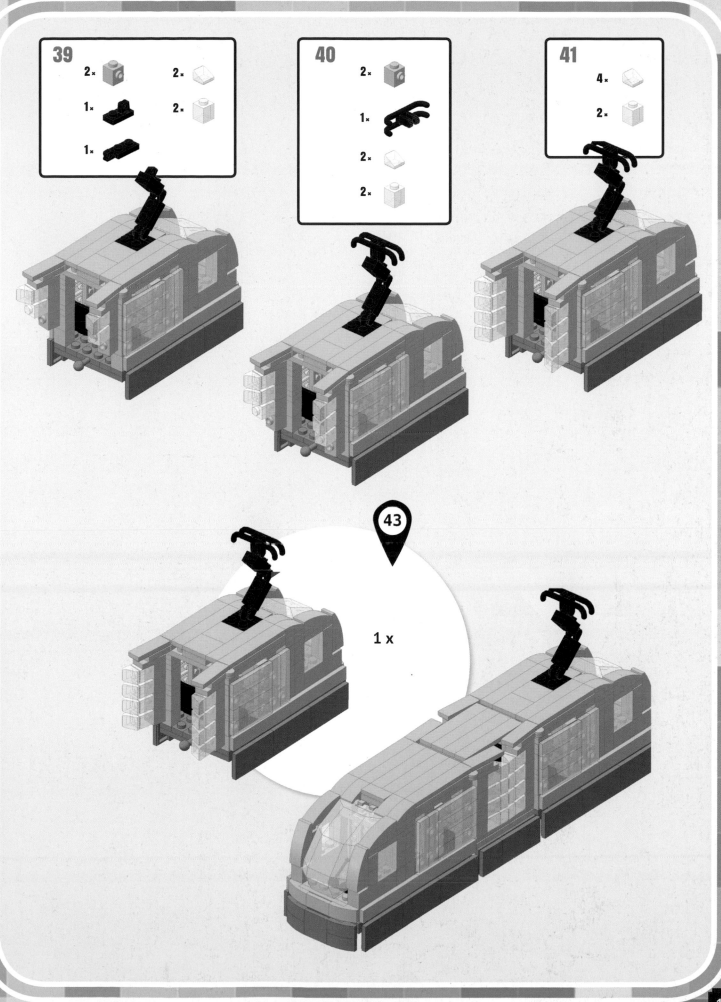

Public transportation is an ecological choice for traveling inside or outside the city. One form is the bus, which can transport many passengers and is among the most demanding constructions in this book.
To build this vehicle, you'll need lots of patience, and you'll have to be ready for a bit of a challenge.

The door really opens!

Pieces required

2 x 3189	3 x 3009	3 x 3456	1 x 4592c03	
45 x 3024	5 x 3034	1 x 3795	4 x 32064	
1 x 3068b	2 x 3666	2 x 93273	3 x 3029	
7 x 3623	1 x 3794	9 x 3005	4 x 30648	1 x 3460
1 x 6636	2 x 63868	10 x 3023	4 x 3707	2 x 2436
5 x 3008	2 x 60478	1 x 3004	2 x 2412a	2 x 42446
1 x 3710	1 x 30414	1 x 3622	1 x 30663	5 x 3710
2 x 3958	4 x 3307	2 x 4477	1 x 3069b	2 x 3068b
2 x 3069b	7 x 3460	6 x 3036	1 x 3666	3 x 3023
2 x 3822	3 x 3010		16 x 4079	
2 x 4070	4 x 3002	3 x 3032	40 x 3024	
2 x 61678	3 x 3035		2 x 3022	

192

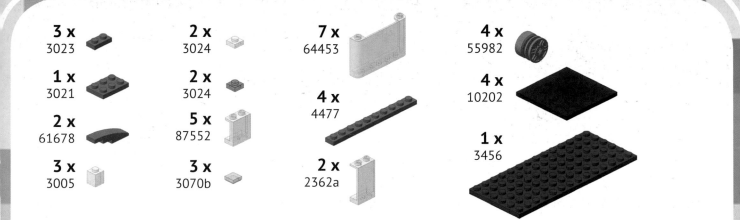

3 x 3023	**2 x** 3024	**7 x** 64453	**4 x** 55982
1 x 3021	**2 x** 3024	**4 x** 4477	**4 x** 10202
2 x 61678	**5 x** 87552		**1 x** 3456
3 x 3005	**3 x** 3070b	**2 x** 2362a	

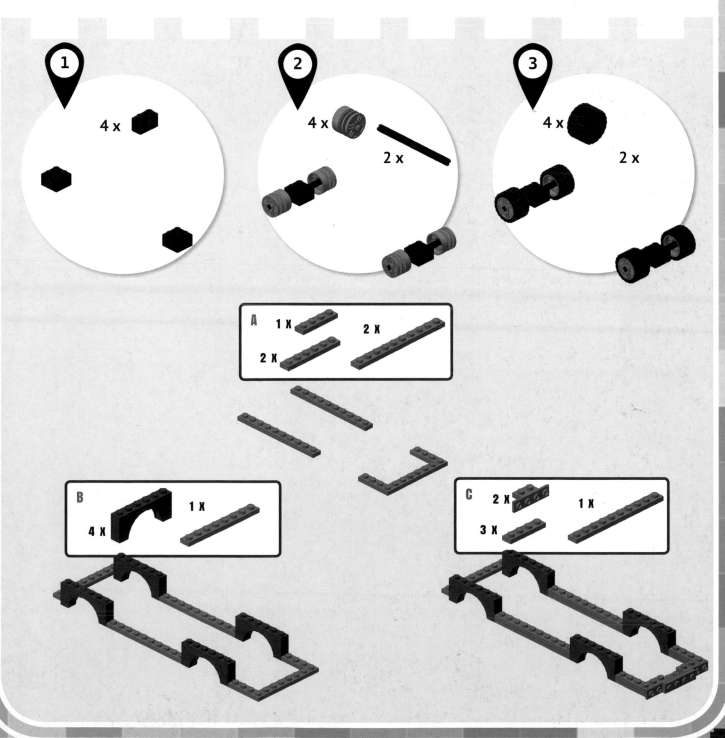

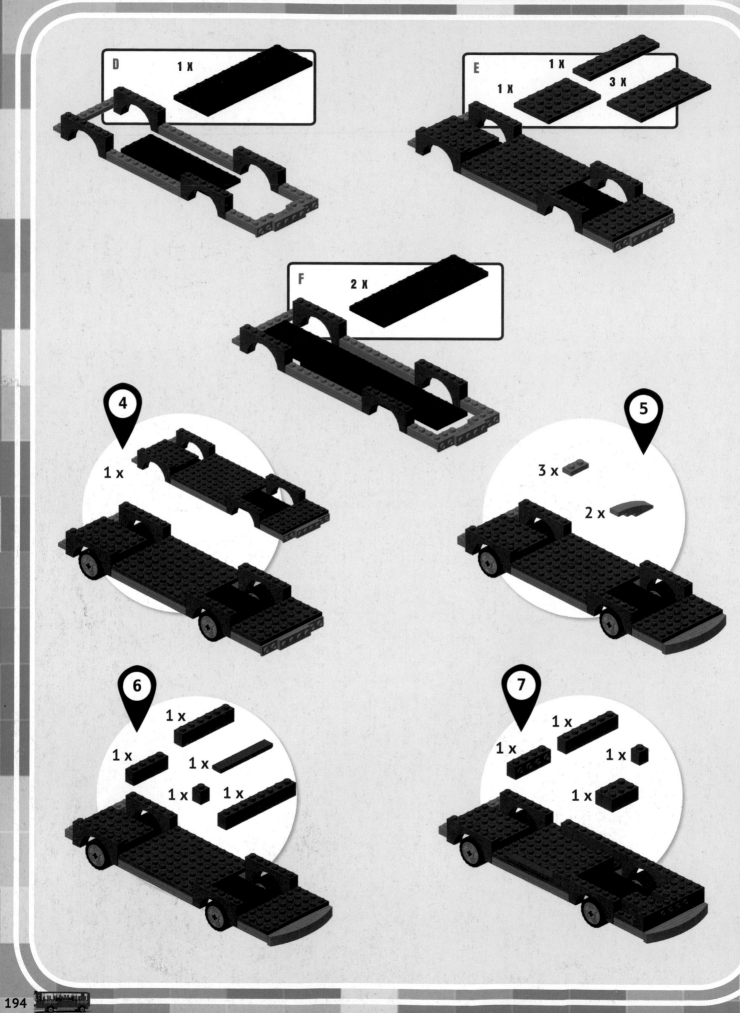

D 1 X

E 1 X 1 X 3 X

F 2 X

4 1 x

5 3 x 2 x

6 1 x 1 x 1 x 1 x 1 x

7 1 x 1 x 1 x 1 x 1 x

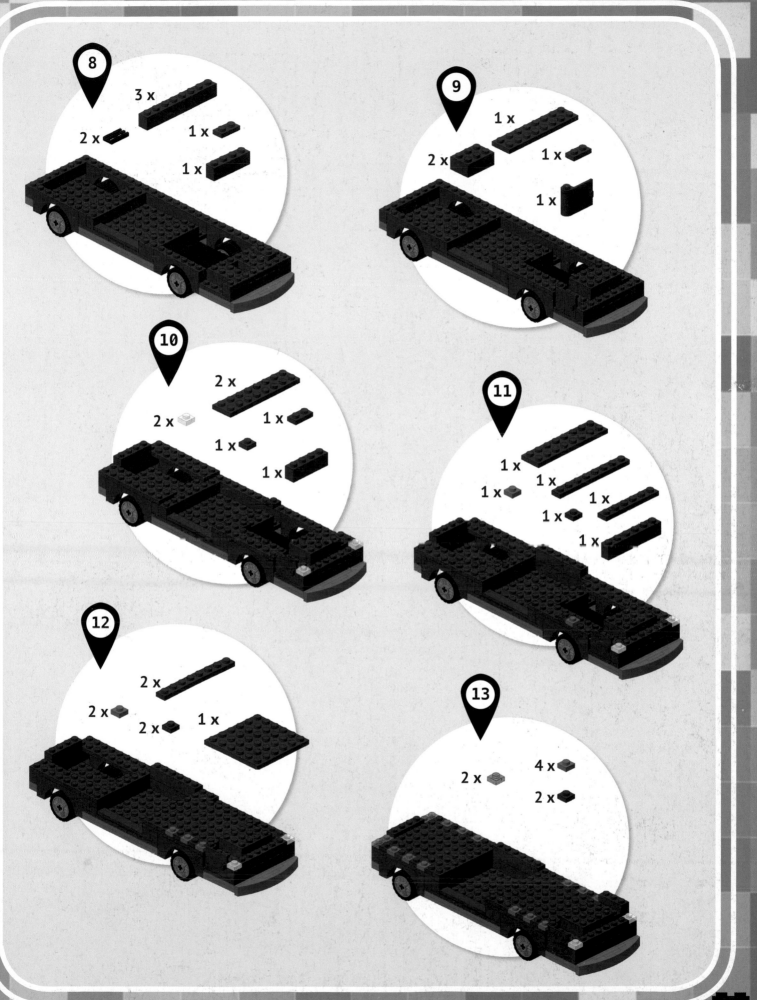

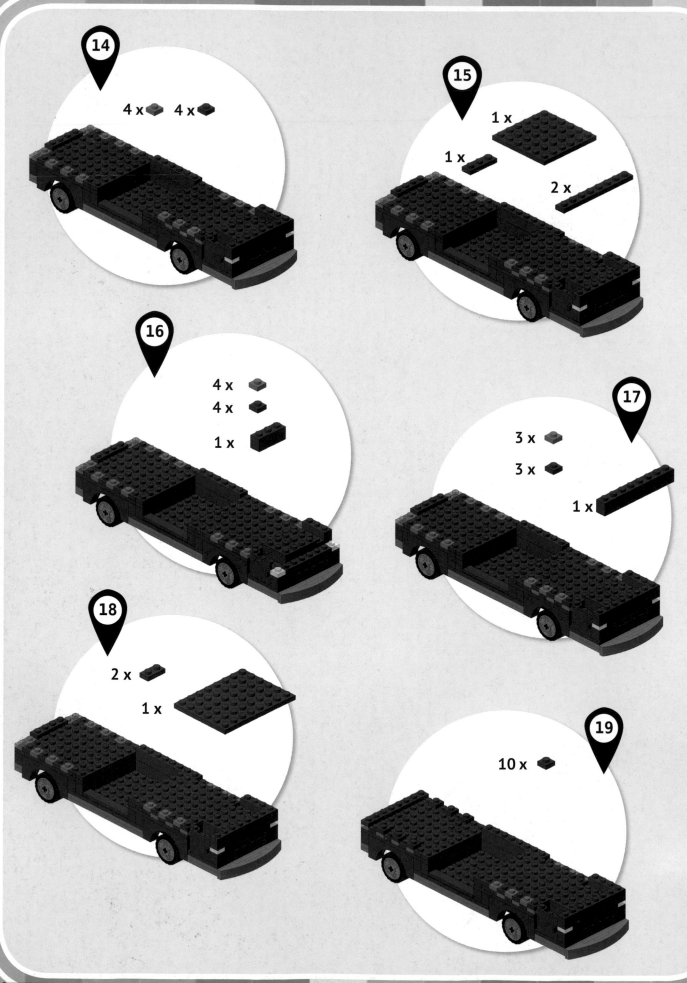

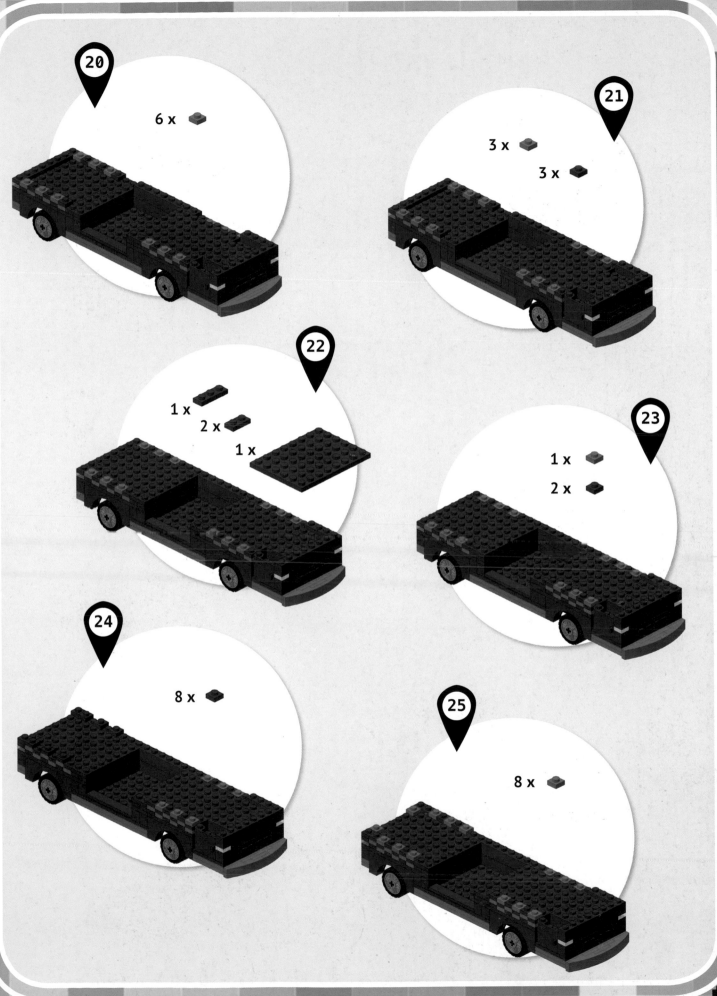

20
6 x

21
3 x
3 x

22
1 x
2 x
1 x

23
1 x
2 x

24
8 x

25
8 x

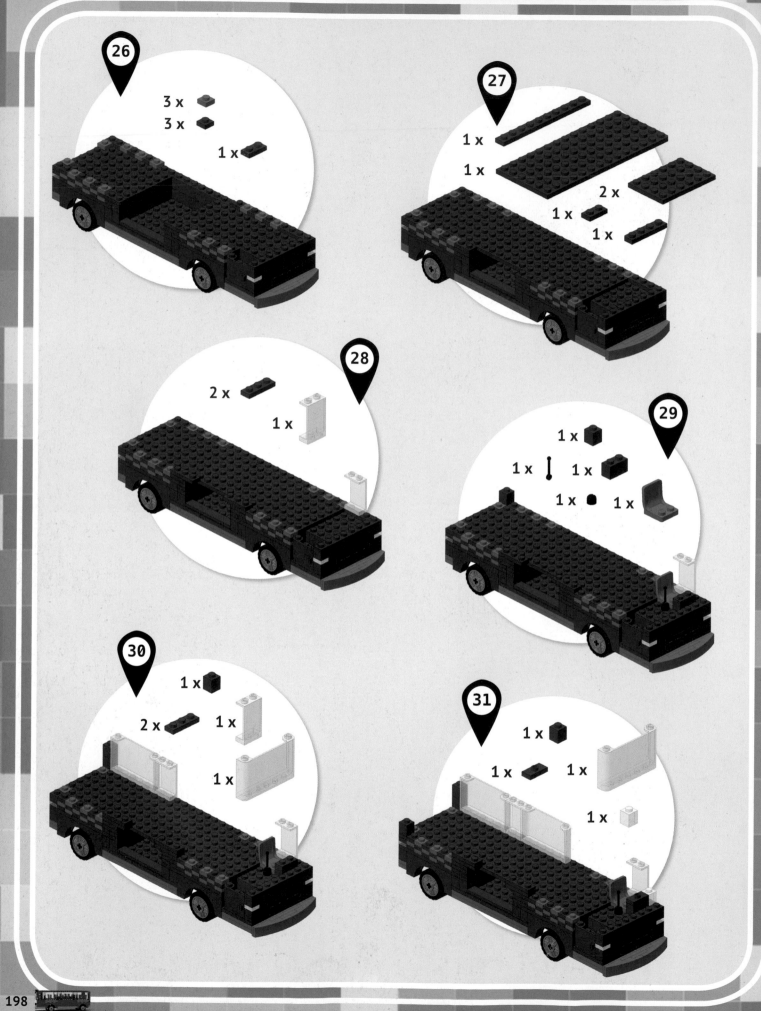

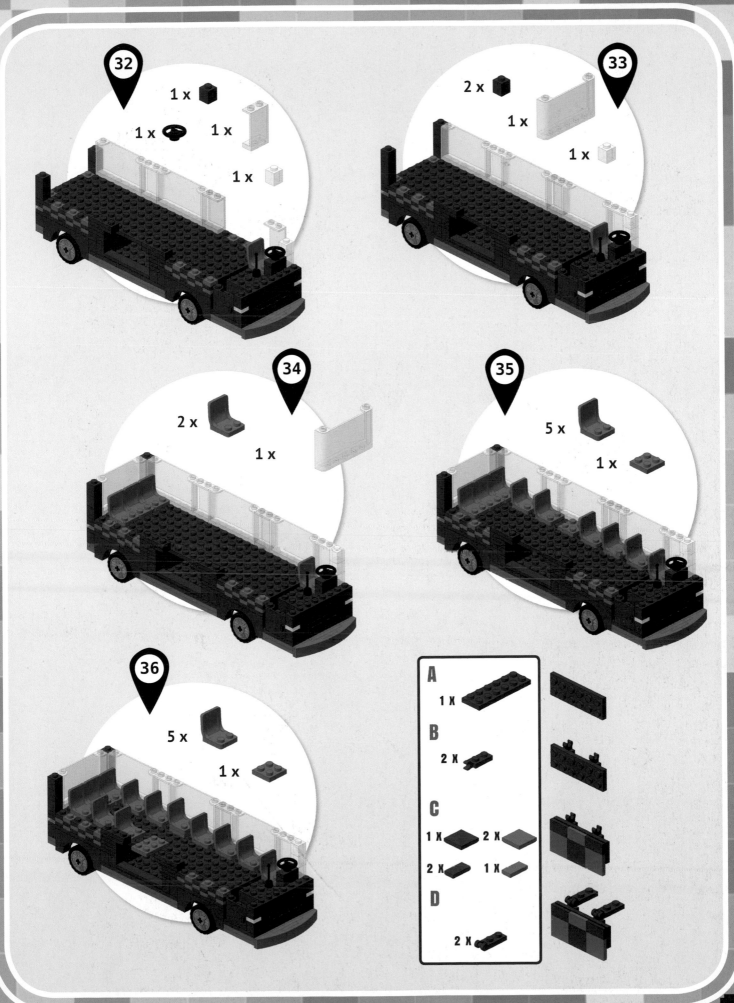

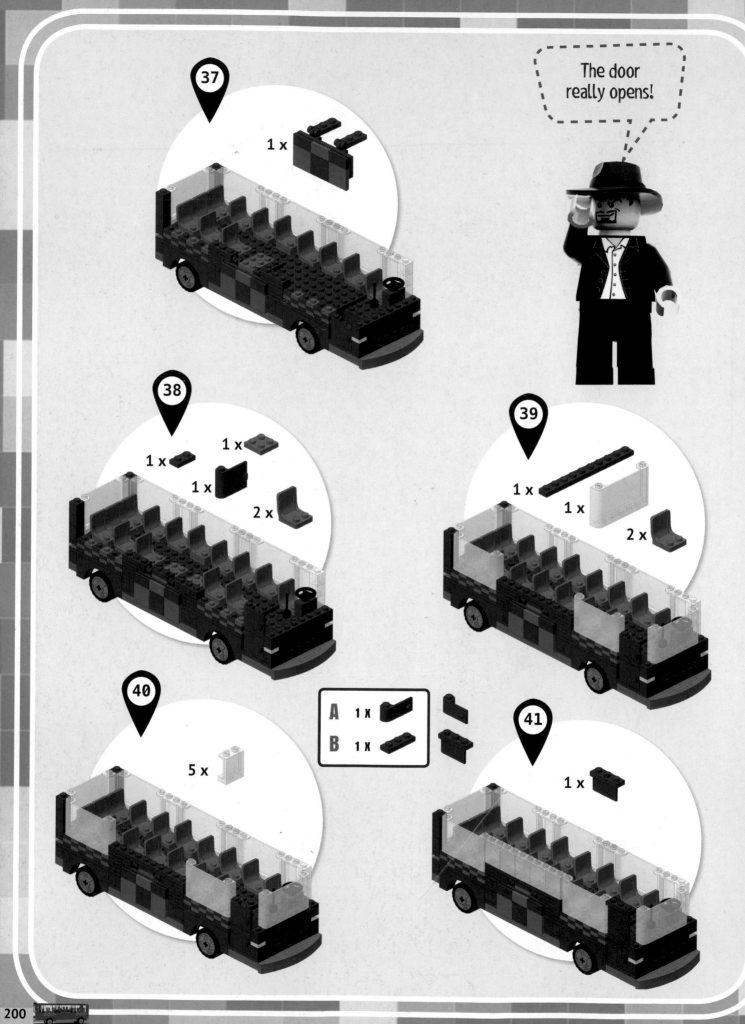

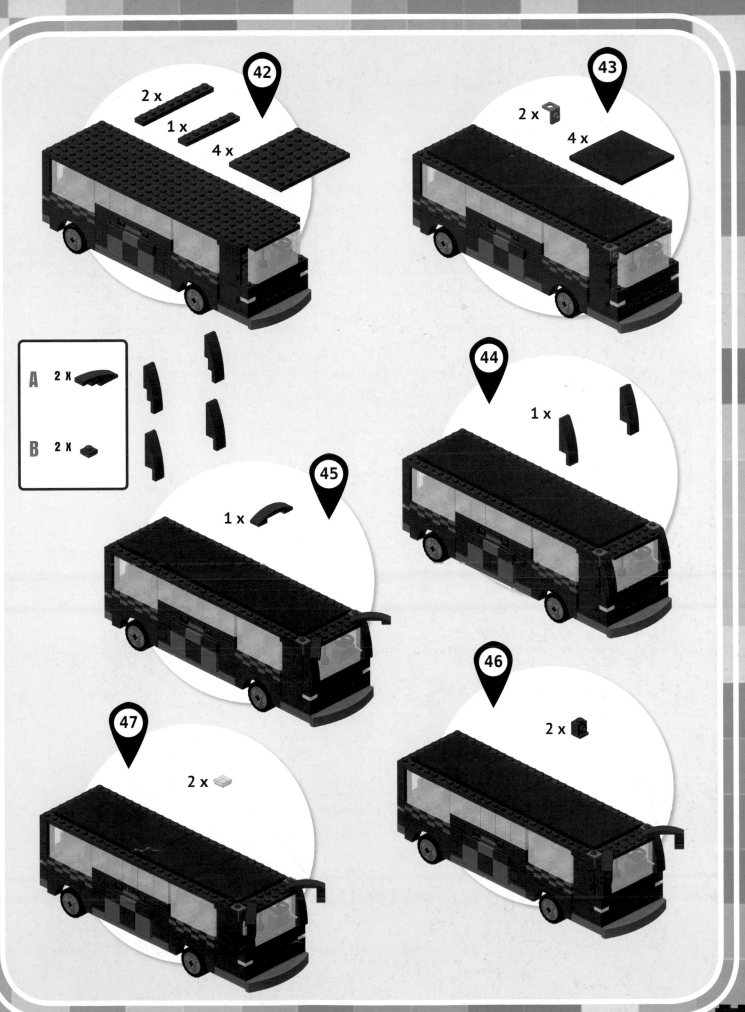

42

2 x
1 x
4 x

43

2 x
4 x

A 2 x
B 2 x

44

1 x

45

1 x

46

2 x

47

2 x

ACKNOWLEDGMENTS

I would like to thank everyone who helped make this book possible. I am grateful to many people and organizations for their amazing support: the publisher, NuiNui; ItLUG, always ready to provide information to all the LEGO® fans in Italy; and Cremona Bricks, the association that brings together LEGO® lovers in the Cremona region. My greatest thanks go to Chiara, who has stood by me and knows better than anyone else how much of her precious time I needed to write this book. My sincerest gratitude to my mother, to my friends, to Kenny, Aurora, Edwin, Gloria, Ethan, Ryan, and Emily, who make up my family and are the main reason why, at my age, I still play with construction toys!

Finally, I must give special thanks to RomaBrick, the Roman LUG (LEGO® User Group), whose members are an endless source of inspiration for me: Massimiliano "Dogens", Marcello, Marco "Khanc", Antonio, Alessandro, Luca (all of them...), Andrea, Bicio, Carlo, Gianluca, Ugo Maria, Leila, Laura, Claudia, Giovanni, Mario, Domenico, Aurora, Michele, Sandro, Massimo, and that ... "blimp" Jonathan. If I have inadvertently forgotten anyone, please forgive me.

MODELS

SNOWBOARD ::::::::::::::::::::::::
www.nuinui.ch/upload/40-vehicles-p14.zip

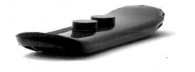

SURFBOARD ::::::::::::::::::::::
www.nuinui.ch/upload/40-vehicles-p15.zip

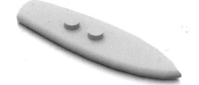

SKATEBOARD :::::::::::::::::::::::
www.nuinui.ch/upload/40-vehicles-p16.zip

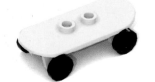

ROWBOAT ::::::::::::::::::::::::::
www.nuinui.ch/upload/40-vehicles-p17.zip

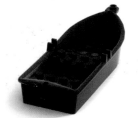

CANOE ::::::::::::::::::::::::::::
www.nuinui.ch/upload/40-vehicles-p18.zip

BICYCLE :::::::::::::::::::::::::::
www.nuinui.ch/upload/40-vehicles-p19.zip

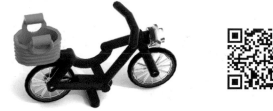

SEGWAY ::::::::::::::::::::::::::::
www.nuinui.ch/upload/40-vehicles-p20.zip

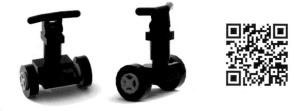

MOTORCYCLE :::::::::::::::::::::::
www.nuinui.ch/upload/40-vehicles-p21.zip

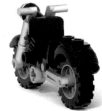

MOTORCROSS BIKE :::::::::::::::::
www.nuinui.ch/upload/40-vehicles-p22.zip

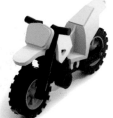

POLICE MOTORCYCLE ::::::::::::::
www.nuinui.ch/upload/40-vehicles-p23.zip

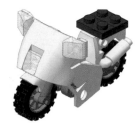

JET SKI :::::::::::::::::::::::::::::
www.nuinui.ch/upload/40-vehicles-p26.zip

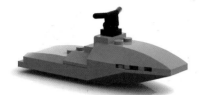

MOTORBOAT ::::::::::::::::::::::::
www.nuinui.ch/upload/40-vehicles-p28.zip

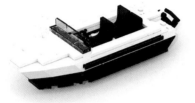

QUAD ::::::::::::::::::::::::::::::::::
www.nuinui.ch/upload/40-vehicles-p32.zip

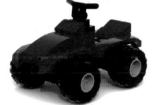

SIDECAR :::::::::::::::::::::::::::::
www.nuinui.ch/upload/40-vehicles-p36.zip

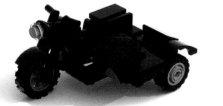

OLD CAR ::::::::::::::::::::::::::::::
www.nuinui.ch/upload/40-vehicles-p38.zip

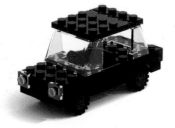

SNOWCAT :::::::::::::::::::::::::::::
www.nuinui.ch/upload/40-vehicles-p40.zip

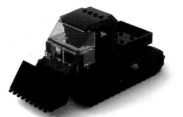

TRACTOR ::::::::::::::::::::::::::::::
www.nuinui.ch/upload/40-vehicles-p46.zip

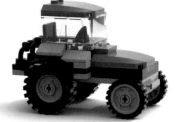

CAR :::::::::::::::::::::::::::::::::::::
www.nuinui.ch/upload/40-vehicles-p52.zip

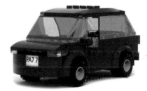

POLICE CAR :::::::::::::::::::::::::
www.nuinui.ch/upload/40-vehicles-p56.zip

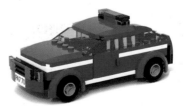

SPORTS CAR :::::::::::::::::::::::::
www.nuinui.ch/upload/40-vehicles-p60.zip

FORMULA 1 ::::::::::::::::::::
www.nuinui.ch/upload/40-vehicles-p64.zip

VINTAGE CAR :::::::::::::::::::
www.nuinui.ch/upload/40-vehicles-p88.zip

VAN ::::::::::::::::::::::::
www.nuinui.ch/upload/40-vehicles-p68.zip

FOUR-WHEEL DRIVE (4x4) :::::::::
www.nuinui.ch/upload/40-vehicles-p92.zip

TRUCK ::::::::::::::::::::::::
www.nuinui.ch/upload/40-vehicles-p72.zip

MONSTER TRUCK :::::::::::::::::
www.nuinui.ch/upload/40-vehicles-p100.zip

BULLDOZER :::::::::::::::::::::
www.nuinui.ch/upload/40-vehicles-p76.zip

ASPHALT PAVER :::::::::::::::::
www.nuinui.ch/upload/40-vehicles-p104.zip

JET :::::::::::::::::::::::::
www.nuinui.ch/upload/40-vehicles-p80.zip

LIMOUSINE :::::::::::::::::::::
www.nuinui.ch/upload/40-vehicles-p108.zip

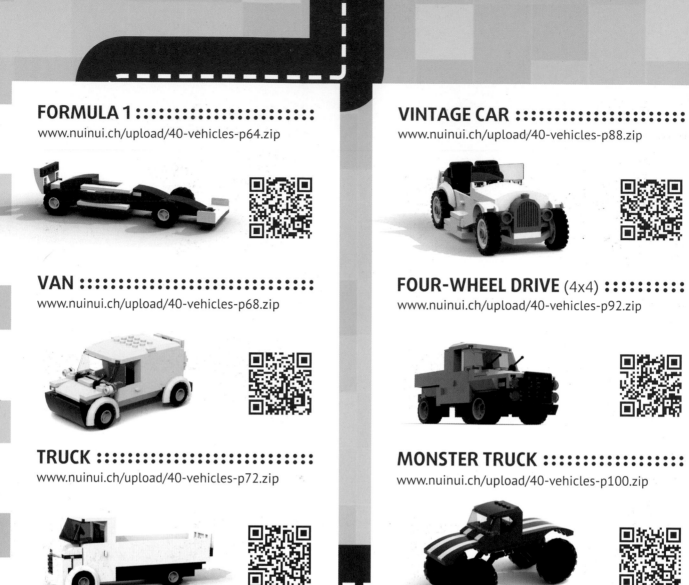
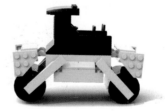

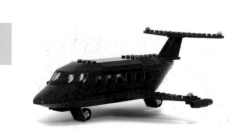

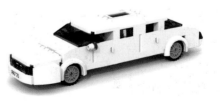

AMBULANCE :::::::::::::::::::::::

www.nuinui.ch/upload/40-vehicles-p112.zip

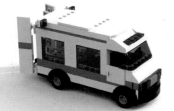

AIRPLANE :::::::::::::::::::::::::

www.nuinui.ch/upload/40-vehicles-p120.zip

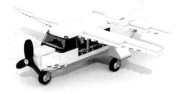

HELICOPTER :::::::::::::::::::::::

www.nuinui.ch/upload/40-vehicles-p124.zip

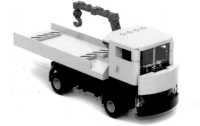

FLATBED TOW TRUCK :::::::::::::

www.nuinui.ch/upload/40-vehicles-p130.zip

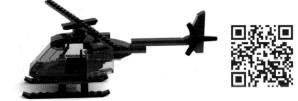

TRACTOR-TRAILER ::::::::::::::::

www.nuinui.ch/upload/40-vehicles-p136.zip

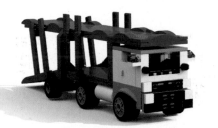

CEMENT MIXER :::::::::::::::::::

www.nuinui.ch/upload/40-vehicles-p146.zip

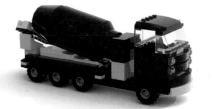

TANK TRUCK :::::::::::::::::::::

www.nuinui.ch/upload/40-vehicles-p154.zip

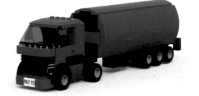

FIRE TRUCK ::::::::::::::::::::::

www.nuinui.ch/upload/40-vehicles-p166.zip

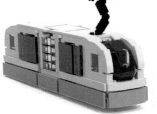

TRAM :::::::::::::::::::::::::::::

www.nuinui.ch/upload/40-vehicles-p178.zip

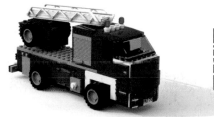

BUS :::::::::::::::::::::::::::::::

www.nuinui.ch/upload/40-vehicles-p192.zip

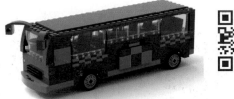

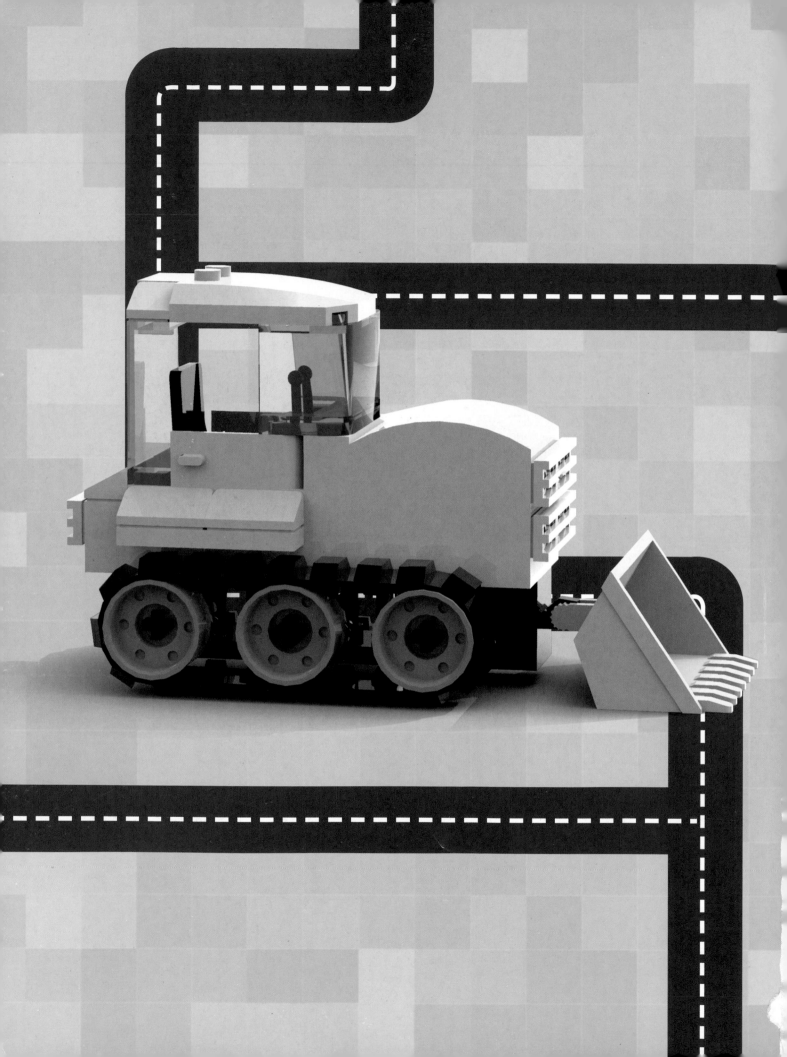